W9-DFO-468

Lessons in Classical Painting

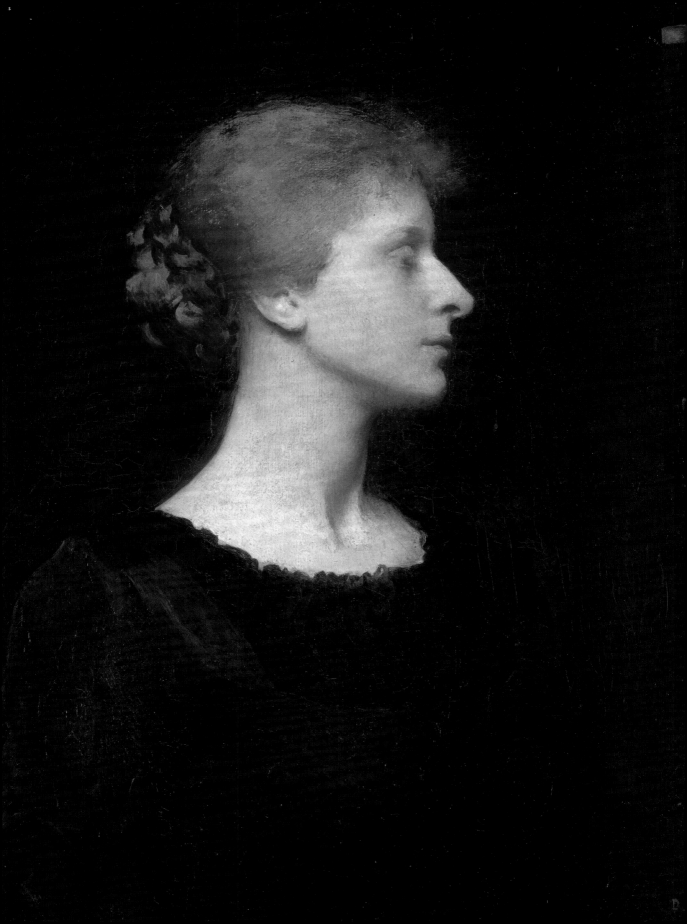

LESSONS *in* CLASSICAL PAINTING

Essential Techniques from Inside the Atelier

Juliette Aristides

WATSON-GUPTILL
Berkeley

Copyright © 2016 by Juliette Aristides

All rights reserved.

Published in the United States by Watson-Guptill Publications, an imprint of the Crown Publishing Group, a division of Penguin Random House LLC, New York.

www.crownpublishing.com
www.watsonguptill.com

WATSON-GUPTILL and the WG and Horse designs are registered trademarks of Penguin Random House LLC

Library of Congress Cataloging-in-Publication Data

Names: Aristides, Juliette, author.

Title: Lessons in classical painting : essential techniques from inside the atelier / Juliette Aristides.

Description: Berkeley : Watson-Guptill, 2016. | Includes bibliographical references and index.

Identifiers: LCCN 2015041361|

Subjects: LCSH: Painting—Technique. | BISAC: ART / Techniques / Painting. | ART / Reference. | ART / Techniques / General.

Classification: LCC ND1500 .A645 2016 | DDC 750.28—dc23 LC record available at http://lccn.loc.gov/2015041361

Hardcover ISBN: 978-1-6077-4789-5

eBook ISBN: 978-1-6077-4790-1

Printed in China

Design by Margaux Keres

10 9 8 7 6 5 4 3 2 1

First Edition

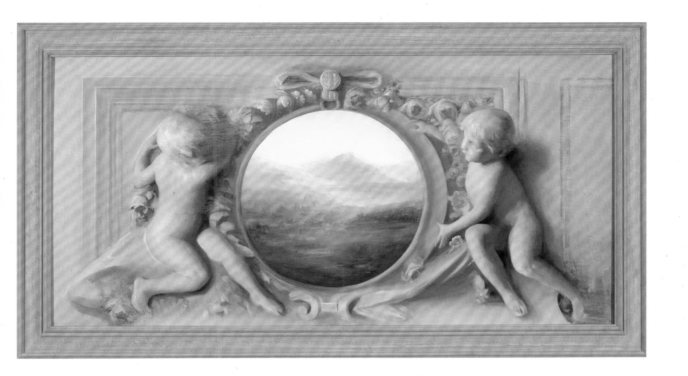

For my parents and the poet

*Painting is one of the highest means that
God chose... to make man participate in all the most beautiful
and best of what he had ever created.*

–*Giovan Paolo Lomazzo* (*Idea of the Temple of Painting*, translated by Jean Julia Chai)

CONTENTS

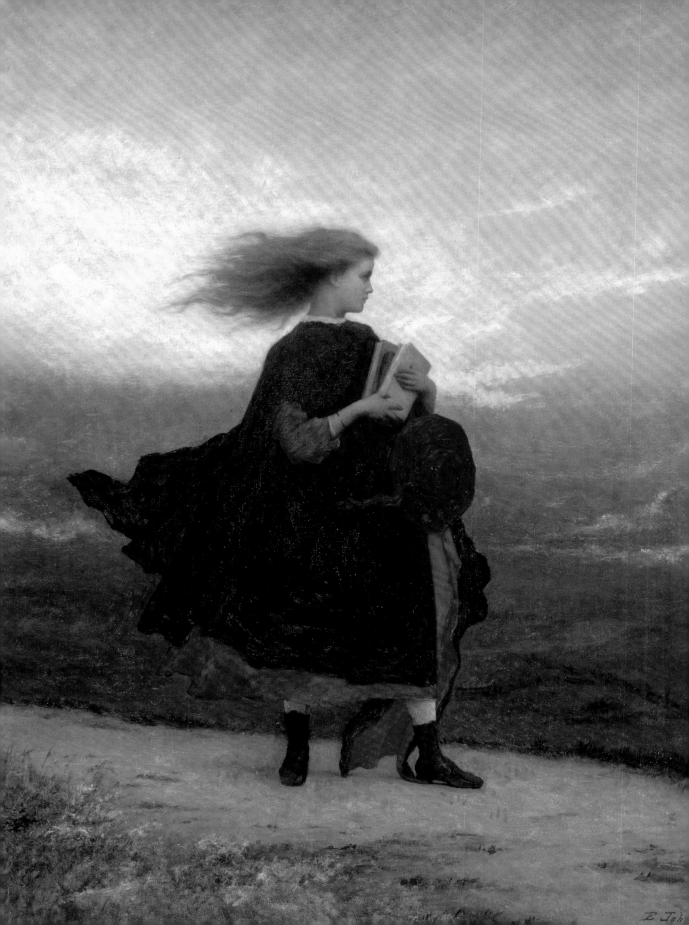

PROLOGUE

How do people manage to find a way for themselves in this world? I always thought it a miracle that a person can be born, grow up, leave his or her home, and make a credible life; as subject to chance and fate as a seed from a dandelion, blown through the air, resting where the circumstances perfectly conspire for it to grow. It always appeared equally possible that the wind could just blow the seed forever. To me, the process of successfully growing up never felt inevitable.

During my teenage years I felt that endlessly drifting was a distinct possibility. The ordinary often felt miraculous; things that seemed obvious to others stupefied me. The trees outside my bedroom window appeared slightly different every day—I found the view oddly and endlessly engaging. To my surprise, the road next to my house wasn't black, but violet. I also began to wonder how I, whose only skill was to be easily stumped, could get a job—or if I even wanted a job.

By high school I made friends with my sketchbook. Through my sketchbook I found a means to engage with the world. I could finally start to ground my ideas through art. I brought this notebook everywhere with me. It was a place to record my thoughts; it formed a buffer against the world and a filter for my imagination.

When I graduated, through fate or grace, I found a rigorous art teacher who ran a private studio. I remember struggling. Everything I did seemed to come out painfully wrong. I even had to relearn how to hold my pencil. I recall my teacher yelling that he wouldn't let me paint the back of his garage. Yet, in his studio, not only was it okay

OPPOSITE Born in Maine, Eastman Johnson studied in Düsseldorf, Germany, and later in Paris with Thomas Couture. He was interested in furthering American painting and subject matter. Johnson lived through the Civil War; this painting captures the passion and emotion of a resilient people who faced hardship and separation.

Eastman Johnson, *The Girl I Left Behind Me*, circa 1872, oil on canvas, 42 × 34⅞ inches (106.7 × 88.7 cm). Smithsonian American Art Museum (Washington, D.C.). Image courtesy of the Art Renewal Center® (artrenewal.org).

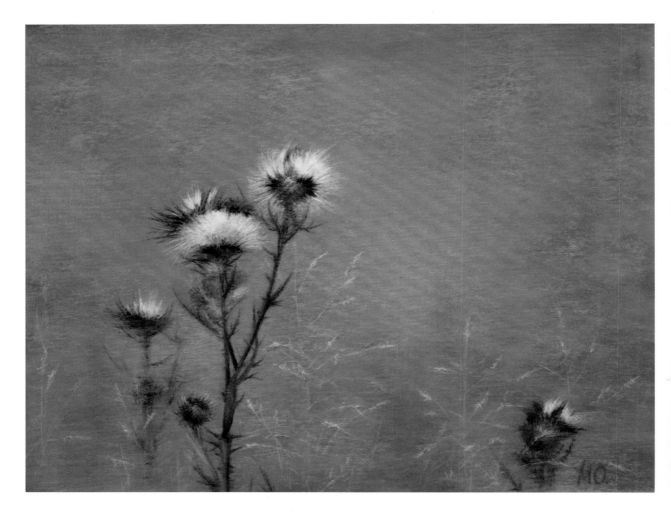

Maria Olano turns her attention to the small forms found in nature in this subtle landscape in miniature.

Maria Olano, *In the Meadow*, 2014, pastel on paper, 9 x 12 inches (22.86 x 30.48 cm). Private collection.

OPPOSITE As a teenager, John Singer Sargent started his training in the studio of Carolus-Duran, an artist who stressed direct painting in the spirit of Velazquez.

John Singer Sargent, *Man Wearing Laurels*, 1874–1880, oil on canvas, 17½ x 13³⁄₁₆ inches (44.45 x 33.47 cm). Los Angeles County Museum of Art (Los Angeles, CA). Image courtesy of the Art Renewal Center® (artrenewal.org).

to look endlessly at the model or still life, it was required. Suddenly, the rules of the world made sense to me. Though never studious or brilliant academically, I found myself working through the night, relentlessly curious to learn all I could about artistic seeing. I discovered I was not alone, but part of a long tradition.

Even though my first art education experience was difficult, it gave me momentum. I spent the next decade traveling to studios in Philadelphia, Minneapolis, and New York, learning from as many artists as I could, piecing together fragments of lost knowledge about the historical practice of making art. I was on a treasure hunt, and the clues were hidden in the memories of a few scattered individuals who still followed the tradition of drawing and painting and deep in history (recorded in diaries and books). A handful of art students, myself included, awoke to a deep sense of calling, as we sought to reconnect with and save what was disappearing.

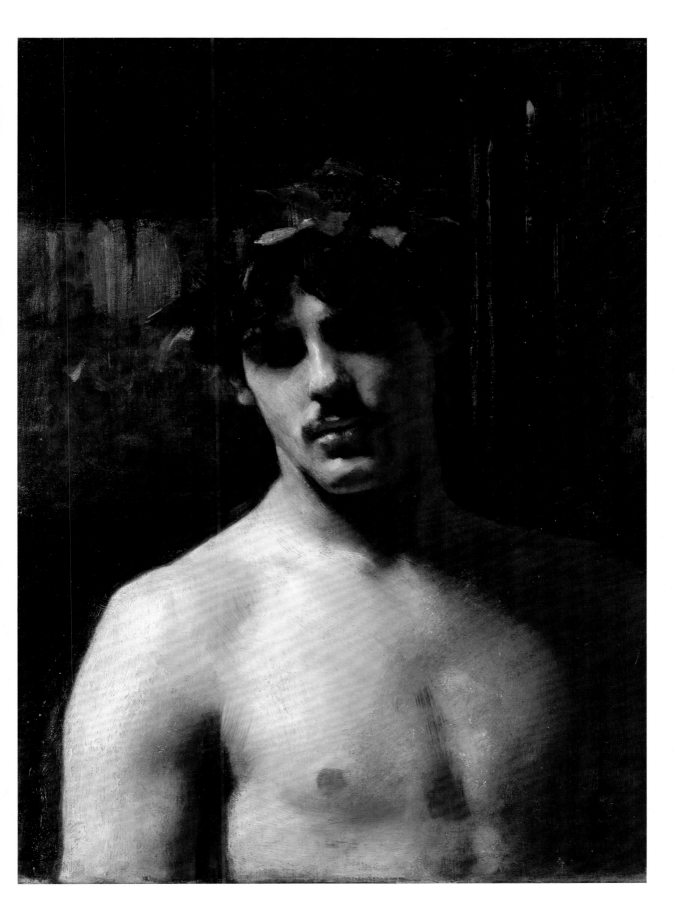

ABOVE, TOP Jon deMartin, *Faith in the Wilderness*, 2006–07, oil on canvas, 26 x 53 inches (66.04 x 134.62 cm). Private collection.

ABOVE, BOTTOM *Entrance to Aristides Atelier*, photograph by Andrei Kozlov.

OPPOSITE Vilhelm Hammershøi, *Interior. Standgade 30, 1901*, 1901, oil on canvas, 26 x 21⅝ inches (66 × 55 cm). Städel Museum (Frankfurt, Germany). Image courtesy of the Art Renewal Center® (artrenewal.org).

My transition from student to teacher was gradual. I found teaching to be another way to continue learning as I was exposed to new artists and ideas. I started teaching at the Gage Academy of Art in Seattle, Washington. A group of students and I renovated a raw space, transforming it into a haven from the tumult of the world and allocating it for the study and creation of art. During the last night of the renovation, I painted the floors until I reached the door and then closed it behind me, not yet seeing the space completed. Early the next morning it was snowing. I wrestled with the unplowed streets, impatient to see the finished studio for the first time. I can't describe the emotion I felt upon opening the door. We had turned a decimated room into an artistic monastery—the first full-time Atelier program in the Northwest.

Over time artists began to travel to Seattle to study with me, just as I had traveled to study with others. Atelier training is no longer a dying tradition. More studios are opening across the country than I can keep track of, and the number of students, once just a handful, is now in the thousands. Despite every reason why this movement might remain small, it continues to grow. There are people, like me, whose main gift appears to be curiosity, who love to investigate and marvel at the world around them. For those who share William Blake's belief that "If the doors of perception were cleansed every thing would appear to man as it is, Infinite," there will always be a place in ateliers for them to study.

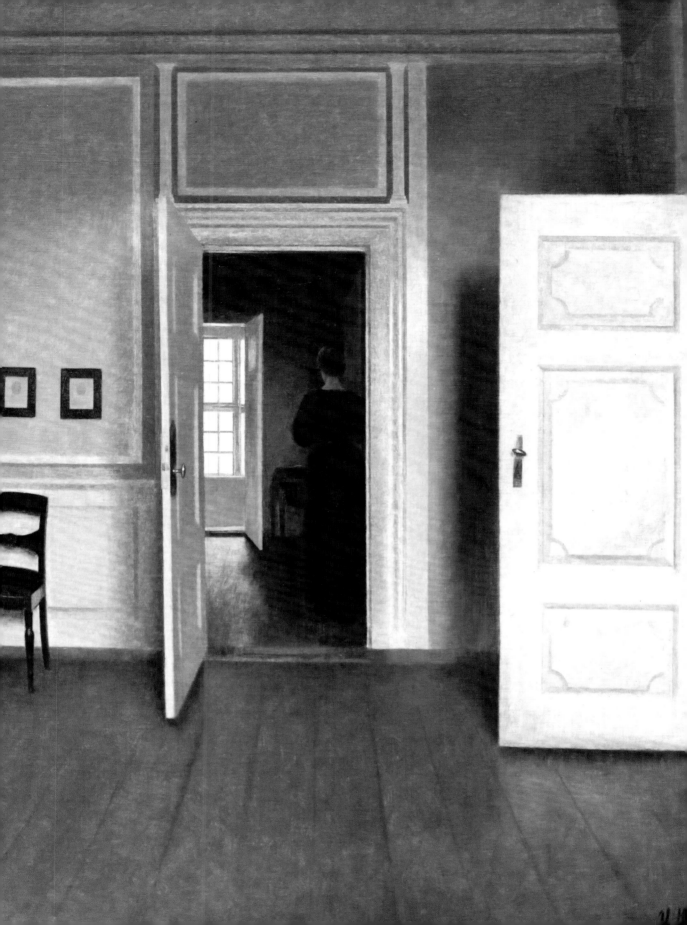

INTRODUCTION

We work in the dark—we do what we can—we give what we have. Our doubt is our passion and our passion is our task. The rest is the madness of art.

—*Henry James (from "The Middle Years")*

I was recently heading out for an evening walk, and opened the door just as someone was ready to knock. A smiling man dressed like a college professor held up a postcard and said, "I have something of yours." My mind raced, trying to place who he was and what he wanted. The postcard was addressed to me but had no postage. The man explained that he had just returned from the Galapagos Islands, where they have a tradition of putting mail in a barrel to be delivered by whomever was traveling closest to that part of the world. This practice dates back to a time when mail was delivered by sailors rather than professional mail carriers.

If you had asked me then, I would have guessed that letters posted using this system had as much chance of reaching their destinations as if they were folded into paper airplanes and flown off the back porch. Nonetheless, the man had looked through the barrel, knowing he would be in Seattle. And, as it turned out, I received my letter in less time than it took postcards I had written in Italy that summer to reach my friends in the States.

It struck me that there are similarities between painting today and mailing letters in the Galapagos. Painting cannot be called art while the uncomfortable element of faith is absent. Just as the residents of the Galapagos Islands trust their letters will reach their destinations, artists need to believe in the value and outcome of their work. There is no such thing as a flawless step-by-step system that results in a perfect product. Personal struggle, talent, inspiration, and passion, when combined with hard work, create a unique outcome. No matter how dedicated and prepared you are, when making art, you are stepping into the wilderness. From this uncertainty comes some of the joy and wonder of art. It is human, imperfect, and filled with mystery.

OPPOSITE (DETAIL) AND BELOW
Winslow Homer fused his lithography background with illustration to create compelling narrative work featuring heroic figures in nature.

Winslow Homer, *Northeaster* (detail), 1895; (reworked 1901), oil on canvas, 34½ x 50 inches (87.6 × 127 cm). The Metropolitan Museum of Art (New York, NY). Image courtesy of the Art Renewal Center® (artrenewal.org).

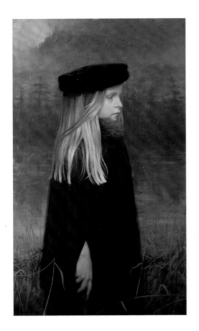

Katherine Stone, *Glad the Birds Are Gone Away*, 2013, oil on panel, 32 x 18 inches (81.28 x 45.72 cm). Private collection.

OPPOSITE Casper David Friedrich was a German Romantic whose melancholic temperament and love of nature helped him produce a compelling body of work. He believed that artwork of substance was born from introspection and solitude.

Caspar David Friedrich, *Wanderer above the Sea of Fog*, 1817, oil on canvas, 37 5/18 x 29 7/16 inches (94.8 x 74.8 cm). Hamburger Kunsthalle (Hamburg, Germany). Image courtesy of the Art Renewal Center® (artrenewal.org).

In this painting, Charles Weed employs rich chiaroscuro (see page 18) to convey the essence of the woods. Weed paints like a modern day George Inness (a nineteenth-century artist who has influenced many contemporary American landscape painters).

Charles Weed, *Oak and Beech*, 2010, oil on canvas, 15¾ x 23⅝ inches (40 x 60 cm). Private collection.

Knowing there is much that can't be controlled, it make sense to enter this profession well equipped for the areas that we *can* influence. This book is a record of the foundational painting skills that I learned as a student, I use in my own studio, and teach in my atelier. It offers many tools, solid artistic principles, step-by-step demonstrations, and hands-on lessons designed to increase your skill. It contains time-honored techniques and those gained through personal experience and shows works of past ages along those of contemporary artists. And finally, it includes essays that focus on specific questions that tend to crop up during a course of study, such as, *How do I deal with criticism?* and *How do I keep going when I feel stuck?*

This book progresses much as you would be taught in an atelier. The study builds on a progression from flat, abstracted painting in black and white to a focus on developing form, followed by studies using a limited palette, and, finally, paintings in full color. It is worth noting that in an atelier you spend at least a year drawing, and for that important subject I have written two books: *Classical Drawing Atelier* and *Lessons in Classical Drawing*.

Learning from a book is not the same as studying in person in a studio; however, books share the knowledge of a community and provide encouragement from people on the same path, allowing you to follow at your own pace. The creation of art requires intense focus and a stretch of uninterrupted time, which, for many of us, may be the hardest part. Yet this undistracted time is essential, since art stubbornly exists on a different timeline than the quick pace of

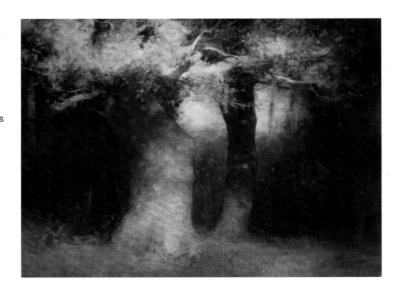

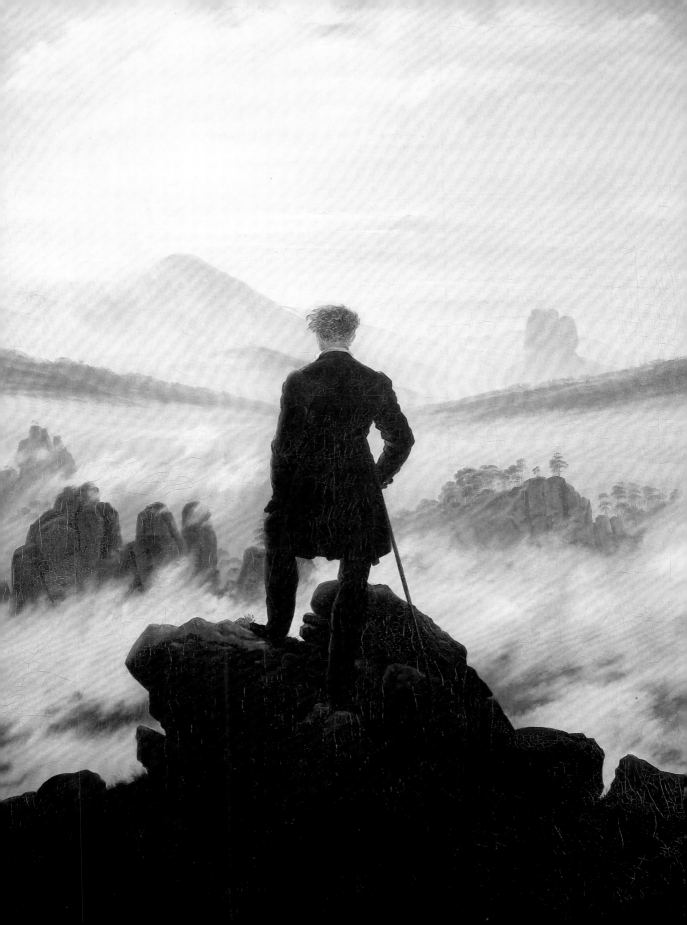

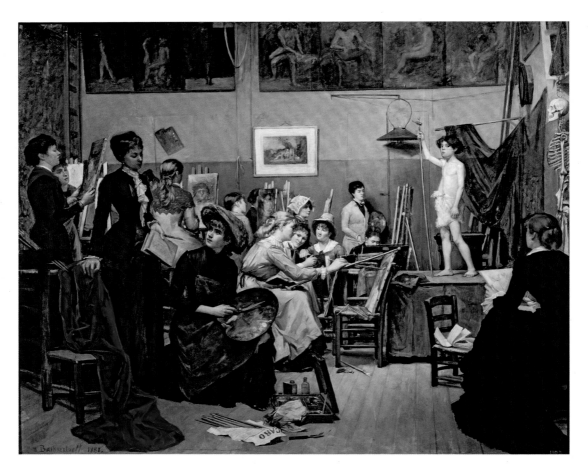

Marie Bashkirtseff, shown seated with her palette, painted her classmates working from the life model at the Académie Julian, one of the few studios open to women in nineteenth-century Paris. You can see many objects still found in a contemporary atelier—the paintings hanging on the wall, the skeleton for anatomy reference, and the model stand—yet surprisingly few easels appear.

Marie Bashkirtseff, *In the Studio*, 1881, oil on canvas, 60 ⅝ × 74 inches (154 × 188 cm). Dnipropetrovsk State Art Museum (Dnipropetrovsk, Ukraine). Image courtesy of the Art Renewal Center® (artrenewal.org).

modern life. It reveals itself by degree and it is worth waiting for. While a teacher, or a book, can make space, provide structure, and facilitate growth, in the end, the journey is one of self-education.

There is a correlation between the act of seeing, the arts (in every form), and a life worth living. Interestingly, the same habits and skills required to become an artist are also needed to become a fully realized person. "Everyone is born with a mind," writes William Deresiewicz, "but it is only through introspection observation, connecting the head and the heart, making meaning of experience, and finding an organizing purpose that you build a unique individual self." The same could be said of finding your artistic voice.

A painting education may have a starting date, but there is no natural ending. The branches of artistic knowledge take several lifetimes to explore. After foundational studies, we all end up specializing in what is most interesting to us. The goal of this book is to provide a strong start, knowing that this will be only a brief introduction in a process of lifelong education. How you choose to apply your training will be part of your own story. What you add to the world through your art will be your gift to others. Henry James noted that, "A tradition is kept alive only by something being added to it." I hope that this book will be a useful tool, enabling you to more clearly add your voice to this great tradition, providing a legacy for those who come after us.

The Académie Julian was a Parisian studio popular with American students such as Cecilia Beaux and Robert Henri. The studio was a warehouse packed with students; light from the large skylights flowed down over the figures, which appeared luminous against the dark walls.

Jefferson David Chalfant, *Bouguereau's Atelier at Académie Julian, Paris*, 1891, oil on panel, 11¼ x 14½ inches. (28.6 x 36.8 cm), de Young museum (San Francisco, CA). Image courtesy of the Art Renewal Center® (artrenewal.org).

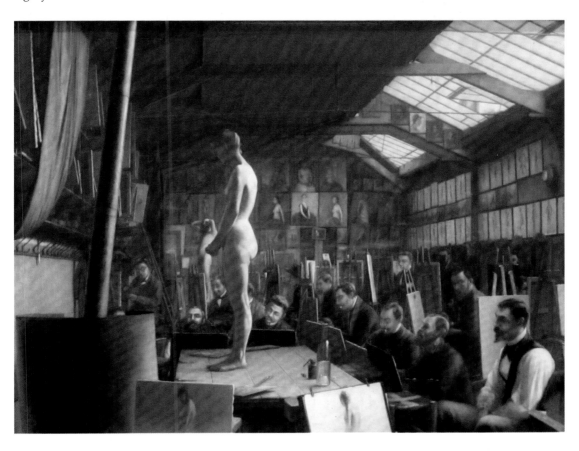

VALUE PATTERN

an arrangement in gray

To look at a thing is very different from seeing a thing. One does not see anything until one sees its beauty.

—Oscar Wilde (from "The Decay of Lying")

We have all experienced moments of eye-catching beauty, when even the least artistic among us are flooded with a sense of visual wonder. Yet, such moments are rare. The necessity of day-to-day living means that our sight is mainly used for negotiating life, rather than meditating on its beauty. We "see" in words, quickly identifying items—such as a faucet, table, bag, and hand—and in the process reduce and compress a complex visual reality. Our everyday lives depend on our ability to quickly absorb and interpret large amounts of data. In the midst of a busy day it's difficult to remember that the items in our sight are not just waiting for us to identify and use them; they are uniquely oriented in space, surrounded by light, and have their own reality. Only after we see something apart from its usefulness can it fall into the sphere of art.

How does a person see objects as more than a collection of tools and instruments and find unexpected beauty in the ordinary? The answer may seem simple; it starts with really *looking*. Artists take the time to look at great length and with concentrated attention at their subjects, allowing them to gradually come into focus. This attention moves an object from background to foreground. Yet making art requires more than patient study; artists need to take practical steps to gain fresh insight.

Finding Formal Shapes

The study of value (black, white, and gray) is an important first step in translating life into art. The artist begins by viewing objects as tonal shapes, and then grouping and sorting these shapes. Artists often squint, looking at the world through half-closed lids (which reduces the amount of information hitting the eye), in order to

OPPOSITE Giulio Aristide Sartorio was an Italian artist whose limited-palette paintings combine the romantic energy of a drawing with the elegance of a classical frieze. Line and tone conveyed all that was necessary for Sartorio to consider a piece a completed work.

Giulio Aristide Sartorio, *The Poem of Human Life* (detail), completed 1901, medium unknown, dimensions unknown. Galleria d'Arte Moderna di Ca' Pesaro (Venice, Italy). Photo credit: Cameraphoto Arte, Venice/© Art Resource, NY.

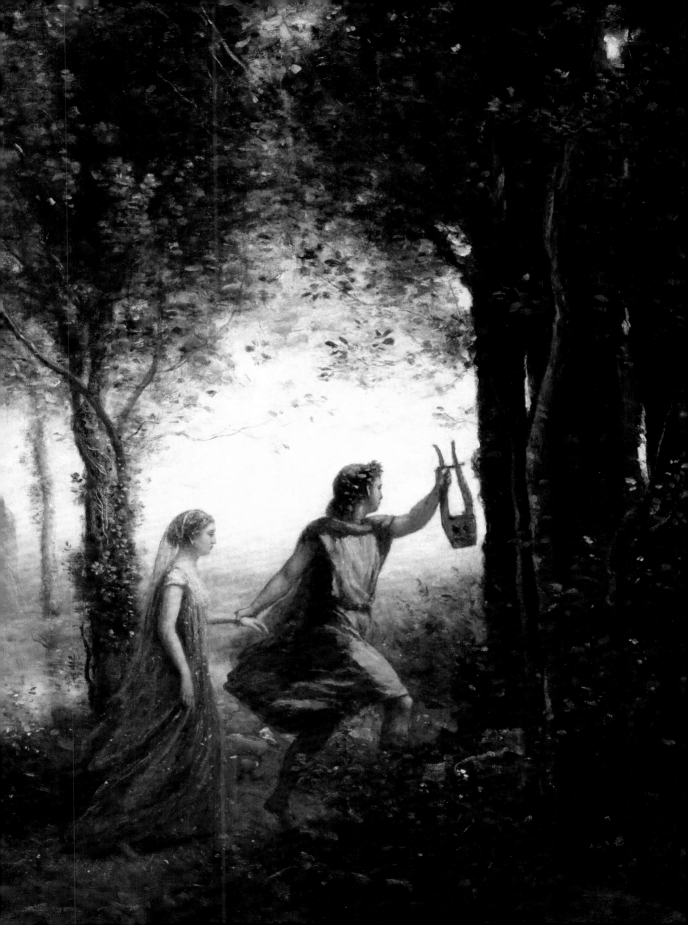

simplify nature. Squinting flattens an object, reducing its color, and abstracting the subject into an arrangement of shapes. Twentieth-century French painter and writer André Lhote observed, "Every object, if for a moment you forget all knowledge you have of its shape, its color, and its substance, becomes a source of unexpected images, and the ecstasy of their capture provides the poetic imagination of the spectator with a springboard of an entirely novel character." In other words, like looking for characters in clouds, if we allow ourselves to see our subject in a new way it can lead to some surprising results.

The ability to simplify any subject into an arrangement of large value shapes often separates the experienced painter from an amateur. I think of this stage as the poetry of a painting because the goal is to create a rich emotional statement using the fewest components; however, instead of words, painters use shapes. These blocks of value become the compositional anchor for a work of art. Paintings, as they progress, can gain in nuance and information; yet the big impact is determined right from the start.

Value pattern (the abstract treatment of lights and darks) elevates a subject from a statement of fact to a meditation on the largest principles in art. It is a painterly way of seeing that enables artists to capture the essential visual truths of nature that lie behind the myriad details. We will spend the rest of this chapter discussing ways to more deeply explore this important subject.

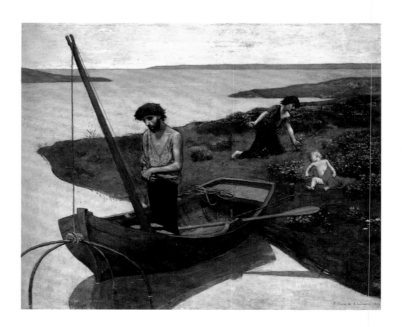

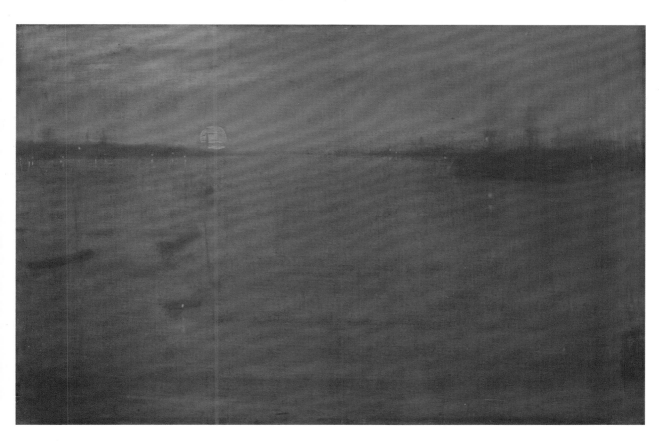

A goal of artistic study is to gain a heightened sense of gratitude toward the visual world. This appreciation changes our perception, and in turn, our artistic practices. By consciously breaking down the natural process of seeing through the study of shape, line, value, and color, we create an avenue into an artistic mode of observing the world around us, as visitors. We learn to see a subject abstractly, for pleasure, as the image hits our retinas, and are no longer bound to name what we see or keep inventory. This new perspective can bring a renewed sense of wonder, replacing what we thought we knew with what is truly there.

James McNeill Whistler created his paintings as a nod to music, even titling works "arrangements" or "harmonies". He was influenced by the simplicity of Japanese prints and his ethereal washes of tone imply a subject rather than state it.

James McNeill Whistler, *Nocturne: Blue and Gold—Southampton Water*, 1872, oil on canvas, 19 ⅞ x 29 ⁵⁄₁₆ inches (50.5 x 76 cm). The Art Institute of Chicago (Chicago, IL). Image courtesy of the Art Renewal Center® (artrenewal.org).

The Poetry of Painting

Once I joined a weekend poetry class and spent hours on a Northwest beach trying to put my thoughts to words. The goal was to distill complex layers of meaning and emotion into a few lines. I went over my poem for days afterward in painstaking deliberation: "Not *gray* but *slate*... no, *ashen* feels right... Then again, perhaps not...." The whole experience took remarkable concentration because nothing could be extraneous. Words, which I have always

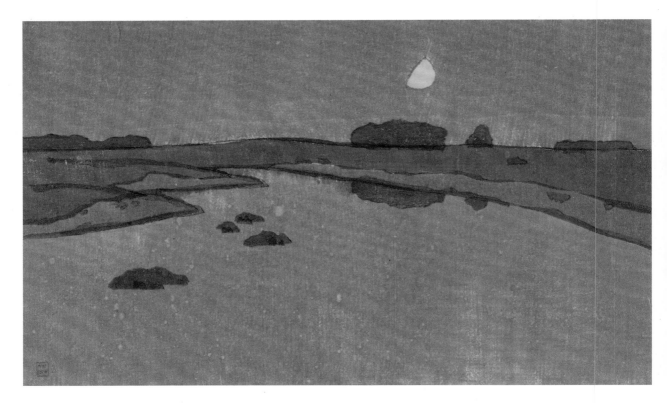

Arthur Wesley Dow believed that "spacing is the very groundwork of design." His paintings, inspired by Japanese woodblock prints, are representational abstractions, a balance between expansive tones and natural subject matter.

Arthur Wesley Dow, *Marsh Creek*, 1905, pencil woodcut printed in colors, hand printed on laid paper, 4¼ x 7 inches (10.8 × 17.8 cm). Collection of Stephen Gray. Image courtesy of the Art Renewal Center® (artrenewal.org).

used freely, now had to be pared down to the essentials. In painting, when you start exploring ways to organize a scene, this same kind of focused attention and deliberate refinement is necessary to ensure you express exactly what you intend. The pleasing arrangement of tonal shapes in a painting is a form of visual poetry.

In great paintings, small shapes are often consolidated into the largest possible groupings.

Woodblock prints provide a clear representation of such poetry. Many examples of simple light and dark value patterns can readily be seen in the elegant, graphic nature of prints. The medium itself requires the artist, like the poet, to work within narrowly defined limits. Many painters in the past, from Rembrandt and Goya to Toulouse-Lautrec and Degas, were also trained printmakers, which enabled them to exchange ideas from one medium to the other. The confines imposed by printmaking forced a real economy in working methods. Artists who trained as printers knew how to do a lot with a little. Furthermore, this understanding gave their work a breadth of vision and timelessness when they expressed their ideas in oil paint.

In woodblock prints, each color area is printed independently, one registered layer at a time. This process prints each area uniformly. Woodblock prints are not able to employ *chiaroscuro*, the high

contrast modeling of light and shadow that has historically fascinated so many Western artists. Instead, flat shapes alone must say everything there is to say about the scene. This poetry of shape is called *notan*, the Japanese word for the contrast of light and dark. The chief source of beauty is elegant simplicity.

The idea that flat, decorative shapes could be arranged across the picture plane resonated with certain artists of the late nineteenth century who were embracing the emerging Modernist aesthetic. Although the harmony of tonal shapes was a feature of work going back hundreds of years, it was distilled and given prominence in more modern times through the work of such artists as James McNeill Whistler, William Nicholson, and Édouard Manet. These tonal shapes can be thought of as scaffolding supporting the smaller elements of a picture. Although great art has always had these shapes, they were hidden; now many modern artists chose to leave the scaffolding exposed.

Another admirer of woodblock prints was Arthur Wesley Dow, who wrote a book called *Pictorial Composition*. Dow was an American artist and educator who thought observation was too greatly stressed in the academies, and found an antidote in the formal design of Japanese art. So unlike the Victorian bric-a-brac aesthetic, the Japanese aesthetic, with its celebration of nature and its emphasis on clean, abstract design, provided an exciting source of cross-pollination for many artists of the early twentieth century.

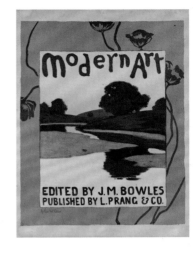

Dow was a prominent educator (Georgia O'Keefe was among his students). Dow was fascinated with the effects capture by Japanese printmaking, with its emphasis on the placement of light and dark shapes, and sought to directly mimic those effects in his art.

Arthur Wesley Dow, *Modern Art*, 1895, color lithography on paper sheet, 20 x 15¾ inches (50.8 x 40 cm). Smithsonian American Art Museum (Washington, D.C.). Image courtesy of the Art Renewal Center® (artrenewal.org).

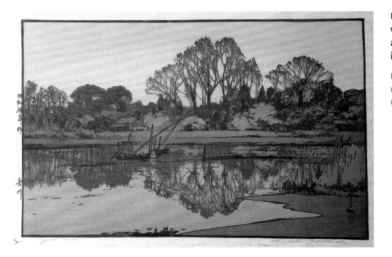

Influence works both ways. This woodblock print from Japan shows atmosphere and gradation, as found in European paintings.

Hiroshi Yoshida, *Yoshikawa*, year unknown, 9¹¹⁄₁₆ x 12¹³⁄₁₆ inches (24.61 x 32.54 cm). Private collection.

Creating Value Shapes

Many successful paintings have surprisingly simple value compositions. Creating a compelling piece of art using only a few tonal shapes is a game of logic where every move changes the outcome. When considering value shapes, ask: *How can the subject be described with the fewest number of pieces?* Often an elegant solution comes only with trial and error.

This project can be completed using any painting media you wish, such as gouache, acrylic, or oil. However, the possibility of blending and adding tones often proves an irresistible temptation (at least to me), so I recommend cutting toned paper into shapes with an X-Acto knife to really master this lesson.

SELECTING THE SUBJECT

Select a subject that will lend itself well to the exercise, avoiding an overly busy or colorful reference image. Carrie Williams chose to study a masterwork by William Sergeant Kendall. However, she could have also set up a still life composition, interior or landscape. The challenge when organizing your own composition is to make the light, shadow, and incidental shapes feel essential to the picture.

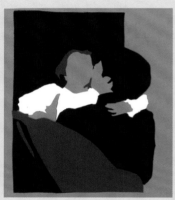

CHOOSING FOUR VALUES

In the example to the left, you can see how Williams grouped like values into larger shapes that could be expressed using three different tones of gray paper and one white piece, which she juxtaposed against one another for maximum effect.

ABOVE Cut paper image by Carrie Williams

OPPOSITE William Sergeant Kendall, a student of Thomas Eakins, frequently used his wife and children as subjects. This piece is simplified, bordering on abstraction, making it relatively easy to use for this assignment.

William Sergeant Kendall, *Beatrice*, 1906, oil on canvas, 30 x 25 inches (76.2 x 63.6 cm). Acc. No.: 1907.1. Image courtesy of the Pennsylvania Academy of the Fine Arts (Philadelphia, PA). Joseph E. Temple Fund.

INTERPRETING THE IMAGE

Cut shapes from the four selected pieces of paper to create a simplified version of the painting. The value shapes can function as a light or a dark, depending on the placement. For example, in Williams's piece, the mother's face, the child's hand, and the wall are all the same value. In the first two instances the value reads as a dark, since it is next to white. However, in the third instance, when placed next to black, it reads as a light. Like a haiku, the distillation of much content into a small statement can create a powerful impression.

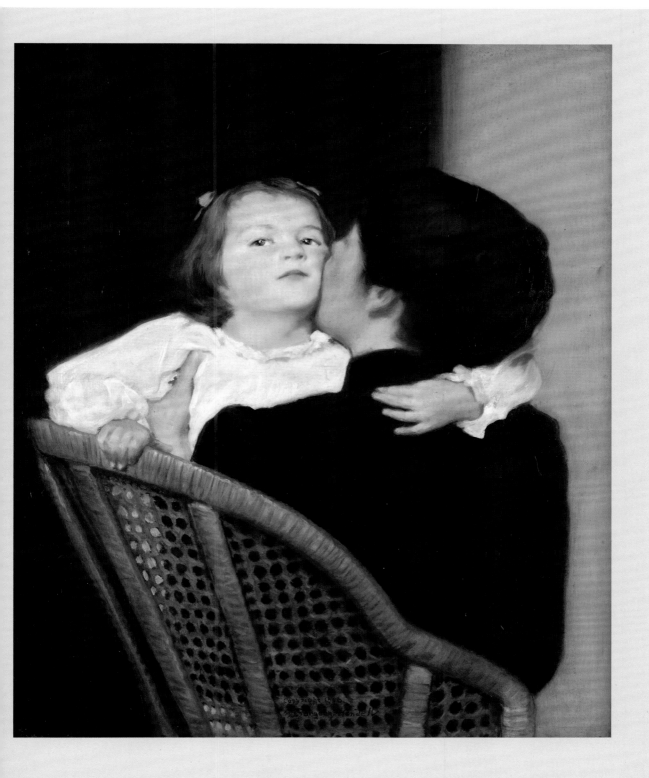

Value Composition

When an artist works out a design, he or she will often spend a considerable period of time moving edges or adding spots of tone and accents around the picture, guiding the eye so that the piece is fluid and balanced. These shifts of emphasis are actually key compositional components. Small elements can offset larger ones. Just as a minor sound in a library attracts a disproportionate amount of attention, a tiny value note in a painting, such as a dark element in a light canvas, can offset a much larger shape.

The placement of objects, color, and the distribution of value falls under the heading of *composition*. Solid composition is an essential component for any painting intended to pass the test of time. The goal is always balance. *Balance* is a sense of harmony—a cohesion of diverse parts into a statement where nothing feels extraneous and nothing can be moved without upsetting the whole. Harmony is not the same as symmetry, which can be predictable and repetitive. Rather, harmony is best achieved when elements within a painting are surprising in some way, often creating a dynamic movement through the piece.

Note: The scales beside the examples in this feature reflect the breakdown of values in each composition.

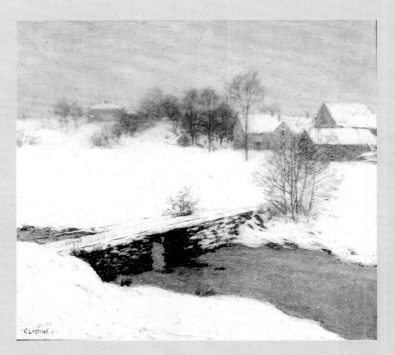

The Z-shaped pattern of the darker values in this painting moves the viewer's eye from upper left along the trees to the houses, across the bridge to the water, and out of the picture on the right side. The vast majority of this high-key (a light image with a dark focal point) image is devoted to the light end of the value step scale (a graduated range of tones from white to black). The smallest element, proportionally speaking, is the bit of black along the bridge. That accent is enough to balance the upper two-thirds of the picture.

Willard Leroy Metcalf, *The White Mantle*, 1906, oil on canvas, 26 x 29 inches (66.04 x 73.66 cm). Private collection. Image courtesy of the Art Renewal Center® (artrenewal.org).

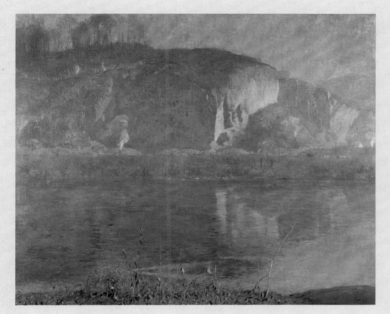

This painting embraces the center of the value step scale, avoiding light and dark, a common practice influenced by Impressionism. The effect is quiet and calm. The only movement is in the small shifts of color throughout the piece. The value accent is the straight gash in the cliffs, which separates the light from the dark and draws our eye to the center of the picture.

Daniel Garber, *Quarry*, 1917, oil on canvas, 50 x 60 inches (127 x 152.4 cm). Acc. No.: 1918.3. Image courtesy of the Pennsylvania Academy of the Fine Arts (Philadelphia, PA). Joseph E. Temple Fund.

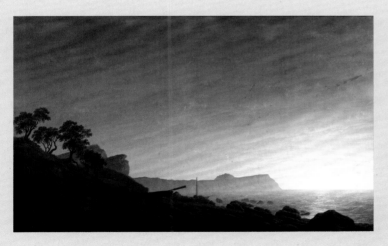

The low-key tonal composition (one that is dark with a light focal point) in this painting capture the final rays of light before nightfall descends. The lightest area of the painting, the sun and its rays, is a relatively small part of the whole painting, yet it balances an entire canvas of mid-tone to dark values. The dark rocky earth anchors the bottom of the canvas and the gradating gray arcs of the clouds lead us to the lights.

Caspar David Friedrich, *Blick auf Arkona mit aufgehendem Mond*, 1805-06, pencil and brush (sepia ink) on paper, 24 x 39⅜ inches (60.9 × 100 cm). Albertina (Vienna, Austria). Image courtesy of the Art Renewal Center® (artrenewal.org).

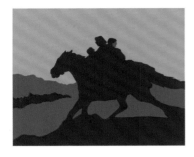

ABOVE In this cut paper diagram, Carrie Williams condenses the powerful image at right into three values.

RIGHT The shapes are so large in this picture that the horse and its three riders appear to be part of the very earth they are riding upon. Eastman Johnson uses the contour to convey most of the information found in this graphically powerful image, one which he witnessed during the time of the Civil War.

Eastman Johnson, *Ride for Liberty— The Fugitive Slaves*, circa 1862, oil on paperboard, 21 5/16 x 26 1/8 inches (55.8 x 66.4 cm). Brooklyn Museum (Brooklyn, NY). Image courtesy of the Art Renewal Center® (artrenewal.org).

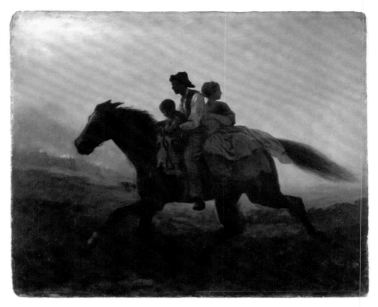

Monochrome Painting

Any amount of time spent working in value pays off quickly. Representational work owes many of its essential qualities to value, and the proof can be viewed when you convert a color reproduction to black and white and see the main feeling of the art remains the same. The other fundamental components of art are drawing, design, value, and color. Mirroring this progression in the atelier, a student spends the first year mastering the components of drawing—which Jean-Auguste-Dominque Ingres rightly called the "probity of art"—before moving to the study of design and then color. In this way, students understand the role of every part of their picture and can identify their weakest areas in order to improve upon them.

Monochromatic studies are an important part of training a student's eye in value and are applied in the future painting process in the form of underpaintings.

Tonal value in a painting functions in both two and three dimensions. In two dimensions, value governs the distribution of big shapes throughout a work of art. It forms the decorative pattern of light and dark that guides the eyes through an image. In three dimensions, value describes the volumetric form of an object and its orientation in pictorial space. The way light gradates across the surface of an object allows us to observe its rotation, its relationship to the light source, and its topography and texture. A study of how light hits an

object is an immersion in the world of small forms, and its language is one of halftones, which reveal the character of an object. The primacy of light is so key that we can forget that the light itself is as important as the object. Light is as essential to artistic beauty as it is to the creation of life.

In value, both flat tone and volumetric form combine to give painters a complete range of expression. Both the breadth of vision seen in a powerful tonal composition and the detailed description showing the uniqueness of the subject are equally necessary. In the atelier, students gain an understanding of the diverse aspects of value by breaking them down into a series of assignments. Students start with flat poster studies done from original or reproductions of masterworks, or from life through studies of the figure and still lifes. From there, they move to working from casts in relief, then casts in the round and, finally, more challenging figure work.

The Importance of Poster Studies

The *poster study* is a small preparatory sketch used by representational painters to test a proposed design for a larger work. In the poster study, the three-dimensional world is flattened into a two-dimensional pattern, making it easy to see if a composition reads well at a small scale. If so, it will also work in a larger painting because, strangely, when it comes to readability, size doesn't matter. Likewise, a composition that doesn't work in a poster study is unlikely to work in a larger painting. A billboard can, at times, be hard to read, while the image on a postage stamp can have clarity.

> *Remain working in large masses,*
> *without detail, for as long as possible*
> *before moving to smaller concerns.*

Poster studies are an excellent way to transition from drawing to painting, moving away from the constriction of line and contour into the freedom of large masses and shapes. The small scale of the poster study provides the perfect place to experiment with tonal shapes. As a practice piece—that is, a work not intended for exhibition—the poster study can release you from the pressure of having to get everything right. It also provides an opportunity to take risks and to see things as they really are, rather than as you suppose them to be. The aim is to sacrifice detail in favor of larger masses, distilling what you see into a more fundamental expression of your subject.

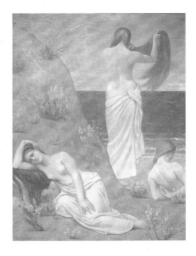

The narrow value range and limited modeling emphasize the contour and large shapes in this Pierre Puvis de Chavannes composition. The figures and environment are treated as abstractions in the greater overall design.

Pierre Puvis de Chavannes, *Young Girls by the Seaside*, 1879, oil on canvas, 24 x 18½ inches (61. x 47 cm). Musée d'Orsay (Paris, France). Image courtesy of the Art Renewal Center® (artrenewal.org).

Practicing the principle of value economy with quick exercises helps students understand the direct effect value has on a finished piece. In my studio, beginning painters start with just two tones—black and white—to see if a subject can be captured with such restricted means. The contours are carefully observed and provide the missing details, just as with the Victorian-era silhouette portraits done with black paper (see page 24). Progressing to the next painting, two mid-tone values are added. Consider how the image changes (losing or gaining impact) as the range is expanded. Finally, with the palette extended to six values, which now feels like abundance, the artist is challenged to keep control and maintain the graphic punch that was established when the palette and the shapes were simpler. Using this progression of exercises sensitizes the student's eye to the possibilities inherent in value shapes.

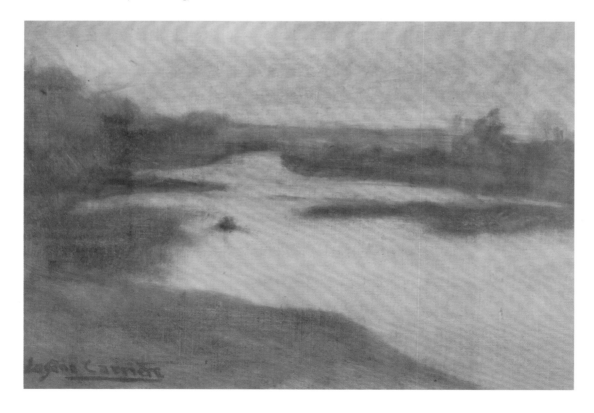

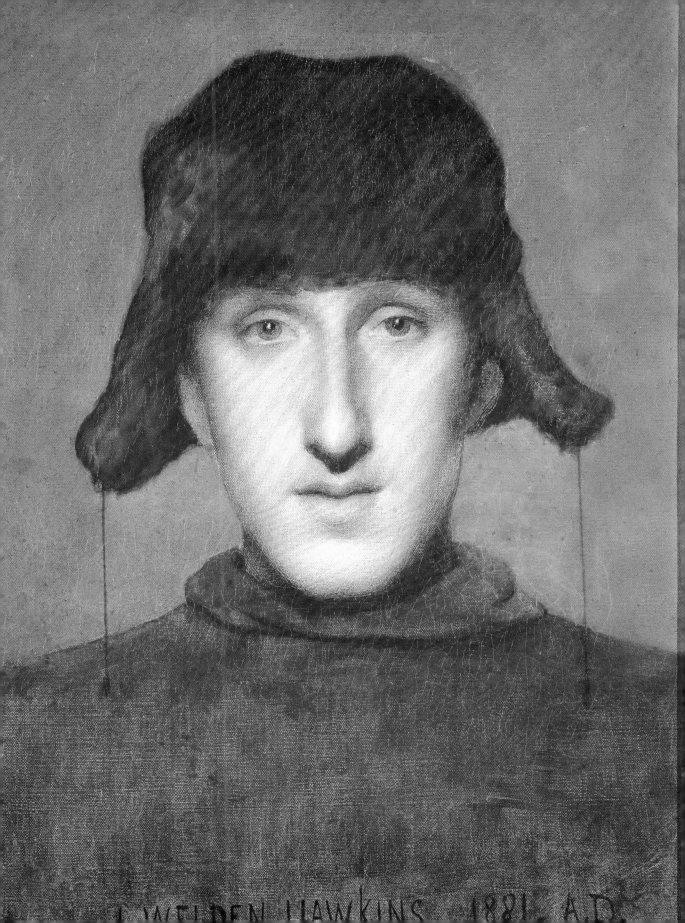

L WELDEN HAWKINS · 1881 A D

LESSON 1

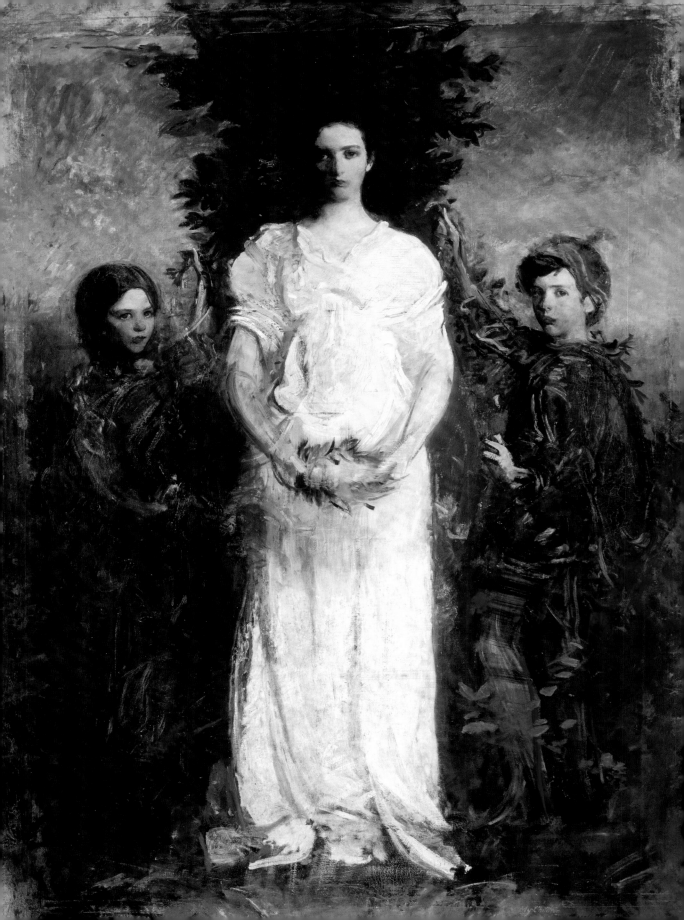

VALUE POSTER STUDY

In this Lesson, the value step scale exercise provides you with an opportunity to practice mixing clean, distinct piles of paint. You can then use the resulting paint piles for the next exercise. Additionally, a finished step scale is a useful tool for comparing values.

Next, you will create a value poster study—small scale (often only a few inches), distilled version of a larger image. By simplifying a painting to its essentials, you can see what makes it great. A painting with a few big shapes has more visual impact than one with a highly fragmented speckling of lights and darks.

A GOOD FOUNDATION

Your aim in the value poster study is to use the fewest shapes to capture the feeling of a picture. *Can the project be done in eight values? What about four? Or two?*

Poster studies are often done as preparatory works for larger painting, and those are done in color. However, you can also create them as quick explorations of compositions or as a means for analyzing masterworks.

Remember: Perfection is the enemy of good work. Often you need to take your best guess at the values and get the canvas entirely covered in order to see how well the tones work together. You can make adjustments later.

OPPOSITE Abbott Handerson Thayer, *My Children (Mary, Gerald, and Gladys Thayer)*, 1897, oil on canvas, 86¼ x 61⅛ inches (219.1 x 155.1 cm). Smithsonian American Art Museum (Washington, D.C.). Image courtesy of the Art Renewal Center® (artrenewal.org).

MATERIALS

Paper

Drawing materials pencil or charcoal (optional)

Panel or canvas

Brushes In a variety of sizes, such as 2, 6, and 8

Palette For the premixing of a value step scale, you can use a tabletop palette made of a piece of glass with white or gray paper placed underneath. For the poster study, it is easiest to switch to a handheld palette for use during the actual painting process.

Paints Titanium white, raw umber, ivory black (I mixed the black and raw umber to make a warmer black that seemed to more closely match the color of the original painting. This is entirely a personal preference—you can use straight black or temper it with any color you want.)

Cloth or paper towels

Odorless mineral spirits

Linseed oil

Palette knife

HOW TO MIX A VALUE STEP SCALE

Create a value step scale with each step representing a pure tone. The goal is to try to have an even gradation between each step so that the jumps feel sequential. Spending time mixing these tones will help sensitize your eyes to changes in value. It will also speed up value mixing for the rest of the exercises in this book, because you simply have to match your values to the master version you've created here rather than rethinking them each time.

Draw 1-by-9 inch (2.54-by-2.86 cm) rectangles on a sheet of prepared paper, panel, or canvas. Subdivide your surface into nine 1-inch squares. It is helpful to make two of these gridded strips so that you can experiment on one and use the other for your final version.

Starting with titanium white, paint on one side of your palette and then add ivory black on the other end. Mix a largish pile of mid-tone gray, aiming for the middle of the line (or your middle value). Then

Using maximum economy in value, Rebecca King limits the scheme to two values: black and white.

Rebecca King, *Two-Value Painting*, 2014, oil on canvas, 2 x 3 inches (5.08 x 7.62 cm). Private collection.

Place black and white paint on your palette.

Mix a middle gray.

Four unblended values are enough to capture the local tone of the still life objects and provide the viewer with all the essential information.

Rebecca King, *Four-Value Painting*, 2014, oil on canvas, 2 x 3 inches (5.08 x 7.62 cm). Private collection.

Mix between white, black, and gray.

mix down toward black and up toward white, aiming to create nine total (including straight black and white) value squares. Be sure that each value is a pure, even mixture, without variation—for this purpose it is essential to mix the paint with a palette knife, which can be cleaned after each value is mixed rather than a brush.

Test your piles of paint in a test strip to see if the jumps between values feel equal. Keep your palette knife clean between each value note by wiping the knife with a soft cloth or paper towel. A well-done value step scale should create simultaneous contrast in each square— the value square will feel lighter on the right (where it rests next to the darker value) and darker on the left (where it is adjacent to the lighter tone). When you squint, the values shouldn't merge together, but rather appear as distinct squares of tone. Don't be discouraged if this exercise takes longer than you expect: the small adjustments essential for getting this right can be maddeningly subtle.

When you get your piles mixed up and have tested them on a value strip to your satisfaction, paint a final version on a strip of canvas or board that you can keep as a master version for future reference. One last piece of advice: Be sure that there is no white showing between the squares and that the paint is laid in opaquely throughout. These small details, if not taken care of, will detract from the finished piece. Any unfinished areas of paint or thick built-up edges of paint form a kind of white noise that can be a visual drag on your step scale (or any kind of painting), lessening its overall effectiveness.

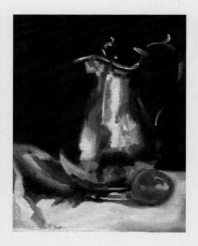

With six values, King reveals the surface texture of the objects and essentially finishes the work with a more nuanced observation of form.

Rebecca King, *Six-Value Painting*, 2014, oil on canvas, 2 x 3 inches (5.08 x 7.62 cm). Private collection.

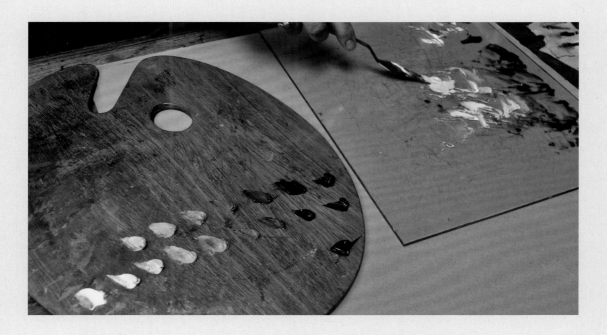

CREATING A VALUE POSTER STUDY

Creating a poster study gives you a chance to work quickly on a small scale and to practice your skills at simplifying. You can apply this project to any subject: still life, figure, portrait, or landscape. It can be done in black-and-white or color. A well-done poster study shows very little information, yet feels complete. That is the essence of great painting.

There are many reasons to invest time in creating poster studies even after you are a student. It is a low-risk way to practice using your painting materials with minimal time investment. It allows you to experiment with multiple compositions before starting on a big painting. And it provides a hands-on way to learn from great artists. (See page 164 for more on the subject of master copies.) Your mantra while doing poster studies could be: Keep shapes simple and edges varied.

When starting your value poster study, use one color like raw umber or black. In subsequent studies, you may want to customize your palette by mixing a neutral color you feel best reflects your subject. It's a good idea to keep your color combinations simple, so they can be replicated later if you run out of paint.

To see a range of possible neutral color choices refer to page 112. These are all combinations used by my students in the past. It is interesting to note how "blue" the black value strip appears next to the other grays.

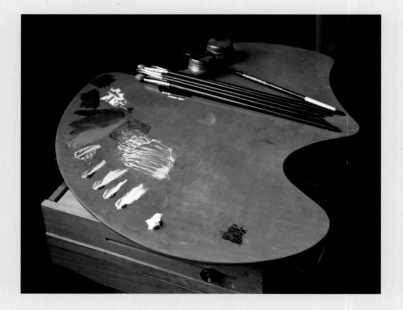

STAGE ONE:
Choosing Your Master Copy

You can work from life or from a reproduction of a painting done by an established master. I chose to do a *master copy* of Carl Vilhelm Holsøe's *A Sunlit Interior,* because it is a simple and thoughtfully designed painting. (For more on master copies, please see page 164.) The best masterpieces to choose are ones that are not overly busy. Select a painting with clear value masses, one that has value as a main component of its aesthetic; you want to set yourself up for success.

To set up your master copy, it is helpful to print out a small picture of the painting you are copying the same size as your canvas or panel and tape the image next to your blank surface. This will allow you to compare the image and painting side by side. There are many copyright-free images available online that you can use, or you can set up your canvas next to a book.

STAGE TWO:
Blocking In Your Subject

To start, sketch broadly, but accurately. Doing so enables you to lock in the proportions of your composition before shifting to value. You can draw directly on the surface of your board with charcoal. Charcoal can be easily erased if you make mistakes. Or you can use a brush dipped in raw umber with some odorless mineral spirits (OMS) to make the paint more fluid.

Be careful that your lines are not too thick and dark so you can make adjustments as you go. The main components of the value sketch are large shapes (with regard to the drawing) and big values (with respect to the painting). When creating a poster study, it is unnecessary (and, in fact, detrimental to the work) to do a detailed drawing. When painting you will find yourself wanting to preserve the details when only big shapes are needed.

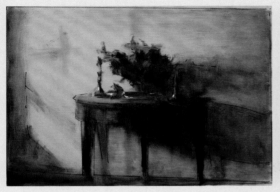

STAGE THREE:
Applying the Initial Wash

Find your big areas of tone in simple shapes. Often I recommend using umber straight out of the tube to do this first pass of paint, because it thins down easily to a wash without getting streaky. The opaque gray paint does not work well for thin washes. Start by massing in the largest shapes, seeing how much of the image can be done with just one tone.

For this first layer, you may use a drop of linseed oil or even OMS to thin the paint (if it feels too stiff to move over the surface easily). However, fresh paint right out of the tube is usually sufficient and recommended. It is a good idea to try and avoid the extremes of either thick, unworkable paint or overly thin, runny paint. Using the largest brush you can find that is appropriate for this small study (6 inches in length at most), build up your shapes.

STAGE FOUR:
Massing In the Opaque Areas

When massing in this first layer of opaque paint, make sure to put down plenty of paint instead of thin washes. I recommend starting to paint in a dark area and covering the largest area of paint— often in the background. In this way, you work from back to front. Flick your eyes back and forth between the master copy image and the study, making sure the values match on both. You can even do a test, placing a small amount of paint directly on the original copy to ensure accuracy. Make sure to cover the whole surface of your poster study. Don't leave gaps between one value note and the next.

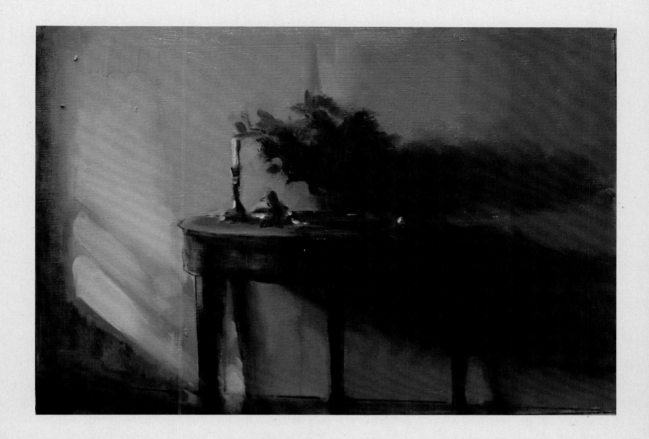

STAGE FIVE:
Sharpening and Softening Your Edges

Lastly, soften the edges where needed to avoid an image that looks like a cutout or overly graphic. Modulation of edges, sharpening and softening where needed, is one of the most important ways to get your painting to feel sincerely observed from life. The large, flat shapes draw the viewer's eye to the edges, because that will be the area of greatest difference or contrast. To compensate for the flatness of the shape as a whole, the edges should be nuanced, modulated with careful attention. This will create balance in the picture. With this in mind, remember that economy of shape should always be balanced by a variety of edges.

As you complete your poster study, ask yourself the following questions: *Where does the likeness of my object reside in the painting? Is it in the drawing, the form, or the light?* Often your thinking will go back and forth—"Now I have simplified too much and the piece looks generic," "now I have too much information and it looks overworked and muddled"—while you strive to find the perfect point where everything just fits in its place.

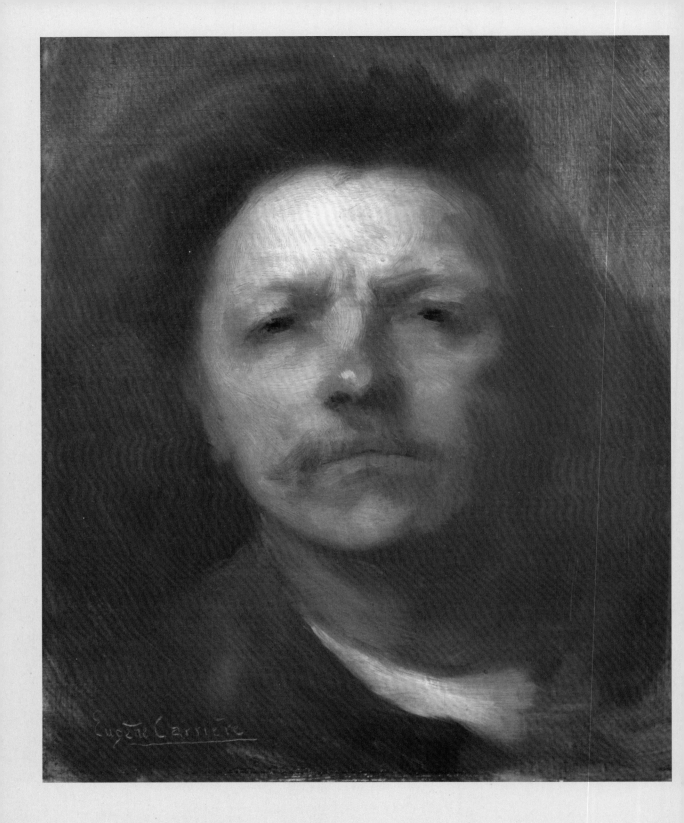

Eugène Carrière

CREATING A TONAL UNDERPAINTING

A tonal underpainting helps you accomplish much in one session, as a simple line drawing quickly becomes a fully developed tonal first pass. This groundwork provides the tonal registration necessary to freely develop your next pass of paint in color. The efficiency of the wipeout underpainting process is appealing. Most paints are additive, where color is placed layer after layer. A wipeout underpainting is reductive. The paint is placed first and then removed to reveal the light ground underneath. One has several hours in which to work with the initial layer of raw umber before the paint becomes too "set" to allow for further manipulation. This window should provide sufficient opportunity, even for a fairly large painting, to produce a satisfactory underpainting with unity. For paintings too large or complex to cover in one session, this process can be done in stages (for example, half the piece done one day and the other half later).

TESTING YOUR CANVAS

Before starting your wipeout, it is a good idea to test a small piece of canvas or panel to see how absorbent the painting surface will be when coated with the underpainting pigment. Some inexpensive acrylic grounds will hold the paint and make wiping out lighter areas difficult. If you find yourself in this situation, you can apply a very thin layer of linseed oil to the entire canvas prior to applying the underpainting pigment layer.

OPPOSITE Eugène Carrière, *Self-Portrait*, 1893, oil on canvas, 16¼ x 12⅞ inches (41.275 x 32.7 cm). The Metropolitan Museum of Art (New York, NY). Image courtesy of the Art Renewal Center® (artrenewal.org).

MATERIALS

Materials for drawing Such as pencil and paper, or charcoal if you are drawing directly on the panel

Lightsource Use a window or a light bulb

Panel or canvas Primed with a painting ground

Palette

Raw umber oil paint You can also use raw sienna or an earth green; feel free to experiment with whatever color you want.

Titanium white Or a "quick-drying" white, such as an alkyd white, is useful here, allowing for overnight drying

Linseed oil (optional)

Cotton paint rag Such as a torn up t-shirt (paper towels not recommended)

Large bristle brush

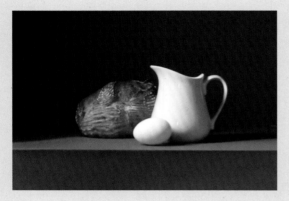

STAGE ONE:
Setting Up Your Still Life

STAGE TWO:
Drawing and Transferring

Setting up a still life is challenging; however, artists become quicker and more confident with practice. Look for large shapes that link together in some way, such as through the shapes of the shadows (see page 32). Your first still life pieces should include solid objects. Avoid glass, busy patterns, or items that are hard to identify. Simple arrangements can be the most beautiful. Often beginners throw many varied and complex objects together that don't relate to one another and that are beyond their skill level. Look for ways to make the objects talk to one another so they feel harmonious. This arrangement has three different objects that belong in a kitchen. Use one clean, single light source, taking care that incidental light isn't bouncing into your setup. Notice how the artist arranged the objects to connect or "speak" to each other. Move from the top of the bread, following the arc through to the right side of the jug. Linking divergent objects in this way helps make a composition appear more unified. Can you find any more connections like this in the painting?

Start by making a drawing to lock in the proportion and composition. Working on a drawing allows you to take the time to pursue accuracy. Notice the general shape of the still life setup within the overall shape of the panel. Look for the placement of the tabletop, the major objects in relationship to one another, and the spaces between them.

Transfer your drawing to the canvas or panel. There are numerous ways of transferring a drawing, such as using a piece of graphite paper between your drawing and the canvas or placing a layer of soft charcoal on the back of the drawing and then going over it with a sharp point. Once transferred, you can secure your drawing to the front of your painting panel with spray fixative, ink, or paint. Or, of course, you can avoid transferring altogether and draw directly on the surface of the panel with charcoal. Now you are free to focus just on value pattern considerations in paint without also worrying about proportion.

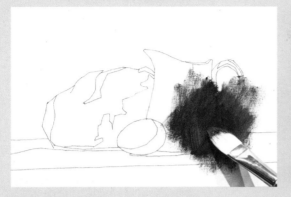 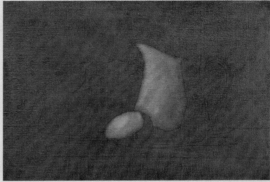

STAGE THREE:
Applying the Imprimatura

An imprimatura is a thin layer of oil paint laid over the ground of the canvas. Completely cover the surface of your canvas with a thin pass of paint, vigorously brushing it on with a stiff, fairly large bristle brush. Don't worry if the paint appears "too dark"—just wipe off the paint with a cotton rag to the desired value rather than thinning down the paint. It may be tempting to use mineral spirits to thin the paint, but that will often result in too thin a layer of paint. I do not recommend it. It is hard to see in a small reproduction, but here you can view the transfer lines through the paint. This initial layer of color allows the artist to work toward a unified color and tone. This sense of tonal unity will stay with the piece to its completion.

STAGE FOUR:
Removing the Lights

Use a soft cloth to pull out the lights, working from large to small shapes. You can do much of the wipeout with the cloth held over the end of your index finger. If your paint layer pulls up too cleanly and is hard to manage, let the paint set for a few minutes. Remember to reposition the cloth frequently during the process so you're always using clean sections of the material. If desired, you can hold the cloth over the back end of a paintbrush handle when wiping out smaller details. A clean, soft brush can also be used to remove paint; this can be helpful for achieving the illusion of three-dimensionality.

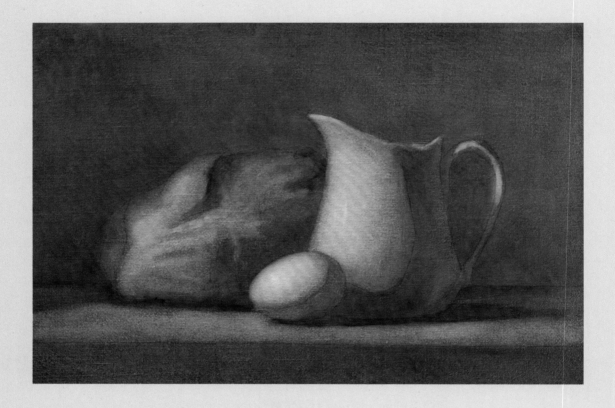

STAGE FIVE:
Adding the Darks and Lights

You can easily leave the wipeout underpainting at stage four, with just the lights removed, which gives you a clear sense of the tone of the underpainting. However, if you want a more developed underpainting that more closely mirrors the tones in nature, you can put more raw umber on your palette and paint in additional darks that create the dark accents and extend the value range.

Complete the full value range by adding white and building up the lightest areas of the canvas. In painting, generally the lights are the most thickly painted, going over the white of the canvas with white paint boosts the sense of lightness and adds mass for subsequent paint layers. Adding white is essentially a *scumbling process*, using a fairly dry brush with a small amount of paint to place a light color over a dark one.

ABOVE David Dwyer, *Pitcher, and Eggs*, 2015, oil on linen, 9 x 13 inches (22.86 x 33.02 cm). Private collection.

OPPOSITE Jordan Sokol, *Studio, Florence*, 2009, oil on linen, 14 x 20 inches (35.56 x 50.8 cm). Private collection.

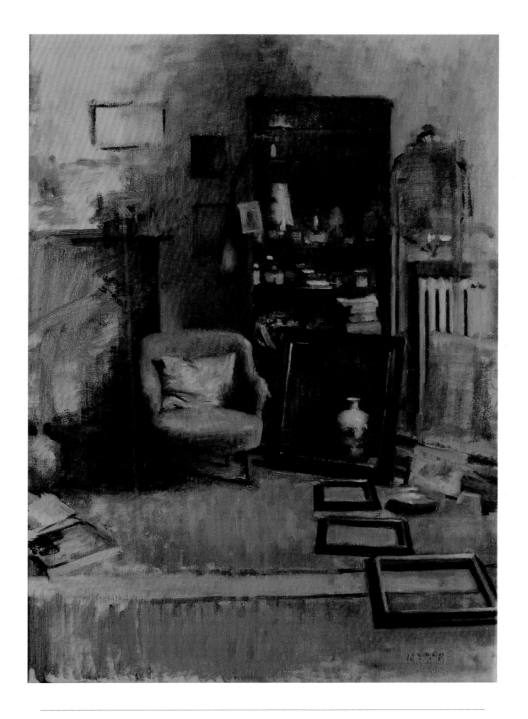

The lover of art is one, and the lover of nature another,
though true art is but the expression of our love of nature.

—Thoreau (journal entry, 1857)

On Seeing

I was walking on a trail in Scotland this past summer when a woman passed me heading in the opposite direction. I slowed to greet her as she went by but she didn't look up. In fact, she could have walked right into me. The enchantment of my walk in the forest was broken and the encounter created a flicker of loneliness in me. A week later, my brother asked me if I could choose one superhero power—the gift of flight or invisibility—which would it be? I chose flight because in a world of distraction it's too easy to be invisible. No superpower necessary.

The job of the artist is to see, and through that intense looking, every place and thing can become an object of unique interest. The subject becomes important because the artist has seen it. If the artist is a very good one, the subject becomes significant to anyone who encounters the work. The effects of an artist's vision are palpable: artists help busy people put down their shovels or turn off their computers and see the possibilities of what's right in front of them. Artists can transform our buildings, gardens, food, and words into art and give us a world worth noticing.

Thomas Couture, the nineteenth-century French painter (who taught Édouard Manet and Henri Fantin-Latour, among

others), recorded his most essential art lessons in a book called *Conversations on Art Methods* to pass on to young students. When Couture introduced the topic of seeing he promised to show his students what he sees (the beauty in art and nature), but with a caveat—he warned the student may in the end see . . . nothing. He wrote: "You are impatient and full of ardor . . . you believe that you are going to be astonished, intoxicated by what I show you; undeceive yourselves. The sight of beauty never creates these raptures in those who do not understand her. She is so simple, she only speaks to the initiated."

Couture noted that we could easily miss what is special in nature and art and walk right by. Poet Rainer Maria Rilke goes one step further, dryly noting that we may not even be able to see the beauty in our own lives: "If your daily life seems poor, do not blame it; blame yourself, tell yourself that you are not poet enough to call forth its riches." However, don't disappear back into your laptop quite yet—all is not lost. Seeing beauty and finding interest in the world around us can be learned through a study of art.

Artists continually warn against inadvertently passing by beauty. This clarity of vision, the commonality among all art, is a gift that comes with time and a fresh vision. People sometimes travel the world for this very reason, so they can come home and see the life they already have with new eyes. The artist can provide this vision, enabling us

Julio Reyes, *The Barrens*, 2011, oil on copper, 10 x 18 inches (25.4 x 45.72 cm). Private collection.

to see without needing the plane ticket. We can't participate in life if we are going fast, or are distracted; beauty can't be bought, only experienced through intense observation of single moments.

Clarity of vision can be an ongoing struggle. Our sense of wonder, our vision, can become clouded for many reasons. Perhaps we are tired, discouraged, or busy. At those times we can require more and more stimulation to feel anything at all. Seeing beauty requires that we let the world exist in its unfamiliarity.

J.R.R. Tolkien discusses this phenomenon in an essay on fairy stories: "Of all faces those of our familiars are the ones both most difficult to play fantastic tricks with, and most difficult really to see with fresh attention.... This triteness is really the penalty of 'appropriation,': the things that are trite, or (in a bad sense) familiar, are the things that we have appropriated, legally or mentally. We say we know them."

Relinquishing one's possessive claim on the world is not a passive activity. How do we capture and keep these moments of clear vision—these visits from the angels of insight—so they do not leave us without their blessing? It takes the spaciousness of a blank wall, the vastness of a meandering path, the solitude of a writer's cabin, the white expanse of a canvas in a studio, and then we are invited to dive inward into the world of imagination and reverie. Part of the artist's training is to slow down and to disengage our sense of the familiar, to begin to break down expectation with a newness of sight—to see what is actually there. To look deeply is an end in itself.

Slowing down allows us to encounter a world of meaning and beauty. Couture reminds us that the transcendent reveals itself just about anywhere when we look carefully. "If you look superficially," he wrote, "you have only a common image; look longer and deeper, the image becomes sublime."

The sublime elicits a response, not necessarily of pleasure, perhaps of awe or even worship. The sublime is not pretty, being more solemn than beauty; it's just as likely to make you weep as smile. When we experience the sublime, there is a promise in it that there is more to life than we can see. For a moment we can escape an ordinary life and connect with something greater than us. By proximity we touch something deep, weighty, and transcendent.

Art is then a sublime connector, a portal to that which is most deeply human. It is the ultimate communication tool, reaching beyond lifetimes and spanning civilizations. It can feel as personal as a voice whispering in your ear or, closer yet, affords you the opportunity to see clearly through another's eyes. By slowing down and learning to see as an artist, we experience the great pleasure to be had from simple things in our own lives. Learning to see what has been there all along is the straw that artists, from generation to generation, have always spun into gold.

Jean-Baptiste Camille Corot, *The Boatman of Mortefontaine*, circa 1865–70, oil on canvas, 24 x 35⅜ inches (60.9 x 89.8 cm). Frick Collection (New York, NY). Image courtesy of the Art Renewal Center® (artrenewal.org).

FORM PAINTING
*the senses of touch and
sight combined*

*Pindar writes, "Man is but a dream of a shadow. Yet when there comes as a gift of heaven
a gleam of sunshine, there rests upon men a radiant light and, aye, a gentle life."*

—*Joseph Campbell (from "The Power of Myth")*

The light source in art reveals the hour of day with all its associations: a quiet dusk, fiery dawn, or the sharp illumination of midday. It is also the great revealer of character—from the general shape of the subject down to its surface texture. Light exposes visual weight, not only the three-dimensional mass of an object but also the detailed characteristics that capture the uniqueness of life. In life, light is a necessity permeating every surface and gap, like air. In painting, it is a layered language used for expression.

In both life and art, light creates visibility, mood, and emotion; yet like a frame around a painting, it's rarely focused on for its own sake unless it's extraordinarily beautiful or unpleasant. A few years ago, I went to a cocktail party lit by a bank of fluorescent lights that gave the space as much atmosphere as a bus terminal. The party lasted about twenty minutes. Alternately, the simplest space can look intriguing in candlelight. In art, light does something similar. It is an essential vehicle for expression; its quality and color can reinforce or undermine an artist's message, be the artist a painter or an architect. In the last chapter, we focused on value pattern, the abstract groupings of dark and light; now we revisit value, but this time as a way to represent the literal elements of shadow and light.

The study of form and the study of light are inseparable; no one can perceive an object's shape or mass without light. Painting from nature requires the artist to understand form, also known as volume. This element is necessary in any solid work of representational art. It gives the illusion of three dimensions, allowing your subject to have visual weight. The key to understanding form lies in two main factors: the shape of the object and the placement and quality of its light source.

OPPOSITE The filtered light of the forest allows the trees to blend into the background, forming a perfect balance for the small forms of the bark and leaves. As our eyes grow acclimated to the darkness we can see endless details in the ground and plants.

Charles Lewis Fussell, *Landscape*, 1897, oil on canvas, 36 3/16 x 29 1/8 inches (91.9 x 74 cm). Acc. No.: 1973.13. Image courtesy of the Pennsylvania Academy of the Fine Arts (Philadelphia, PA). Gift of Mrs. Morris H. Fussell.

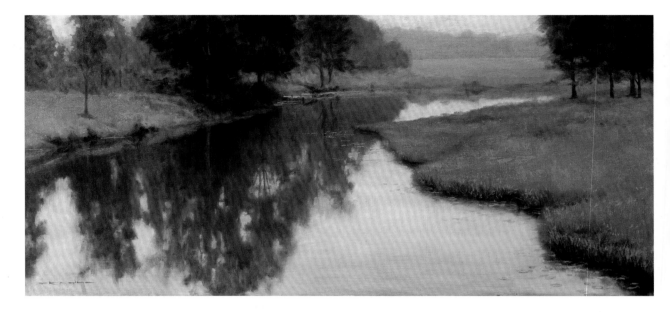

The passing of light throughout a day shows how much light changes the mood experienced in an environment. The evening light here reveals the fullness of color, which appears more intense with the setting sun.

Thomas Kegler, *Evening Glow—Proverbs 11:2*, 2011, oil on linen, 15 x 33 inches (38.1 x 83.82 cm). Private collection.

In art, the light source has three jobs that form a hierarchy of information. The first is to set the tone or mood of a piece by establishing the time of day or direction and intensity of light. The second is to reveal the large mass of a subject and its orientation in space. The third role is to create form, showing dimension and surface texture. We experience all these aspects of light every day. For example, when I walk into a dark room and switch on the light, the first tier information is simply seeing the layout of the objects in the room. Perhaps then I walk through the room and pick up a shirt, looking more closely at the weave of fabric. The minute scale observed in regard to the object, becomes the last element of form painting—the revelation of texture and volume.

> *Form painting is a close examination of an object's surface; the time and focus it requires is an act of devotion.*

To see small forms, our eyes need time to acclimate to a reduced scale, so we can only observe the surface of an object when we slow down. Just as our pupils dilate in a dim light, our eyes need time to recalibrate in order to see small forms. Our vision is designed for hierarchy, with one center of attention presented at a time. It's uncomfortable (and unsustainable) to try and focus on more than that. A conventional test of this point is to look at the window nearest to you and try to see both the spots on the glass and the view beyond the windowpane at the same time. It is only possible to shift your focus from the spot to the view, not to observe both

concurrently. Likewise, we often don't observe large volumes and small forms simultaneously. They appear in sequence.

As a student, I was told that light is the true subject of an artist's work. At the time it didn't make much sense to me. I now believe that comment is profoundly true. I tend to think of the objects I paint as containing meaning, yet light frames their context and suggests their interpretation. The invisible rays, in constant motion, are so foundational to the mood, color, and emotional content of a painting they become a vehicle for meaning. This thought is perhaps reflected in the biblical book of Genesis, where light exists as the first element in creation, perhaps also implying a spiritual component as vital to life.

General to Specific

Learning to paint form teaches us how to carefully observe. Through time and effort our eyes acclimate. Now, not only vast sights impress us, but also the almost imperceptible nuances that inform the things we see. In literature, this same trait can be found in good stories—where the epic scope of "Once upon at time," leads quickly to the introduction of a specific character. Writers and painters both view the world with exacting attention to detail. The combination of general observations about a scene balanced with careful attention to what is happening specifically create sincerity in painting that can lift a work above the ordinary.

Nighttime brings the loss of light and the introduction of a cold palette of colors. The muted color scheme and the low tonal range here echo a quiet evening.

Edward Francis Rook, *Deserted Street, Moonlight*, 1897, oil on canvas, 18 13/16 x 21 3/4 inches (46.2 x 55.2 cm). Acc. No.: 1898.5. Image courtesy of the Pennsylvania Academy of the Fine Arts (Philadelphia, PA). Henry D. Gilpin Fund.

The cold light of a winter afternoon creates a mood of quiet introspection.

Walter Elmer Schofield, *Winter*, 1899, oil on canvas, 29 1/2 x 36 inches (74.9 x 91.4 cm). Acc. No.: 1899.3. Image courtesy of the Pennsylvania Academy of the Fine Arts (Philadelphia, PA). Henry D. Gilpin Fund.

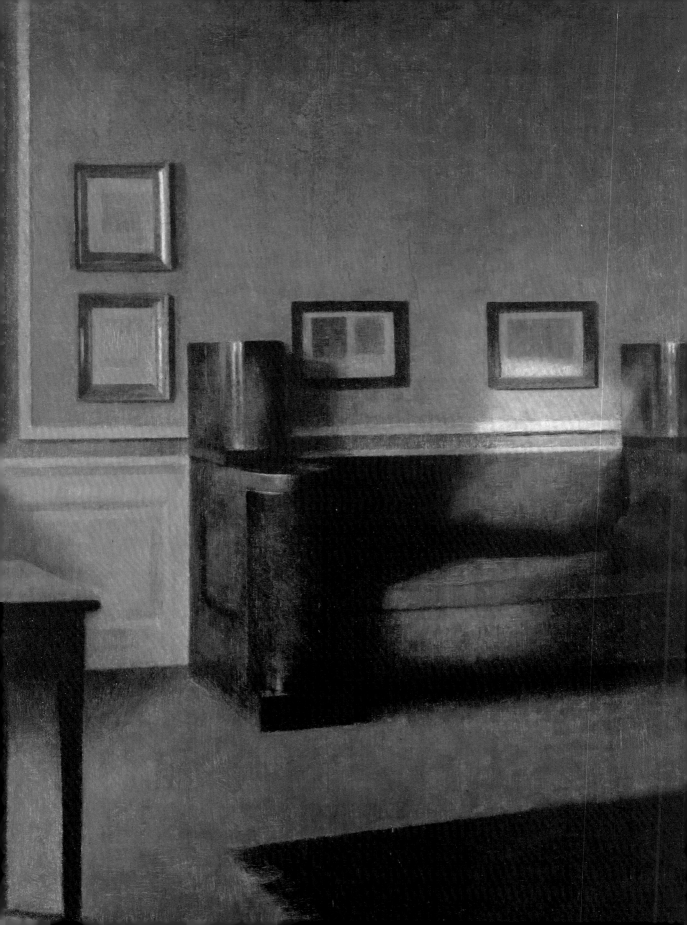

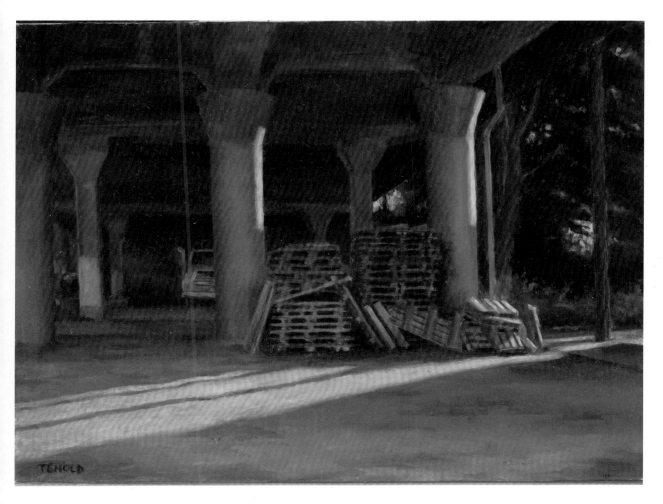

TENOLD

Dennis Miller Bunker (whose striking painting of his subject Jessica can be seen on page ii) weighs in on the subject: "The ability to carry a picture to a high degree of finish without losing its unity of impression is the mark of a master and requires artistry of the highest order. It is the central problem of the type of painting which takes for its main theme the interpretation of the beauty of the visible world."

Form painting is not just for people who love detail or require a tedious intellectual exercise to grow as a person, but is an act of love. By focusing on small areas of form, you learn to appreciate and capture something in a way that few people will ever get to experience. You may be the only person on earth to see and record this particular apple or this face under a specific light. A flower lives for a few days and is gone; although it may only be a daisy, there will never be another that is exactly the same. Tolkien summed it up by writing, "Each leaf, of oak and ash and thorn, is a unique embodiment of the pattern, and for some eye this very year may be

ABOVE Tenold Sundberg painted during *golden hour* (when the setting sun seems to bathe the world in gold). The urban landscape is abstracted into areas of color and value.

Tenold Sundberg, *Under Albro Bridge*, 2013, oil on panel, 12 x 9 inches (30.48 x 22.86 cm). Collection of the artist.

OPPOSITE Vilhelm Hammershøi is the master of interior paintings that convey permanence and stillness. Here only the light appears to move. Nothing seems extraneous.

Vilhelm Hammershøi, *The Sunny Parlor*, circa 1901, oil on canvas, 19 9/16 x 15¾ inches (49.7 x 40 cm). Nationalgalerie, Staatliche Museen (Berlin, Germany). Image courtesy of the Art Renewal Center® (artrenewal.org).

ABOVE Painting simple objects such as the cone, cube, cylinder, egg, and sphere, can help an artist become familiar with how light functions on surfaces with different degrees of curvature. Being able to describe how quickly or slowly a surface changes is key for an artist's descriptive power.

RIGHT The brightness of daylight almost bleaches the form of this pale portrait. The clarity of the daylight helps to provide a sense of mood and contemporary context for the figure.

Candice Bohannon, *Becoming (detail)*, 2013, egg tempera on archival aluminum panel, 10 x 12 inches (25.4 x 30.48 cm). Private collection.

OPPOSITE This sensitive self-portrait handles light so believably the technique disappears into the background, allowing us to connect with the artist's expression and intent.

Nick Alm, *Self Portrait*, 2011, watercolor on paper, 14 9/16 x 10 5/8 inches (37 x 27 cm). Collection of the artist.

the embodiment, the first ever seen and recognized, though oaks have put forth leaves for countless generations of men." When you love something, you want to know what makes it uniquely different, to hold onto, celebrate, and share it with the world.

Basic Shapes

Many artists find that, when studying form, it's best to start with the most basic kinds of three-dimensional objects. The simplicity of a geometric solid allows it to serve as a building block for understanding volume and light in all objects. Many objects, whether natural or designed, can be difficult to wrap our minds around when it comes time to paint them. Doing so seems to require a new vocabulary. Just as it's hard to talk about things or ideas when you don't have the words to name them, painting something can feel insurmountable when you don't know exactly what you are describing. A tin can is easily understood as a cylinder. But what if you want to paint a hammer, or a teapot, or a fountain? The basic solids (cube, sphere, cone, and cylinder) can be combined to create everything that exists—from trees to vacuum cleaners. Painting these forms as practice allows you to understand their structure. This knowledge will be useful later, as you intuitively apply your understanding to the more complex amalgamations that come into play with still life, landscape, and figure work.

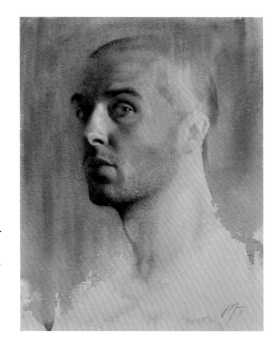

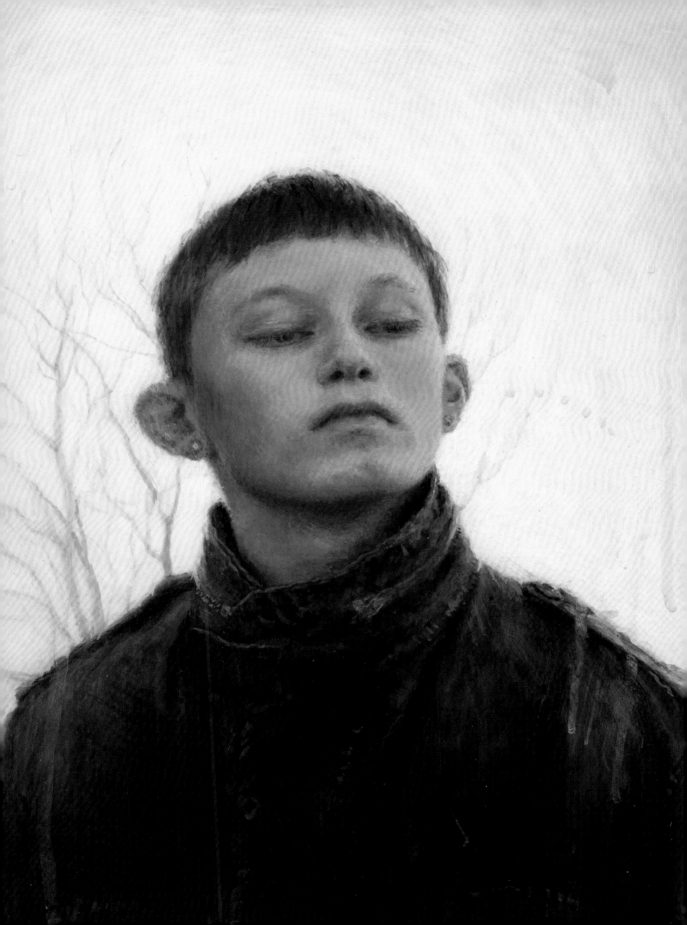

Using Geometric Solids to Understand Form

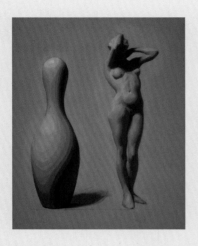

As demonstrated by this grisaille underpainting by Jon deMarin, painting a bowling pin can provide practice for painting the complex combination of shapes found in a nude.

Simple geometric solids are a useful entryway into the study of how light hits an object. When flattened, the cone becomes a triangle, the cube a square, and the sphere a circle. A shape reads as having volume when you can see two or more of its planes. In painting, these planes are often shown by a shift in value. By this means, it quickly becomes apparent that value is the painter's main tool for creating the illusion of value. Once you grasp the principles of value with simplified forms, you will have a mental template that expands to include complex composite structures, (combining spheres, cones, cylinders, and even cubes) like those found in a figure, landscape, or still life.

UNDERSTANDING TAPERING FORMS

The aim of this kind of study is to gain a mental template to help a student understand how light hits complex forms in nature. Often once you can visualize this intellectually it helps to see what is happening with your eyes. The ways in which we see modeling factors (see page 69) are variable. The value scale appears to expand or contract depending on the degree of the subject's surface curve. A narrow form with a quick transition will show a compressed value scale and one with a gentle, curving surface a stretched-out scale.

The exercise of painting a shape like a bowling pin allows you to explore how light hits combined forms that taper and flare. Handling the value for a bowling pin is the same as doing so for the human figure. In each case, the bands of tone follow along the length and width of the subject. All basic geometric shapes and principles are applicable to each. For example, the arm that's bent and facing you directly resembles a cylinder. As a result, it receives varying intensities of light as it moves towards or away from the light.

The double-curved figure is complex, with light bouncing off and rounding off its up-facing planes. By treating the value as unblended bands of tone, it is easy to see how values function optically before they are blended together; the light decreases as the curved form arches away from the light source.

EXPLORING THE DOUBLE CURVE

Understanding how light works on simple geometric forms will quicken your ability to visualize light on complicated forms. The *torus ring* is a geometric form that has a peculiar type of double curvature, where all cross-sections are circular. The three-quarter view (shown on the left in the image) reveals its form best. Here you clearly see the foreground ring is convex, the background ring is concave, and the light source is from above. The top of the foreground ring and the bottom of the background ring are brightest because of their orientation. Also notice that the shadow widens as the ring turns under on both the foreground and background ring.

In the profile view of the torus ring (shown in the middle in the image at right), you can see that the center slightly bulges outward because it's closest to the viewer in perspective. Meanwhile, the top and bottom go back slightly into the depth plane.

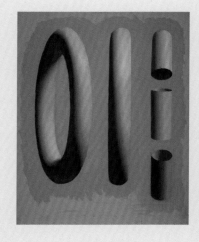

Under the tutelage of Michael Aviano (a New York painter and influential teacher who studied with Frank J. Reilly in the 1940s), deMartin painted this grisaille oil painting.

Notice how many simple geometric shapes reveal themselves in this pastry. The table is a box, the cream puff a cylinder, the raspberries spheres (covered by tinier spheres), and the cream itself forms the double curves found in the torus ring.

John Morra, *Raspberry Cream Puff*, 2009, oil on panel, 5⁴/₅ x 7⁴/₅ inches (14.73 x 19.81 cm). Private collection.

Lighting Your Subjects

When lighting a still life you decide whether to use a natural or artificial light source and which direction the light should come from. If you have access to a window—especially a north-facing one—you will have cool, consistent light to work from during the day. If the window is very large, creating too diffuse a light source, you can reduce and shape the light by blocking off parts of the window. If you have a south- or west-facing window, the light may be too intense and changeable during the midday or in the afternoon to, however the light will be fine certain hours of the day. I have painted from a west-facing window and the light was fine during the morning hours before becoming unusable in the afternoon.

Consider your light source. It creates the mood and atmosphere of your painting.

While natural light may be the best choice when a window or skylight is well positioned, there may also be many times when natural light is not accessible or even desirable to use. Simply put, natural light may not be the best match in all situations. For beginners, the clarity of an artificial light makes it much easier to see big, clean shapes. The difficulty with using artificial light is that you often need several light sources—one for the setup, one for your panel, plus whatever light may already be in the room. The diffuse bouncing light may be difficult to control.

RIGHT Mancini, a contemporary of John Singer Sargent, painted a boy in his studio. The child is bathed in light from the window. Note: the strongest lights are always those closest to the light source.

Antonio Mancini, *Lo Studio*, 1875, oil on canvas, 20 ½ x 26 inches (51.5 × 66 cm). Galleria Nazionale d'Arte Moderna (Rome, Italy).

OPPOSITE Adolph Menzel, *The Balcony Room*, 1845, oil on canvas, 22²¹⁄₂₅ x 18½ inches (58 x 47 cm). Alte Nationalgalerie (Berlin, Germany). Image courtesy of the Art Renewal Center® (artrenewal.org).

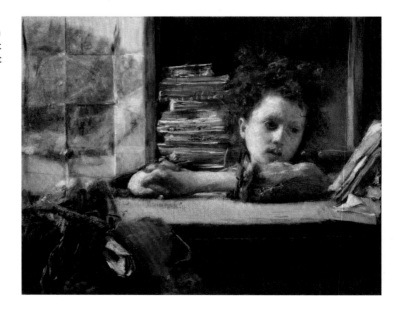

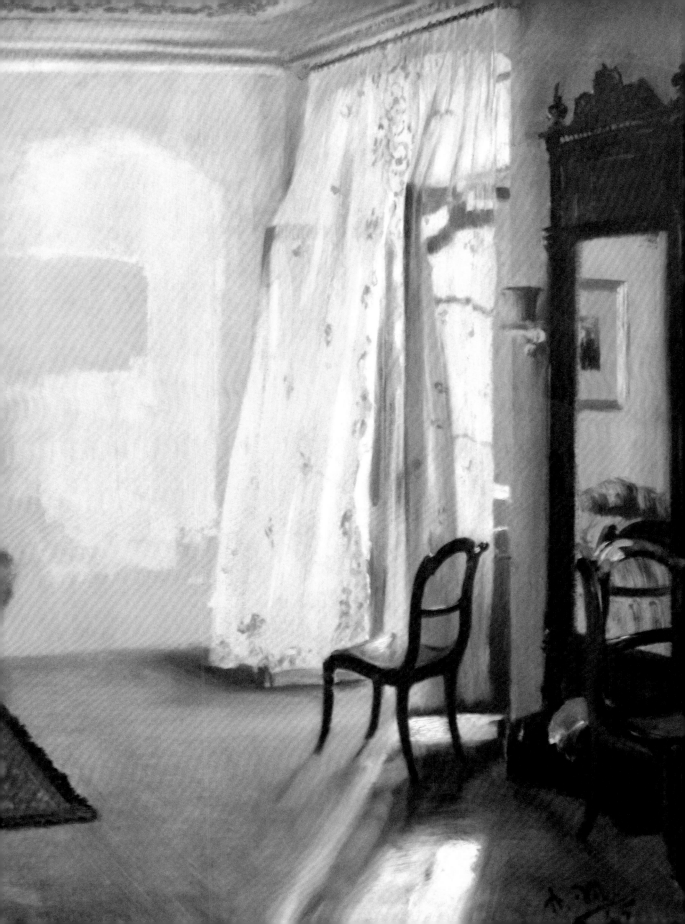

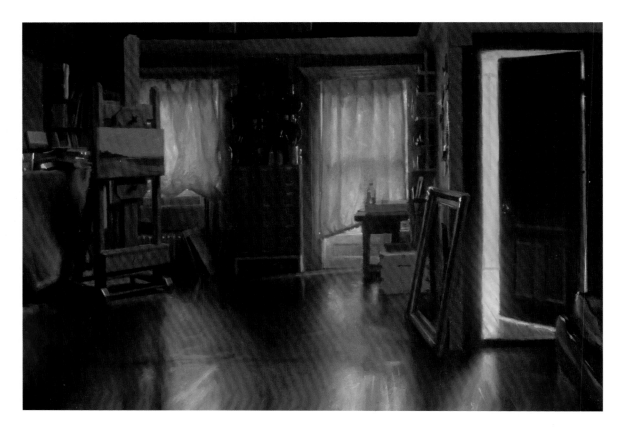

There is no direct light illuminating the objects in this painting. The studio is in darkness, while the diffused light seen through the curtains and the intense backlight of the bathroom become the focal points.

Jacob Collins, *Studio Interior*, 2000, oil on canvas, 12 x 18 inches (30.48 x 45.72 cm). Private collection.

One solution to this problem is to create a *shadow box*, an open box (usually just three sides and a top) that can keep incidental light from hitting your still life. In the studio, we create simple shadow boxes that block the light from spilling in from other parts of the room using wood or foam core.

To create a light source for your still life, clip a light or desk lamp with a moveable arm to your shadow box or to the table, and then adjust the light to illuminate your subject. Different kinds of bulbs, ranging from warm to cool, are available and you should make your selection depending on what you like best. The more natural-looking (and not-too-strong) bulbs are cool, casting an even, subdued bath of light across your subject. The stronger the wattage of your light source, the more extreme your lights and shadows will be.

Whether you choose to use natural or artificial light, the angle in which you position your light source matters. Most artists light their subjects (still life, figure, or portrait) from above to match the light from the sun. Light that shines at an angle onto the subject is called *form revealing* because the shadows created echo the volume of the object. Front-facing light flattens the subject into a more graphic

two-dimensional shape because drawing attention to the contour of the subject. For example, if you paint a cylinder without a top or bottom ellipse, when it's lit from the front, it appears as a rectangle. The flat light, coming from the front, create large unified light shapes allowing for delicacy of coloring and drawing (see portrait of Hawkins on page 27). Artists of different periods painted pale, flattened images to spiritualize their subjects who cast no shadow; or contemporary work which places the models into the bright sun removing the moody chiaroscuro. Lighting an object with half shadow and half-light flattens form, because it obscures the three-dimensional nature of the planes (revealing only two of the three planes).

In a contemporary artist's studio, you can see windows that allow natural light along with fixtures for artificial light. Many artists' studios are simply work spaces, the creativity and beauty springing from the internal world of the mind.

Amaya Gurpide, *Winter at Beverly Road*, 2009, oil on linen, 24 X 20 inches (60.96 x 50.8 cm). Private collection.

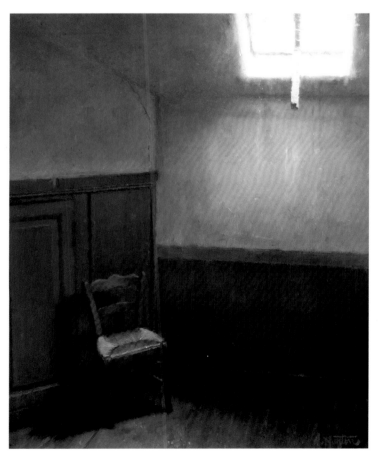

The narrower the opening for the light, the more focused the light source will become. Here a small window creates an intense brightness of the light and rich darks in the shadow. It feels moody and introspective, which is fitting since the painting represents Van Gogh's Room in Auvers sur Oise, France.

Nicholas Martin, *Room Number 5*, 2013, oil on linen, 12 x 16 inches (30.48 x 40.64 cm). Private collection.

The light is shining from the upper right to lower left, revealing the girth of the gourds and the knobbed texture of their surface. You can see the direction of the light from the placement of the highlight and shadow.

Travis Schlaht, *Fall*, 2012, oil on linen, 20 x 20 inches (30.48 x 50.8 cm). Collection of Edward Lamberger.

Shadows

Darkness, when well positioned, can set in motion a whole series of form-revealing opportunities; however, when placed poorly, darkness destroys the form. For this reason, a discussion of shadows is inseparable from a discussion of light. Occasionally, when I travel to teach, I enter a life-drawing room to find the model lit with a bank of overhead fluorescent lights that illuminate the entire room. Flat light coming from all directions makes it difficult to create a visual hierarchy between the subject and the background. The chaotic lighting makes the artist's job infinitely harder, because the light and shadow are not organized into larger shapes. A traditional *life room*, a room where artists work from a nude model, like the painting of Académie Julian found on page 11, will have a bank of north-facing skylights, which is the ideal lighting for establishing simplicity and unity. Without proper lighting you cannot control the effects of the various shadows on your painting.

A shadow is created when an object blocks the direction of the light. If a shadow on an object is caused by, say, the projection of a nose, or the wrapping of a cheek as it turns away from the light, it's

called a *form shadow*. By contrast, a shadow thrown from an object is aptly named a *cast shadow* (ie, my shadow on the sidewalk). It is still called a cast shadow when it falls on another object. Let's say my shadow falls on a stack of books; the shadow on the books would still be my cast shadow. The shadow has an interesting role because it is responsible for both obscuring and revealing the form on which it falls (depending on the circumstance).

> *Keep your shadows unified and simple. Lights in the shadows should still be dark; reflected lights should be subdued.*

The shape and angle of a cast shadow reveals the direction and angle of the light source. Cast shadows appear shorter when the light source is above; likewise, they extend dramatically when the light lowers—just as your shadow is shorter during midday, when the sun is overhead, than at evening, when the sun is low and your shadow can be elongated threefold.

The darkest part of a cast shadow is called the *dark accent*. It can be found immediately under the object as it rests upon the ground plane. The dark accent can be significantly darker than the areas around it, depending on the setup. The outermost part of a shadow is the *penumbra*, from the Latin word *paene* (almost) and the Italian word *umbra* (shadow). Umbra is the more diffused area that transitions between the edge of the shadow and the light. Its effects are seen as most pronounced towards the end of the shadow that is farthest from the object.

This night scene shows a self-portrait of the artist in a cloud of smoke. The scene has a melancholy quality caused by the unnaturally warm light and the obscurity of the shadows.

Richard Thomas Scott, *Cancer and the Tempest*, 2012, oil on linen, 20 x 16 inches (50.8 x 40.64 cm). Collection of Hanna Nabintu Herland.

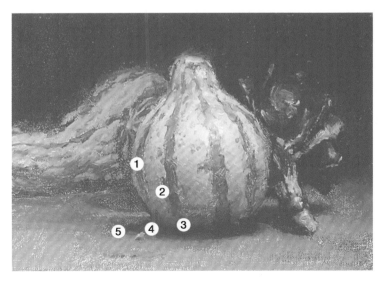

The diagram to the left illustrates the anatomy of light and shadow as subdivided into five value steps. In nature there are a seamless gradation of values, artists often simplify for clarity.

1. Form shadow
2. Core shadow
3. Dark accent
4. Umbra
5. Penumbra

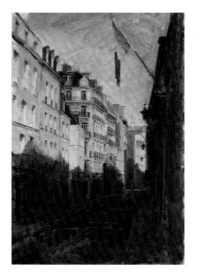

Using shadows to get an object to stand in relief against its background while revealing its form is a basic technique of traditional art. Some artists such as Abbott Handerson Thayer (whose work can be seen on pages 94 and 201) and Solomon J. Solomon determined that the opposite could equally be true. Through carefully studying nature, they determined how to obliterate contrast between an object and its ground. Both artists were pioneers of military camouflage. They knew from studying nature that when a subject has dark and light patterns on it, as you would find from a random cast shadow or pattern, it becomes difficult to see the depth and shape of the subject. A shadow can either inform a subject or compromise its contour and structure.

ABOVE A vast shadow envelops the city street subduing the buildings, flattening information and creating a strong sense of value pattern.

Travis Schlaht, *In the 7th*, 2012, oil on linen, 13 x 9 inches (33.02 x 22.86 cm). John Pence Gallery (San Francisco, CA).

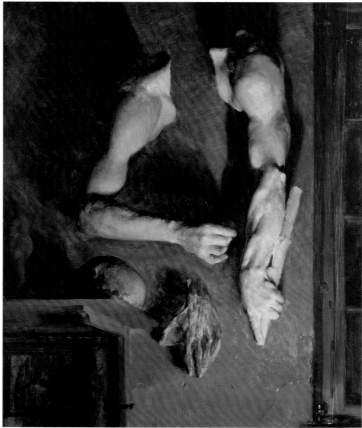

Lighting from below creates an eerie feeling for this portrayal of a studio. The plaster anatomical casts similar to those found on many artists' walls, shed long cast shadows against the wall.

Adolph Menzel, *Atelierwand*, 1852, oil on paper mounted on board, 24 x 17⁵⁄₁₆ inches (61 x 44 cm). Alte Nationalgalerie (Berlin, Germany). Image courtesy of the Art Renewal Center® (artrenewal.org).

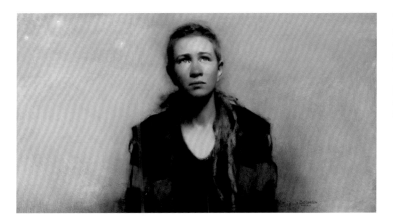

The artist treats the lights and shadows as broad planes, including the most essential information. The three-quarter form lighting gives the impression of volume by creating strong shadows.

Stephen Bauman, *Daydreamer*, 2012, oil on panel, 15¾ x 19⅜ inches (40 x 50 cm). Private collection.

THE CORE SHADOW

The terms *core shadow*, *terminator*, and *bedbug line* all refer to the darkest edge of the shadow that exists just before the surface of your subject turns toward the light. This shadow line is a key player in turning form (creating the illusion of three dimensionality), and gives your piece a solid foundation. The line running down the length of an arm, alternating between straightness at the boney wrists and a curved swelling with the muscles of the forearm, tells the viewer that the arm is not just another long rectangle. Notice in Adolph Menzel's painting *Atelierwand* on page 66 how essential and descriptive the core shadow is along the cast of the arm, revealing its anatomy.

> *The core shadow provides vital information about the girth, volume, and character of your subject.*

At first glance, the core shadow line can appear simple, but it becomes remarkably varied the longer you gaze at it. As with the halftones, it can take some practice to visually isolate the core shadow because you are used to focusing on more easily identifiable elements, such as the contour of the figure. The core shadow offers vital clues about the nature of your subject, revealing girth, volume, and overall character. The curved, crescent shape of the value sphere (seen on page 88) shows that the shape is a continuously curving surface.

The core shadow has an elusive quality that may initially look like an uninterrupted line; yet with careful observation, you will find that it exists not as a continuous stripe but rather a series of connections

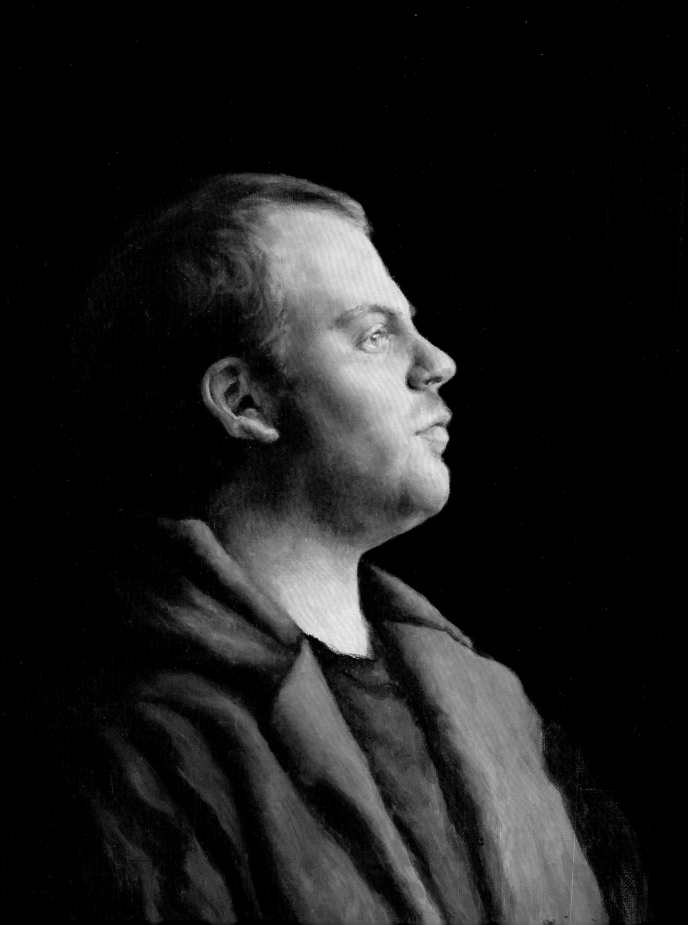

and breaks. This ambiguity can at first be frustrating, especially when you are looking for certainty, and instead see the core shadow dissolve into vagueness impossible to pin down, a semipermeable membrane full of uncertainty rather than an impervious barrier. However, the core shadow adds character and interest.

Over the course of working on a painting, artists generally move from formalizing the core shadow from a few simple lines in the early stages to seeking subtlety in the line as the painting progresses. This approach allows for more freedom, as pursuing refinement from the start can be stifling. By using straight lines, instead of curves, to find this first core shadow, you distill the complex information down to its essence. If the placement is correct, the initial line will feel sufficient. In which case, it becomes safe to continue, subdividing the line into smaller and smaller segments. Or you can finesse the lines into fluid curves. If the initial line does not feel accurate, subdividing it will just add to the confusion, and the corrections will be harder to identify.

Attempting to delineate a core shadow too aggressively often results in failure. Early in my training I sought certainty and clarity in every instance, regardless of the ambiguity in my subject. I just wanted a simple answer and for it to be *right*. Through time, I learned that it was actually preferable to allow visual confusion to occur in my paintings. This ambiguity shows a subtlety of observation and reveals the quality of thought in which the artist is engaged. Somehow taking time to wrestle with doubts and confusion in the core shadow results in a more personal, nuanced outcome. In other words, if you don't see how the core shadow transitions, or if it falls away entirely, don't rush to a decision. Just let it exist, as it is, uncorrected. This kind of careful observation is a point of visual honesty, making the work more accurate and allowing it to bear a closer resemblance to nature.

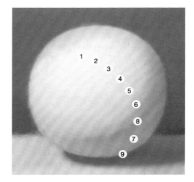

In this illustration of a value sphere we analyze how light hits a form and relate it back to our value step scale.

The value step scale represents the steady gradation from highlight to dark accent.

Light
1. Highlight
2. Light (halo surrounding the highlight)
3. Local light (the local value of the object)

Middle
4. Light halftone
5. Middle halftone
6. Dark halftone

Dark
7. Form shadow
8. Core shadow
9. Dark accent

OPPOSITE Linda Dulaney delineates a complex core shadow and then develops the tiny nuances of light that roll across the surface of the model's face. The strong value contrast helps to give this portrait a big impact.

Linda Dulaney, *Matt*, 2011, oil on canvas, 18 x 14 inches (45.72 x 35.56 cm). Collection of Bay Area Classical Artist Atelier.

The core shadow, also known as the terminator or bedbug line, separates the light from the dark side of the object.

Turn the halftone by placing gradations of value (a mini value step scale), which extend from the core shadow into the local light.

The completed cylinder bridges the light and the shadow by means of a fully developed halftone, becoming a single, seamless unit.

Halftones

The existence of *halftones*, also known as *mid-tones*, creates a twilight effect that appears to creep around a volume, revealing its depth. Unless you are an artist, you can go your entire life without seeing halftones; yet, they provide a remarkable wealth of information about the character of a subject and its relationship to the light. Halftones extend from the darkest internal edge of the core shadow, up through the *local value*, or average value under normal light, of your object.

Extend the breadth of the halftones to increase the sense of your object's girth.

The three images above demonstrate the role of halftones. In the first image, the light and shadow divide the length of the cylinder. The third dimension is implied by the ellipses at the top and bottom, but there is no placement of halftones. In the second image, two value step scales generate stripes that wrap around the circumference of the cylinder, gradating from dark on the right to light on the left. These two halftone stripes seem too dark to be believable; however, in the third image, where they have been softened and blended, these values sit believably. This dark extension of tones is the *halftone*, which becomes an essentially invisible bridge between light and dark in the finished piece.

Look back at Linda Dulaney's image of Matt on page 68. The modeling in the face shows careful attention to the *sub-forms*, which are all the minute changes happening within the larger planes. Tiny forms, which can appear as imperfections or furrows, create character in the realm of halftones. These tiny deviations in tone celebrate the distinctive, idiosyncratic, imperfect, and human. Halftones reveal character in a figure or object. It takes a shadow to create this revelation. It is an axiom that the appearance of light is only created by the existence of darkness.

Perhaps an easy way to visualize this concept is to look at a piece of handmade pottery. I once traded a still life painting for a dinner set of pottery, where each piece showed the hand of the craftsperson. If you look at pottery as an example of small forms—such as the half-sphere of a bowl—the variations in gloss, pockmarks, and lumps marking the surface make each piece unique. Each ridge and valley is a tiny sub-form that exists interdependently of the larger shapes. The miniscule forms modulate the larger shapes, and the larger shapes provide the context in which the smaller forms can be understood. If you think of a whole shape like, say, a hand, the sub-forms are the wrinkles, swellings, and crevices.

Artist John deMartin holds up a blank, scored piece of paper next to a finished value step scale. On the right, he arcs the scored paper so the light above can illuminate it. The result of light hitting a bent form is an uncanny match to the value step scale. This example illustrates what a great metaphor the value step scale is for understanding and recreating turning form.

Reflected Light

The hot, bouncing color that fills the shadow side of the face is a good example of reflected light.

Jeff Hein, Life 1, 2012, oil on panel, 34 x 14 inches (86.36 x 35.56 cm). Private collection.

Light, whether *ambient* (general) or *directed* (focused), that bounces off objects in its path and projects their colors and values onto other nearby objects, is called *reflected light.* Reflected light is important in a painting because it creates three-dimensionality, revealing the surface of the object obscured by shadow. The reflected light is more muted than the primary light source, just like moonlight hitting the earth is less illuminating than direct sunlight. Sometimes photographers and artists will artificially amp up the reflected light by placing foil or paper close to the shadow of an object to ensure that more light bounces, allowing them to get more information or color into the shadow.

Premixing your values enables a clean application of paint. Place each brush stroke on the canvas without reworking.

How you portray light in the body of your shadows often depends on your aesthetic sense. In some art movements, such as Tenebrism (associated with the artist Caravaggio, whose paintings are characterized by extreme darks and a few brilliant lights), artists favored no reflected light at all. Instead, they relied on heavy chiaroscuro (form revealing light and shadow), and atmospheric darks, which created mystery when everything beyond the core shadow disappeared. In other styles, such as the sun-filled work of the Impressionists or the beautiful clarity of a Bouguereau painting, you see every turning form in the shadow side of the face. You can still see a light and shadow side of the head, but the differences can be very subtle.

Most artists, even those who enjoy finding information in the shadows, deliberately soften the value contrast in that area so it doesn't compete with the lit side of the object. Too much detail in the shadow undermines its coherence and can make the shadow distracting. Here physiology of the eye can work against you. When you focus your attention on rendering reflected light, your eyes adjust to the murkiness and compensate by enlarging your pupils, enabling you to see more information. The end result is that half-light found in the tone appears lighter, jumping out of context. When painting the reflected light, artists often compensate for this distortion by either stepping back to see the entire piece, which allows their eyes to readjust, or by comparing the area they are working on to a higher-contrast area.

In order to correct for the jumping of tone that occurs when your eyes acclimate in dim light, or conversely, when you start to see more information in the lights than necessary, you must set up a system of comparisons to help you test for the truth. To do this, artists identify the lightest area on their models, which will be compared with every other light in the painting. Likewise, you can choose the area that looks the darkest and use that to test for accurate relationships.

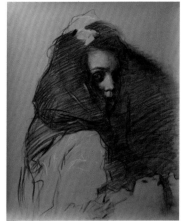

ABOVE In this drawing Teresa Oaxaca groups the shadow of her head into the shadow on the wall and leaves it as one big shape; no reflected light casts into the shadow of her face.

Teresa Oaxaca, *Dark Self Portrait*, 2014, charcoal and white chalk on Hahnemühle "Ingres" paper, 25 x 16 inches (63.5 x 40.64 cm). Private collection.

LEFT Oaxaca chose to cast reflected light into the dark side of her face here, bringing the shadow side into relief and defining the edge.

Teresa Oaxaca, *In My Shadow*, 2014, oil on canvas, 30 x 29 inches (76.2 x 73.66 cm). Private collection.

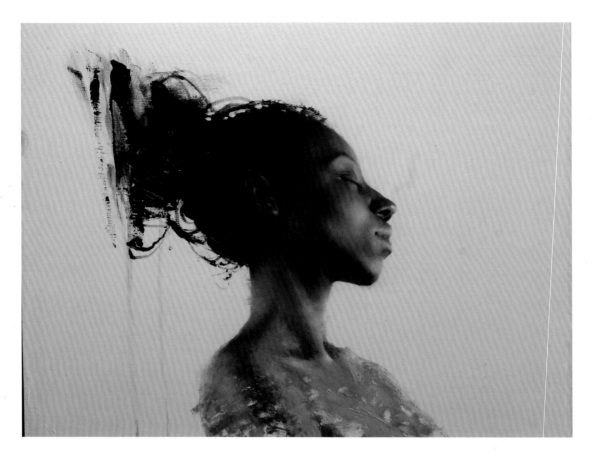

The local tone of Ketsia is darker than the background, casting her head into almost total relief against the lightness of the ground. Study the sphere (opposite) to see how local tone interacts with background color. Notice how Sprick changes the range of values in his subject's shoulder to play with lost and found edges, pushing the viewer's eye to the center of the form.

Daniel Sprick, *Ketsia in Profile*, 2013, oil on canvas on board, 22 x 28 inches (55.88 x 71.12 cm). Private collection.

Local Tone

The local tone of an object is its main value under normal lighting conditions. The local color of an object, similarly, is its main hue under normal lighting conditions. A lemon, for example, will be on the lighter end of the value step scale, while an eggplant will appear almost black.

The five value spheres painted by Jon deMartin (opposite, top) each show a different local tone or "skin color," in order to demonstrate this idea. Each sphere, which is shown under the same lighting condition, appears different because of the lightness or darkness of the local tone. The dark sphere, pictured at top, has very little value gradation over the surface so it appears as essentially a uniform value. The sphere almost appears wet, because the light doesn't build up gradually; instead, it is reflected suddenly in a concentrated blast. The circumference of the sphere is in total relief, preventing any passage of light to the outside edges. In the adjacent sphere, there are no lost edges around the circumference and only the slightest separation of light around the highlight, with the shadow accounting for the bulk of the globe. The third

(middle) sphere separates into a clear shadow shape, with a lost edge around the center of the local tone at the boundary of the shadow and an extended mid-value area, which is part of the light. The fourth sphere has a more compressed midtone, which leaves a clear distinction between light and shadow. The lightest sphere, at bottom, gives the appearance of the shadow shape almost dissolving into the background, while the bright white of the local tone stands in sharp relief. The highlight is nearly the same color as the local tone and is so diffuse that it is swallowed up by the overall light.

Understanding how light works with local tones and how the edges separating light and shadow dissolve or remain in relief in relationship with the surrounding areas are both essential for effectively painting naturalistically. When figure painting from life, knowing how different local tones affect the degree of modeling and the general effects of light can help you make informed decisions necessary for the successful rendering of form.

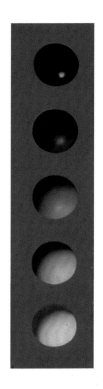

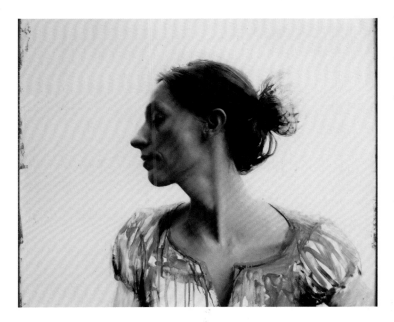

These painted spheres show a range of different local values (black, gray, and white). The local tone affects the relief of the object against the background, dictates soft or lost edges around the circumference of the spheres, and impacts the appearance of the core shadow.

LEFT The light (coming from the right) allows the lit part of the back and neck to fade into the background. The shadow on her face stands in stark relief against the background. Compare this lighting scheme to the pale local color in the fourth value sphere.

Daniel Sprick, *Julia, Who Was from Russia*, 2012, oil on board, 26 x 24 inches (66.04 x 60.96 cm). Private collection.

On Highlights:
An Essay by Alan Carroll

Painting reflections in metallic sheen is different than painting form on a matte surface. The addition of specular highlights gives a mirror-like gleam to the armor.

Adolph Menzel, *Armor Chamber Fantasy*, 1866, pencil, body color, heightened with brush on white, and brown paper, dimensions unknown. Albertina (Vienna, Austria).Image courtesy of the Art Renewal Center® (artrenewal.org).

Rembrandt's portrait of Alexander the Great, *A Man in Armour*, employs techniques that had been invented in ancient Greece some two thousand years previous by Apelles—a fitting tribute seeing that Apelles was Alexander's favorite portrait painter. Notice how Rembrandt dropped the value on everything other than the gleaming metal.

Rembrandt, *A Man in Armour*, 1655, oil on canvas, 54 ⅛ x 41 ⅛ inches (137.5 x 104.5 cm).Kelvingrove Art Gallery and Museum (Glasgow, Scotland). Image courtesy of the Art Renewal Center® (artrenewal.org).

> *Every time a man sees something new in the world, he finds something new in himself….What you see reveals you. We do not so much interpret nature—for nature needs but little interpretation—we interpret ourselves.*
>
> —*William Chalmers Covert* (Wild Woods and Waterways)

The Western notion that value is the best means of producing the illusion of depth originated some two thousand years ago with the legendary painter Apelles, whose fame at the time was unrivaled. Apelles's big discovery was that black recedes and white advances,

The acanthus is a plant, that grows in the Mediterranean; its leaves became a motif commonly used in ancient Greek and Roman architecture, such as on capitals and friezes. These two images provide a before-and-after look at the use of highlights. The addition of white brings the lit areas of the plant into high relief allowing them to stand out more sharply against the background.

Alan Carroll, *Acanthus Leaf*, 2014, casein on paper, 8 x 6 inches (20.32 x 15.24 cm). Private collection.

or to put it another way, hollows are dark and ridges are light. The term *highlight* carries with it the sense that something light is also high in relief. His addition of a white line along the leading edge of a plane pushed space forward toward the viewer. The gleam on a raised edge destroyed any spatial ambiguity as to the direction of the three-dimensional relief that might arise from a shifting light source because our mind perceives a light surface as protruding forward.

A highlight naturally draws our attention and informs us of spatial depth. Physiologically, if the visual data received by the eye is *highly contrasted* or has *concentrated detail*, we interpret this surface as being close to us. When we see surface texture, our eyes make small jumps (called *saccades*) from point to point. While looking at a bright or rough surface, our brain picks up the message that that surface is near to us.

Bright highlights on metallic objects—called *specular highlights*—pose an additional problem. They are different than regular highlights because they reflect the intensity of the light source. Unfortunately, white pigment has an upper limitation, as far as its ability to depict this effect. It can never be that bright. So artists have to cheat when painting to create the effects of light.

Artists such as Rembrandt understood that if they simply painted everything else darker, then the lights would automatically look brighter. Rembrandt's ability to capture the effect of metallic sheen was a hard-won technical victory that owed much to Apelles (see the painting opposite). Indeed, there is a direct line from his early innovations that carries all the way through the Renaissance to inform representational painters to this day.

Edges

Many students looking to discover the secrets of great painters spend the majority of their time studying palettes and painting mediums. However, their time may be better spent elsewhere. One of the best-kept secrets of great paintings has to do, surprisingly, with the manipulation of edges, which causes our eyes to move throughout a painting. Edges are essentially the lines, contours, and transitions between one area (object) and another. I like to imagine the range of edges is similar to music: values represent the notes, while edges represent their emphasis, essentially loudness and softness. A sharp edge provides an accent, which focuses our attention and creates visual hierarchy. How an artist handles edges will influence the aesthetic of his or her work. A large part of a painter's personal style is seen in how he or she handles the contour of objects. The crisp, linear outline in a painting by Botticelli or Puvis de Chavannes (as seen on page 16) creates striking definition and graphic clarity.

Lost edges occur when the tone of the object matches the value of the background.

Differing treatments of edges create a variety of end results. For example, the primitivism of the hard edge can be useful for conveying the epic scale of wall murals, as found in fresco painting or in oil painting that mimics fresco. I never quite understood the influence and appeal of Puvis de Chavannes's work until I saw it in person. Often, the scale of his art is large and meant to be viewed from below, at a distance. These paintings were not for a living room, but for a grand enclosed place such as the Pantheon. The clarity of the image was not only essential for it to be read well from far away, but also to fit within the architectural nature of the setting. These paintings belong *in situ*.

Other artists have used hard edges for different purposes. During the nineteenth century, certain artists found a renewed interest in the method of using hard edges for defining space. They gravitated toward the formal use of flat tone and hard edges because those devices conveyed a sense of honesty and innocence. This is seen, for example, in religious work of the Medieval period, which is not overly sophisticated or slick. The Pre-Raphaelite movement was concerned with flat lighting and firm edges for this very reason. And, of course, this rejection of naturalism later became a defining element of Modernism.

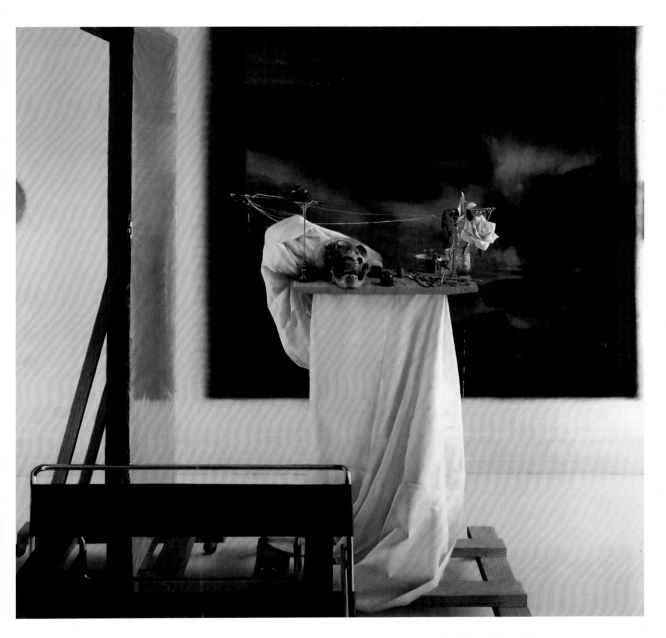

Daniel Sprick's paintings show a remarkable range of edgework. Compare the sharp, quick contrast found in the drapery against the background with the softened gradations between the picture frame and background. The seascape is fuzzy, while the rose is crystal clear. Sprick's beautifully balanced painting has a modern simplicity of a large shape juxtaposed with smaller forms.

Daniel Sprick, *Through My Fingers*, 2010, oil on board, 60 x 60 inches (152.4 x 152.4 cm). Private collection.

Manipulating Edges with Intention

OPPOSITE Aram Gershuni, using classic light on the simplest object, transforms it into a meditative, iconic image, proving it is the artist's eye—not the subject—that makes a painting.

Aram Gershuni, *Loaf of Bread*, 2011, oil on wood, 13¾ x 15¾ inches (35 x 40 cm). Private collection.

RIGHT The diagrams here, isolate principles seen in details of the painting on the opposite page:

A. A lost edge of dissolving form
B. A soft focus or diffused edge
C. A high–contrast sharp edge

Consider the employment of edges in Aram Gershuni's strikingly realized still life on the opposite page. Using the simplest and most basic of compositions—this loaf of bread could almost be a single classically lit sphere—Gershuni transformed an everyday object into an iconic image worthy of contemplation. The success of the work is a result of the artist's vision translated into beautifully lit form, elegant value pattern, and exceptionally varied edges. Compare principles of lost and found edges in the images below. The diagrams on the left correspond with details of the painting, *Loaf of Bread*, on the right. In the first row, we see the sharp edge dissolve into a lost one. For the second row, we see the treatment of a diffuse edge. In the final row, we see the intense focus of a sharp, high-contrast, edge.

The way I see it, edges are the last and most difficult and subtle component to develop in the personal evolution of a painter. Drawing, tonality, even color, can all be learned more rigorously, but edges are more personal. It's really where the soul of the painting resides.

—Aram Gershuni

LESSON 3

VALUE SPHERE PAINTING

The aim of this exercise is to create the experience of volume using tone. This practice allows you to get comfortable handling halftones, ensuring a seamless gradation of middle values that link your lights and your darks. Painting simple geometric objects is a quick way to understand the building blocks of more complex forms, and will save you much time down the road. The sphere (which is found everywhere in representational art, from the bulging of a vase to the arching of a nose) is by far the hardest of the shapes to convincingly represent, so it makes sense to study it independently from the others. This exercise will also give you some experience in paint handling and, because the shapes are so straightforward, it is easy to see where you are off. You could do the project here with an alternate objects—like an egg or piece of fruit—and achieve the same result. However, you should spray paint the objects white first, so you are not distracted by their local color. Plan on completing this Lesson over a few days, rather than in one sitting. That way, you can let one layer dry before working on the next. Don't worry if it's not perfect. The knowledge you internalize will stay with you long after you have finished the project.

OPPOSITE Louis Welden Hawkins, *Innocence*, circa 1890, oil on canvas, 19¾ x 28¾ inches (50.165 x 73.025 cm). Private collection. Image courtesy of the Art Renewal Center® (artrenewal.org).

ADJUSTING YOUR LIGHTING

For this exercise, find a white ball or spray-paint a palm-sized ball with matte white acrylic paint, then place it on a table or in a shadow box with a single light source. Make sure the light is coming in at an angle, giving you a clear shadow shape that looks like a crescent. Put a gray piece of paper under and behind the sphere.

MATERIALS

Panel

White ball

Gray paper (optional)

Pencil or charcoal

Brushes In a variety of sizes inclduing 2, 4, 6, and 8

Paint Titanium white, ivory black, and raw umber

Palette

Fixative (optional)

Odorless mineral spirits

Lighting For this exercise it is helpful to have a clear, strong light source. Artificial light, in this instance, is preferred because it simplifies the shapes, making them easy to see.

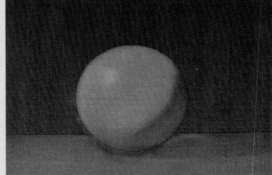

STAGE ONE:
Drawing the Circle

STAGE TWO:
Applying the Underpainting

On a small board or canvas no larger than 12 inches by 14 inches, using your charcoal or pencil, draw (or trace) a circle indicating the ball and, behind it, a horizontal line marking the back edge of the table. Next, sketch the shadow shape on the ball and the shadow cast by the ball on the table. Ink over your lines to secure them or lightly spray them with fixative. Make sure your lines are light, because they may show through your paint layer if they are too thick and dark.

You can do a thin wash underpainting to get rid of the white ground and provide a roadmap for the subsequent paint layer. Using a thin layer of raw umber, tone the shadow shapes, background, and foreground. Be sure not to leave any seams of paint where the edges meet. The goal is to create unity and to cover the entire surface except for the lightest areas. You can, alternately, skip this step and just paint opaquely, going for a direct finish.

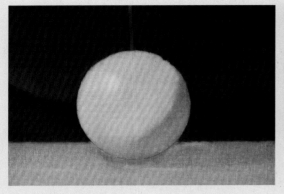 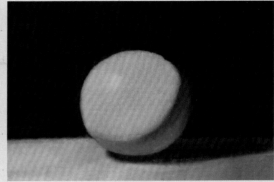

STAGE THREE:
Articulating the Background

Mix up a value step scale (see page 32) using white and black paint before you start. Begin by choosing the value that most closely matches your background tone and paint only this area. You don't have to match it exactly, but give it your best guess. You can always go back and adjust the value later. By working from background to foreground, you will get the majority of the panel covered right at the beginning. Avoid painting your brushstrokes in a parallel manner to achieve some variety in the way the paint sits on the surface. Make sure that you apply the paint opaquely, but not so thickly that you are seeing a paint layer with deep brushstrokes. This big background value will provide the context for the subsequent steps.

STAGE FOUR:
Defining the Shadow Areas and Table

First, paint the form shadow, taking into account the reflected light. Carefully observe the form shadow as it approaches the circumference of the sphere and paint the edges as accurately as you can. The darkest part of the painting may be the accent where the sphere touches the surface. The edge of the cast shadow will be sharpest near the sphere and increasingly diffuse with distance. Keeping the edges soft will allow you to go back and make adjustments easily.

Next, paint the surface on which your subject rests. If the light is shining from above, remember to show the gradation between where the light is hitting most strongly (in this case the front) and where it dwindles—as it moves toward the edge of the surface and the right edge of the panel.

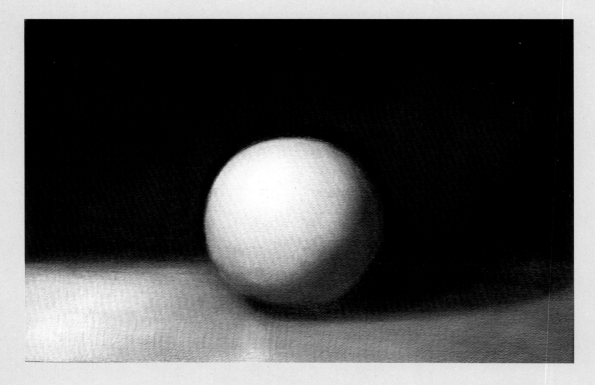

James Hansen, *Sphere*, 2015, oil on linen, 6 x 8 inches (15.24 x 20.32 cm). Private collection.

STAGE FIVE:
Adding the Lights and Highlights

You will have covered the entire panel except for the illuminated portion of the sphere. The painting as a whole may have come together quickly; however, now the pace will slow down as you focus on this one area. I recommend using a smaller brush, which forces you not to put too much paint down too quickly. Now is the time when the form takes shape, so carefully observe your object. Starting with your darkest tones, match the value of the core shadow. Working with small tiles of paint that gradate from dark to light, move perpendicular to the core shadow. Albert Boime who wrote *The Academy and French Painting* encouraged the use of six mid-tones to link the lights with the dark. These tiles were carefully juxtaposed as if the artist were working on a mosaic. Start with four value steps, moving carefully from the dark value all the way to the lightest. As you apply each value, begin in one area and move steadily across the sphere, until it is covered completely with paint. Don't worry about making sure the transitions are perfectly smooth, and don't blend everything together. When you are done, look at the entire painting, making sure the entire piece works as a whole.

David Gluck, *The Proposal*, 2014, oil on panel,
20 x 26 inches (50.8 x 66 cm). Collection of the artist.

Painting a Cast

The techniques for painting form, explored in the value sphere lesson (page 85), can easily be applied to other subjects such as eggs, fruit, and still life items, which can be spray-painted white (or left as is). One excellent place to practice figure work, apart from with a live model, is with the plaster cast of a sculpture. A plaster cast gives you an opportunity to test your skills on a figure (or part of a figure, such as a hand), under easier conditions. Unlike a live model, the cast is uniformly white, doesn't move, and can be positioned for the best view under ideal lighting. Painting from a cast provides you with an opportunity to work as long as you like without feeling rushed for time. You can find a cast from online sources that provide everything from busts to masks, reliefs, or ornaments.

Working from a cast has a long history as an intermediary step—a cross between a master copy and working from life. I recommend painting the subject as carefully as you can. It is here that you get a chance to test your technical ability, a practice run for your later paintings from life, in color. Elizabeth Zanzinger demonstrates the process in the example here.

Drawing the Form

Drawing the Form

Zanzinger began by creating a preliminary drawing (see upper left). This gave her the opportunity to explore accuracy with proportion and set up the composition.

Locking In the Values

Zanzinger applied the first pass of tone to her canvas (see lower left). She used a thin layer of oil paint, locking in the drawing and the general values. This stage provided a blueprint for the final paint layer, establishing how the finished painting would look.

Locking in Values

Refining the Transitions

In the final opaque paint layer (below), Elizabeth concentrated on turning form and exploring her paint handling. Starting with the background, Elizabeth created a context for the cast. After the background was massed in, she painted from the bottom of the pedestal and drapery, carefully moving up the figure. In this way, she was able to gain confidence and skill in paint handling before tackling the sensitive areas of the figure, hair, and face.

Elizabeth Zanzinger, *Apres Allesgrain*, 2010, oil on canvas, 34 x 19 inches (86.36 x 48.26 cm). Private collection.

LESSON 4

FORM PAINTING

With this Lesson, you will develop a figure painting by using a grisaille (painting in grays) underpainting. This method of painting has a long history. It is useful because it allows an easy transition from drawing and into color through tone, allowing you to focus on one element at a time. You can quickly build up the bulk of your image in value, and then, concentrate all your energy on color without also having to worry about the drawing itself. This method also has the benefit of helping you unify the entire image, by linking the shadows with the background and setting the figure in high relief. In this example ahead, the artist shows a progression from a tonal underpainting on a gray ground to a color overpainting. If you are a new painter, it may be helpful to focus on the monochromatic underpainting and then stop at Stage Two. Doing so will provide you with an opportunity to practice figure painting without the added element of color.

PREPARING YOUR PALETTE

Artist Michael John Angel, director of the Angel Academy in Florence, Italy, painted the sample painting for this Lesson. He used a specific palette (listed in the Materials list below). I recommend using whatever paints you have and not stressing if you don't have one particular brand over another. It is far better to get experience painting than to wait until you have an exact tube of paint. All artists have their favorite brands and colors. Over time, familiarity will turn your palette choices into reliable friends. Slight differences of color will not drastically affect the outcome here.

MATERIALS

Drawing supplies

Panel or canvas (with mid-tone gray ground)

Palette

Raw umber (or another color or your choosing) and white (for the underpainting)

Brushes such as filberts in sizes including 2, 4, 6, and 8

Odorless mineral spirits

paint rag

Basic palette White, Naples yellow, yellow ocher, cadmium red, burnt umber, burnt sienna, permanent alizarin crimson, ultramarine blue, ivory black, raw umber

 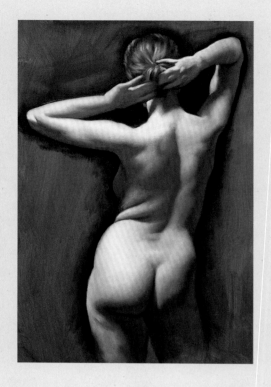

STAGE ONE:
Capturing the Gesture

Find the relative proportion of your figure on a medium gray ground using raw umber thinned with odorless mineral spirits. Your surface should be prepared in advance with a mid-value gray acrylic or oil. Try to strike a believable compromise between the lively, somewhat exaggerated gesture and empirical reality. After locating a few gestural lines, articulate the drawing using straight lines, taking care to find the shadow shapes. And finally draw a careful outline of the figure Notice that artist Michael John Angel keeps his shapes accurate, but simplified. Too much detail at this early stage can fragment the painting and slow down your process.

STAGE TWO:
Massing In the Lights

Angel establishes the main areas of light, which will serve as a guide in the next stage for adding color. He creates this grisaille layer by massing in the lightest lights with white, then drybrushing the halftones to give the illusion of form. At this point, Angel's palette consists of black, white, and a few midtone grays. (See the value step scale example on page 32 for more on how to mix these values.) Approach this stage as if you are applying white chalk to toned paper.

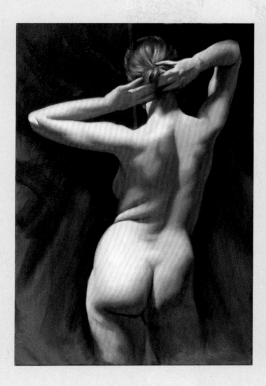

STAGE THREE:
Exploring Temperature Ranges

Find the local color of your figure's shadows, spotting in several areas to determine the correct value and color. Do the same for your lights and mid-tones. Keep in mind, this should be an exploratory stage. These tentative colors are best mixed on the palette with brushes, not with your palette knife. Once you have settled on believable tones, spot your main colors for the figure.

STAGE FOUR:
Modeling the Form

Mix the main colors that you found in the previous step in a convenient quantity. Use the palette knife to add a small amount of medium. The consistency of the paint should be such that it spreads easily over the canvas, but is translucent (ie, semi-opaque) not transparent. The colors should also blend easily with each other, without either slipping around or being too dry and difficult to manipulate. The emphasis here is on modeling the largest shapes and on establishing major landmarks.

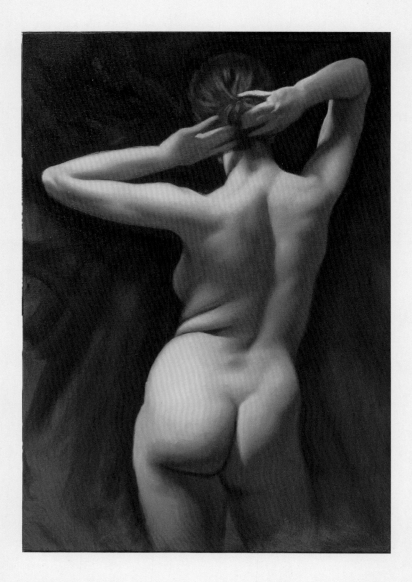

STAGE FIVE:
Resolving the Image

Apply the final layer of paint more carefully, giving attention to blendings (ie, the quality of the edges) and nuances of color. At this stage, the paint should be thinner than in previous stages, but not necessarily transparent. The final working on the palette involves smoothing out here, roughing up there, graying areas, making a few areas higher chroma, correcting shapes, and so on—whatever needs doing to bring the painting to a finish.

Michael John Angel, *Vanessa*, 2015, oil on canvas, 24 x 16 inches (60 x 40 cm). Collection of the artist.

The Drawing.

The Tonal Underpainting.

The three images seen on this page illustrate the progression of a painting using the tonal underpainting method.

ABOVE, RIGHT Juliette Aristides, *Fox*, 2015, oil on panel, 24 x 18 inches (60.96 x 45.72 cm). Private collection.

TEMPERATURE
*unlocking the secrets
of color*

*I will confess my own private belief, which I do not wish anyone to share,
that of all the books and all the famous sayings that have come as a revelation to
human beings, not one is strictly true.... They are not meant to be statements of fact.
They are cries of distress, calls of encouragement, signals flashing in the darkness.*

—G. Gilbert Murray (from "Literature as Revelation")

There are at least as many variations of color in the world around us as there are restaurants in New York City. In life, color is not an event to be isolated and then analyzed, but rather a kind of benediction, enveloping everything. Our taste in color remains as personal as our favorite books; yet a deeper knowledge of how color works adds to our range of self-expression. Building a foundational knowledge of color is equivalent to learning to read as a child—it's tough work when you start, but in exchange you gain a lifetime of insight and freedom. Every artist benefits from a basic understanding of how to recognize, identify, mix, and apply color.

Every studio has a different way of transitioning its students from drawing to painting. In my atelier, we use temperature as a gateway between our studies in value and the full-color palette. Starting with a limited, two-color palette centered on a study of warm and cool tones here, we'll progress to the full-color palette in the next chapter. Developing a strategy for painting in color is essential for a painter. Subdividing the fluid experience of seeing color into its component parts allows you to gradually build up your skills, focusing on one new element at a time.

It is important to note that everyone's relationship with color is unique and often highly personal. My first memory as a child was sitting on a giant stone under the sun, mesmerized by miniscule crawling spiders, each one a bright pinprick of cadmium red. I didn't think any living color could be so vivid, so tiny. Although I derived much pleasure from looking at color, I was unaware that I was seeing only the most basic information. As I grew up, every object appeared to me to be a single hue—a lemon was yellow, a tomato was red;

OPPOSITE William Bouguereau, an admirer of Raphael, taught at the Académie Julian where, significantly, he taught both men and women. His work was hugely influential in his lifetime and his technical skill continues to be a high mark in painting the human form.

William Bouguereau, *Study: Head of a Young Girl*, 1898, oil on canvas, dimensions unknown. Private collection. Image courtesy of the Art Renewal Center® (artrenewal.org).

ABOVE Laura Theresa Alma-Tadema's work is unusual in that it combines a naturalism of everyday scenes with almost haunting light and shadows.

Laura Theresa Alma-Tadema, *Girl on Stairs*, date unknown, oil on canvas, 10 x 7 inches (25.4 x 17.78 cm). Private collection.

RIGHT The Belgium-trained painter Lawrence Alma-Tadema specialized in highly detailed, beautifully rendered reconstructions of antiquity. This informal composition of his daughter walking through a door is an essay in blues, greens, and grays, all contrasting gently with the warmth of her skin.

Lawrence Alma-Tadema, *Miss Anna Alma-Tadema*, 1883, oil on canvas, 44½ x 30⅞ inches (113 x 78.5 cm). Royal Academy of Arts, Burlington House (London, United Kingdom).

I didn't know that there was more to see. Later, as an art student, my teachers would point to intermingling blue notes in warm shapes and pink tones in frosty shadows, and I saw nothing.

In order to improve my painting skills, I studied color formally, creating many charts until I had an understanding of color theory. Yet knowing color theory did not make me a better painter, or even a better observer of color. (Similarly, learning anatomy didn't make me a better draftsman.) It was only when I applied the theory to the process of creating real paintings that I started making headway. There is simply no way to avoid the fumbling first beginnings. The only way to get better at painting from life is to paint from life. There are no shortcuts.

It took much time, but eventually, through experimentation and study, the door to color cracked open and I glimpsed an alternate world. Winston Churchill experienced something similar. "I found myself instinctively walked," he commented in "Painting as a Pastime," "noting the tint and character of a leaf, the dreamy, purple shades of mountains, the exquisite lacery of winter branches, the dim, pale silhouettes of far horizons. And I had lived for over forty years without ever noticing any of them except in a general way, as one might look at a crowd and say 'What a lot of people!'" After a time, I caught a glimpse of color variations. Gradually, the veil over my eyes was lifted and I could stare at an object and see what my instructors saw, an ephemeral mingling of color.

Despite the miracle of finally seeing color I still encountered the difficulty of having to paint with it. A pottery bowl on a windowsill—which once seemed to be a simple black—now appeared as a confusion of color. The longer I looked at the bowl, the more I saw and the less confident I felt painting it. The blue reflected from the sky bounced off the highlights; the terracotta undertones showed through parts of the glaze; the violet notes reflected off the ledge. Yet in time, with a plan, these complexities of color not only became possible to paint, but doing so became a pleasure.

Painting in color requires a strategy, a system that gives consistent results while still allowing room for the unexpected hues found in life. A little bit of study goes a long way toward identifying and mixing color. In this chapter and the one that follows, I will present

Lawrence Alma-Tadema fell in love, and later married the young artist Laura Theresa Epps, whom he met at Ford Madox Brown's London studio. Alma-Tadema found great success with his art in London thanks to his classical themes and remarkable skill in painting surfaces such as marble.

Lawrence Alma-Tadema, *Interrupted*, 1880, oil on wood, 17 x 12 inches (43.2 x 30.5 cm). Fulham Public Library (London, United Kingdom).

The black jug reflects back the blue from the sky and reveals warmer notes peaking through the uniformity of the black local color. Sadie Valeri's attention, not only to value but also to the shimmering effects of natural light, lends a liveliness that comes from direct observation of life.

Sadie Valeri, *Black Jug*, 2010, oil on panel, 8 x 10 inches (20.32 x 25.4 cm). Private collection.

ways to make your studies in color as direct and fruitful as possible. We will explore characteristics of paint, what happens when you mix colors together, and how to arrange them on the palette in a consistent way. We will dive into several color theory ideas with a few experiments and quickly link them to practical lessons to test your skills. I will also present ways to think about color that will enable you to become more fluid and confident over time.

An Introduction to Warm and Cool

Michael Klein creates a graphic image by grouping his light shapes together on a dark ground. The two strong color notes, the yellow and red rose, create balance, moving our eye from one side of the picture to the other.

Michael Klein, *Bouquet*, 2008, oil on linen, 20 x 24 inches (50.8 x 60.96 cm). Private collection.

Temperature refers to the relative amount of yellow (warm) or blue (cool) in a color compared to the colors around it. Imagine walking into a room painted in linen white, and then imagine walking into a room painted in mint white. You can probably see the difference in your mind's eye. Paint manufacturers have literally dozens of exotically named varieties of white from which you can choose. Unlike hue, chroma, and value, which are inherent qualities of color

Victoria Dubourg Fantin-Latour met her future husband, Henri Fantin-Latour while doing a master copy at the Louvre. A bright floral piece on a neutral background keeps the viewer's eyes moving from one side of the picture to the other with an equal distribution of pink, red, and yellow.

Victoria Dubourg Fantin-Latour, *Flowers*, date unknown, oil on canvas, dimensions unknown. Image courtesy of the Art Renewal Center® (artrenewal.org).

(to be discussed in the next chapter), temperature is not considered an integral component. Nevertheless, it is important for color accuracy. A study of temperature contains the key to understanding full-color painting.

In my atelier, we devote an extensive period of time to studying temperature as a transition between grisaille (painting in grays) and the full-color palette. By choosing to focus on what is perhaps the most difficult task of all (finding the color in white or limited-color objects), we cut right to the heart of the matter. Once our eyes are acclimated to a shift between two temperatures/colors, it becomes easy to navigate an enlarged palette. As the painter Robert Henri observed in his book *The Art Spirit*, "The effect of brilliancy is to be obtained principally from the oppositions of cool colors with warm colors, and the oppositions of grave colors with bright colors. If all the colors are bright there is no brightness."

You may be surprised to find that a painting made using warm and cool tones creates an unusually colorful piece when completed. Often a painting can give the appearance of full color while utilizing a surprisingly limited intermingling of grays, accented by one or two strong color notes.

A painting exists as a world unto itself and remains consistent to its own reality. Just as great fictional literature can convey timeless truths that are unrelated to the facts found in a daily paper, the truth

Henri Fantin-Latour, *Hollyhocks*, 1889, oil on canvas, 29 x 23 ³⁹⁄₅₀ inches (73.8 × 60.4 cm). Private collection. Image courtesy of the Art Renewal Center® (artrenewal.org).

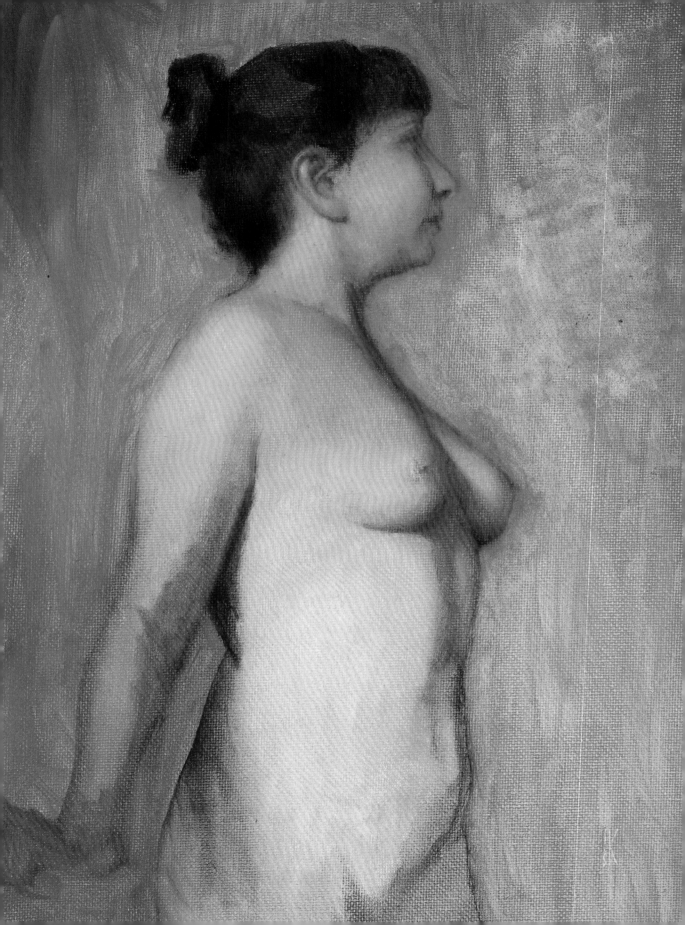

in color can be both "true" in representing the essentials and be highly interpretive. Color needs to be emotionally and relationally true rather than photographically true. Through color emphasis, an artist can guide the viewer's eye to what is significant in the composition and state a mood that reflects his or her personality. Color relationships are subjective. The world of color is filtered through our own eyes, our individual sensitivities, and our personal emphasis. Understanding this principle truth is essential in order to begin our first step into color: warm and cool.

A transitional warm/cool palette was never used when I was a student, although it was recommended by some historical texts. I wondered why it fell out of use, so I posed the question to several artists. There seemed to be a consensus that using such a limited palette is harder. How can using two colors be harder than using twenty? After much thought I realized, *Of course, a two-color palette is not only harder; it's nearly impossible.*

BELOW John Zadrozny creates only a few admixtures (two or more colors mixed together) at any one time out of the almost limitless possibilities. This photograph shows how he set up his limited palette of black, white, viridian, and burnt sienna, with the other mixing done as needed with a paintbrush on the palette.

RIGHT The two color chart, with viridian green on the left and burnt sienna on the right, shows a few of the variations that you can make with such a limited palette and with the addition of white. (See page 119 for how to make a color chart.)

There is no way a two-color palette could be sufficient to capture the variety of hue and chroma found in nature because the spectrum of colors found in roses and limes or sunsets and forests could never be reduced to such simple schemes. However, if the limitations of the palette are understood and the subject of the painting is carefully chosen, it is more than possible to use two colors with striking results. An ideal arrangement involves using only one or two strong color notes, while a muted color palette governs the rest of the image.

Studying each part of a painting separately makes complex problems more manageable. Limiting the scope of each artistic principle will enable you not only to know the range available to you, but will also help you to target problem issues. Imagine a marionette, where each string pulls an isolated part of the puppet's body; the string on the left lifts a specific arm and no matter how hard you pull on a different string, the arm will not rise. Likewise, it is helpful to know exactly which artistic string will yield the desired result in a painting—and for that, drawing, value, color, and composition should each be understood in turn. When trying to determine what is going well or poorly with color, you look for value to assess issues of lightness and darkness and you look for temperature to understand rhythmic distribution of color tones overall.

When introducing the student to color temperature, we limit the palette to two colors for the sake of simplicity, only adding more when absolutely necessary. At this point, the student knows how to manipulate tones into a believable image using value alone. With the understanding of value in place, the student can expand on his or her understanding of color by asking how warm or cool an area is compared to the areas around it. Appreciating shifts in temperature provides an important key to understanding color in general.

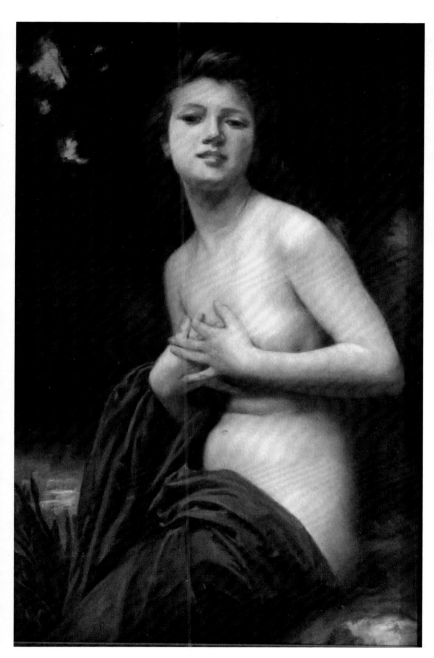

ABOVE The artist created a value poster study to do a trial run of his palette. This gave him a chance to practice his color and develop a strategy before beginning his final piece.

John Zadrozny, Study for Master copy of William-Adolphe Bouguereau's *Spring Breeze*, 2011, oil on linen, 15 x 10 inches (38.1 x 25.4 cm). Private collection.

Zadrozny used two colors—burnt sienna and viridian green—to paint the entirety of this master copy. The two colors together add believability to the warm and cool relationships. The artist noticed that when he blended the two colors they never became as neutral as he'd expected. (See the color map on page 202.) That was because neither color, when mixed together, moved to the center of the color wheel.

John Zadrozny, Master copy of William-Adolphe Bouguereau's *Spring Breeze*, 2011, oil on linen, 15 x 10 inches (38.1 x 25.4 cm). Private collection

Understanding Temperature Relationships

Dealing with ambiguity is an essential part of becoming a good colorist. Even for people with painting experience, subtle grays can be difficult to identify. Sometimes, even with our best efforts, we can't name or pin down a color because the area we are studying can appear to be, say, both green and orange. At that point, I recommend making an educated guess. Each painting has a life of its own and it may accept or reject a color note. If your estimate works, the painting will feel harmonious and move ahead; if the painting rejects the color note, the artwork will feel disjointed.

Sometimes, I will put down the right color and yet it looks wrong in the painting. The painting must work together as a whole, and if the color note feels wrong, either it is wrong or everything around it is. Understanding this concept of treating the painting as a unified composition is one of the main goals of studying color theory. The widest lens to assess color relationships through is that of temperature.

These value strings are all made using a different color of paint for each line. These paints include raw umber, Cassel earth, ivory black, or a combination. The string that looks almost blue is just ivory black and white. If you cover this line with a piece of paper or your finger, notice how much more gray (rather than brown) the other lines appear without this point of comparison.

This color chart shows a line color with ultramarine blue and burnt sienna passing through a range of neutrals in between them.

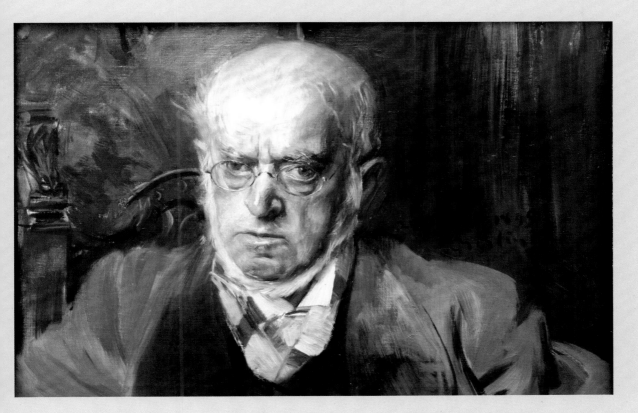

The experiences in our lives are continually weighed, whether deliberately or unconsciously, in relation to other things. We know what it is to be cold because we have experienced heat. If the range of experience is reduced (let's say, for instance, you have never tasted the sweetness of sugar), the range is adjusted accordingly. (A piece of fruit becomes the sweetest dessert as a result of this limitation.) The relativity experienced in life is mirrored in color. Verisimilitude in color relationships has more to do with the contrast of warm and cool within an understood range than a wide range of colors.

The painting above of the artist Adolph Menzel, whose work can be seen on pages 60 and 66, is an animated character study capturing a fiery, inquisitive personality. The painting could be described as an essay of grays. The only spark of clear color is found above his right brow and ear. The rest is muted in range. The coolest note is found in the steel of his jacket, which may be nothing more than a gray mixed from black and white. This mixture forms the palette of color—one red note and the rest a muted exploration of warms and cools.

ABOVE Boldini's energetic brushstrokes and elegant painting style made him a popular painter in his day. In this painting of the artist Adolph Menzel, whose work can be seen on pages 61 and 66, Boldini uses a limited palette with an impressionistic technique, applying alternating temperatures in quick succession.

Giovanni Boldini, *The Painter Adolph Menzel*, 1895, oil on canvas, dimensions unknown. Alte Nationalgalerie (Berlin, Germany).

The Illusion of Color with Warm and Cool

The accurate portrayal of color has more to do with effective temperature shifts than an enlarged palette with dozens of paints on it. The interplay between neutral and chromatic and warm and cool gives a painting its life and provides a sense of reality. Harold Speed wrote in *Oil Painting Techniques and Materials*, "And this position of the warm and of the cool colors in flesh painting, is one of the most important considerations in coloring; as it is on the opposition of the warm and cold colors, that the vitality of coloring very largely depends." You can discover the secret of successful color painting within a discussion on temperature.

Warm or cool colors remain a matter, not of absolutes, but of believable relationships and personal perception. Hot tea may appear a golden orange in a white cup, yet muted and cool compared to a burning ember. Even within a single object there are differences in the intensity and temperature. "For the benefit of the layman," André Lhote, French artist and writer, states, "we must point out that it is an absolute law that the transition from a *warm* shadow to *warm* light is effected with the help of a *cold* tone." He notes that when you study objects carefully, you can see that they undergo a change of color as they move across the surface of the form. An excellent way to study this idea is by making a color chart.

For example, consider any three adjacent squares below toward the middle of the temperature range:

In the grand scheme of things, all three tones are close to gray. When viewing the tones placed side by side, however, we can easily see that there is a clear shift between warm and cool even in this attenuated range.

ABOVE, TOP This is a two-color chart with Venetian red on one side and a blue-black on the other. The combination leans toward violet when mixed together. The painter and writer Harold Speed recommends this combination as an entrance to figure painting when the model is fair skinned. He noted, "Painting with red for your warm and black for your cold, and a mixture of both for your neutral tones, a surprising amount of color vitality can be obtained, by the right placing of the warm and cold colors."

ABOVE, BOTTOM Harold Speed recommends experimenting with two colors such as burnt sienna (or transparent earth orange) for painting models who have more olive complexions. The admixtures lean toward yellow and green.

OPPOSITE Kate Lehman brings together elements of abstraction along with fully realized areas of turning form to create a whimsical pattern of warm and cool tones.

Kate Lehman, *Eloïse Eonnet as SeaWife*, 2015, oil and patina on copper, 24 x 24 inches (60.96 x 60.96 cm). Private collection.

Lighting Your Still Life

This morning I was writing while it was still dark, and my small desk lamp cast a golden glow across the table. The sun had not yet risen when I decided to turn off the lamp and make myself a cup of tea. The minute I turned off the lamp, the world seemed bathed in pre-dawn colors, the sky a deep ultramarine, the paper and walls a silvery world of blues and grays. The difference in the color and intensity of the light source dramatically changed the appearance of my workplace.

Take note of the color of your light source (remember that light itself has a color). The local color of the light is a foundational element that can go unnoticed, so when choosing a light source, pay close attention to its color and temperature. Does it lean toward the blue or the yellow, cool or warm? Your choice will determine the color scheme for your painting and inform all your color choices. It is the foundation on which the rest of your work will depend. If you have access to natural light, that is often the most interesting and exciting to work from. Because the light from the sun is lively, varied, and constantly shifting, it creates an effect artificial light can only approximate but never duplicate.

Color leans either warm or cool as it shifts across an object toward or away from the light.

That being said, many artificial light sources are available, each with different characteristics. Light bulb manufacturers understand that the temperature of the bulb affects the atmosphere of a room. When you are buying light bulbs, look for two aspects of the light: one, how bright it gets and two, what the temperature of the color is. The temperature of the light can be cool, like natural north light, or warm, like the glow of a candle. Also, consider the brightness of the bulb, whether you want a bright spotlight or one that is gentler. Many artists care deeply about the color of their light source and opt for one that is as close to natural daylight as possible, check the CRI (a color rendering index) label on the bulb, looking for one that's close to 100. Many shops that sell bulbs will have a display showing or explaining the range of color options available.

When I use artificial light I just buy the bulb I personally like, not necessarily what is theoretically best. I tend to prefer a mixture of warm and cool and will sometimes use two bulbs, or use daylight and shoot other light into it with an additional light source. You're the artist, you choose the light that gets you excited to start painting.

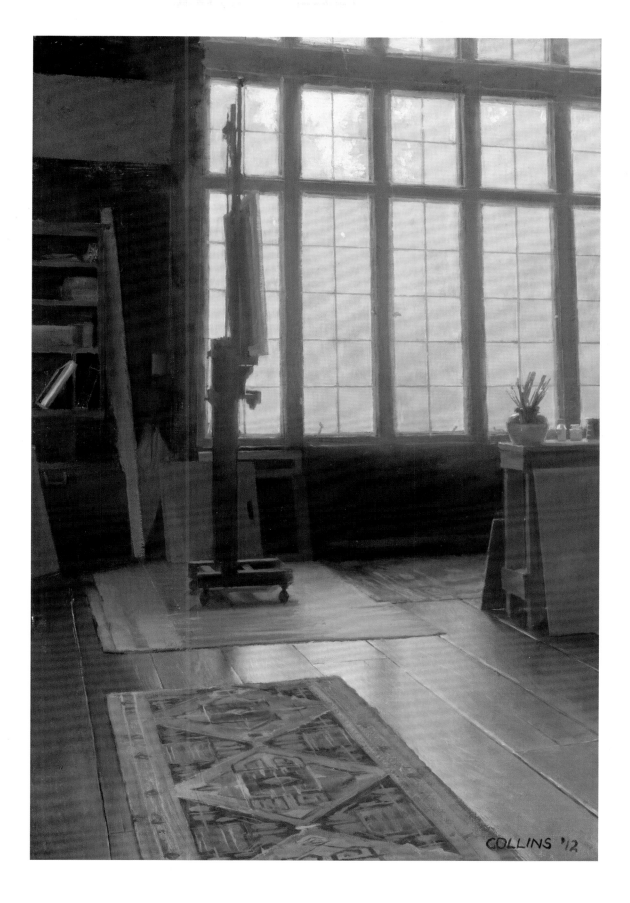

COLLINS '12

Warm and Cool Color Chart

The objective of this exercise is to create a grid showing the range of values and temperatures that are possible using just two colors. While working through this example you will familiarize yourself with the enormous range of values and temperatures that exist, even among two colors. After mixing these tones, you will start to see the tiny differences between warm and cool tones, which will be handy later when you begin to identify color.

PREPARING YOUR PANEL

Using a pencil and ruler, draw a 9-by-9-inch grid onto your panel, and subdivide it into 1-inch squares. When you are finished, the panel should be nine square across and nine squares down (for a total of eighty-one squares).

CREATING YOUR COLOR CHART

As you mix your colors separately on a piece of glass or palette and then paint your grid, try to make the increments between each tone uniform, with no major jumps between them.

MIXING YOUR PAINT

Squeeze ultramarine blue on the left and burnt sienna on the right of your palette. Be sure to use enough paint so you will have plenty for mixing the numerous variations in the following stages. Mix seven steps between the two colors. The easiest way to approach this task is to make a dead neutral halfway between the pure ultramarine blue and pure burnt sienna, using your palette knife to mix the paint. Make sure to clean the knife between each mixture. Once you have made the mixtures, apply them to the top row of your panel, placing the pure ultramarine blue in the upper-left corner, the pure burnt sienna in the upper-right corner, and the variations in the squares in between.

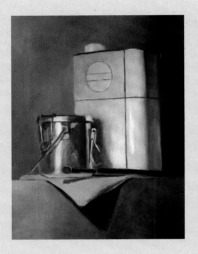

Using a palette of burnt sienna and ultramarine, Andrew DeGoede painted some of his artistic tools. The resulting painting is an essay in grays with warm and cool accents.

Andrew DeGoede, *OMS & Brush Washer*, 2015, oil on linen, 11 x 14 inches (27.94 x 35.56 cm). Private collection.

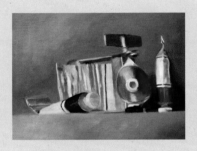

DeGoede captured the tubes of paints—a palette of two colors: burnt sienna and ultramarine plus white— that he used for making this image.

Andrew DeGoede, *Paint Tubes & Wringer*, 2015, oil on line, 8 x 10 inches (20.32 x 25.4 cm). Private collection.

TINTING THE PURE HUES

Because the value of both ultramarine blue and burnt sienna are dark, you will not be certain that the color steps you created previously are successful until you tint them with white. Start this process by mixing your pure ultramarine blue with white, creating seven intervening stages like you did above. Repeat this process by mixing your pure burnt sienna with white. Once you have created your tints of the pure hues, apply the variants to your panel. Make sure to clean your brush after every mixture so that you don't get variations in your tone. Part of the goal of this exercise is to mix clean, distinct tones.

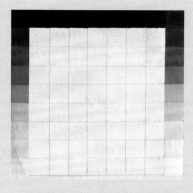

DEFINING THE NEUTRAL VALUE RANGE

Repeat the process of tinting your color, this time concentrating on the mixture you made that is a 50/50 blend of ultramarine blue and burnt sienna. When you have completed your variants, apply them to your panel, again cleaning your brush frequently to prevent contamination.

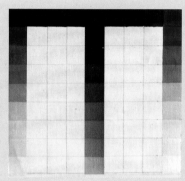

ARTICULATING THE TEMPERATURE VARIANTS

To complete the rest of the grid, simply add white to your six remaining color piles as you would with a value step scale, making each successive step lighter as you work. Test your color notes against the finished value step scale you created (see page 32) to make sure your values are evenly spaced. Once you have mixed the color variants, apply them to your panel.

LESSON 5

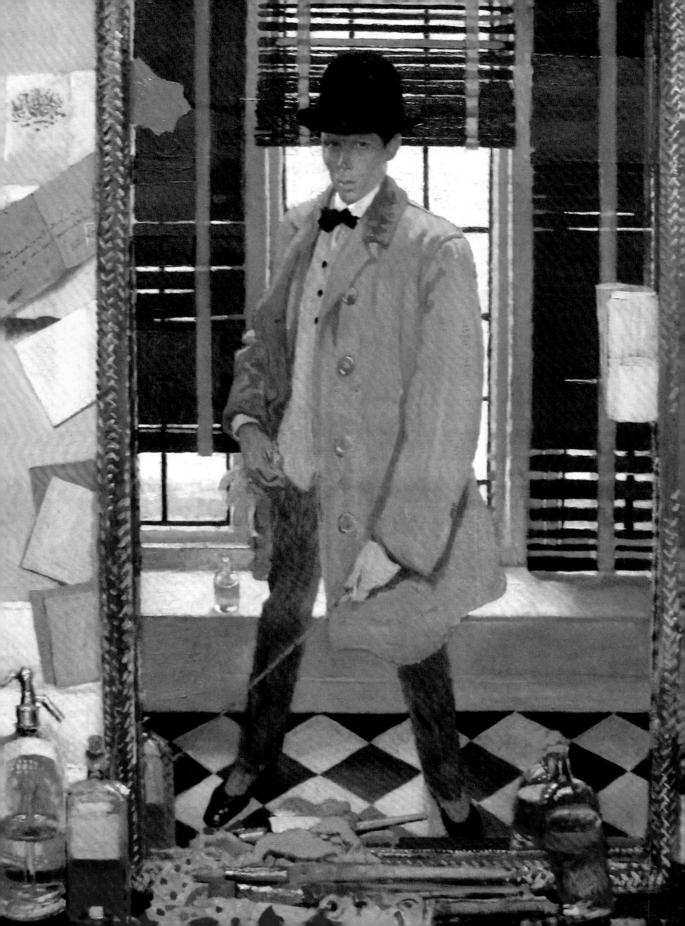

WARM AND COOL PAINTING

Using a two-color palette provides an entranceway into color without as many variables as are found in a full palette. By focusing on temperature shifts you can understand the secret behind painting in color. You will learn that it is necessary to push the color in order to have it read and how to create a lively surface through warm and cool rhythms. The limited nature of the palette in this lesson will allow you to understand color logic by isolating it, making it relatively easy to move from these subtle color relationships to more obvious ones.

SETTING UP YOUR STILL LIFE

Consider setting up your still life in a shadow box (see page 62) with a dark, cool background. The artist featured in this lesson, Tenold Sunberg, crushed some cans and spray-painted them white. In order to get more color in the white objects, he positioned the cans on a piece of bright orange construction paper, which bounced reflected warmth into the shadows. He lit his subject with a blue max daylight bulb because he wanted the painting to look as if it was painted under natural light.

PREPARING YOUR PALETTE

Premixing the oil colors with a palette knife is important for successful limited-color painting. The range between two colors is so subtle that if you don't have clean piles of color to work from, you will be unable to see the differences between the color notes. If you mix these piles with a brush, it can easily result in a muddy painting.

OPPOSITE The Irish artist Sir William Orpen's subject matter reflected what was happening in his life. He was a successful society portrait painter who also painted scenes from the trenches of World War I. In this painting, you see the artist in an unusual backlit lighting situation, holding his limited color palette.

Sir William Orpen, *Leading the life in the West*, circa 1910, oil on canvas, 40⅛ x 33⅛ inches (101.9 x 84.1 cm). Metropolitan Museum of Art (New York, NY). Image courtesy of the Art Renewal Center® (artrenewal.org).

MATERIALS

Still life objects Choose neutral or white objects to paint or, if colored objects, make sure they work with this palette. Some subjects people have painted before are garlic, drapery, keys, crumpled paper, metal, and eggs.

Graphite pencil

Charcoal

Pitt permanent ink pens

Panel or canvas

Brushes in a variety of sizes including 2, 4, 6, and 8

Palette glass or wood

Paints Burnt sienna, ultramarine blue, and white

Paint rags

Palette knife

Odorless mineral spirits

STAGE ONE:
Creating a Poster Study

STAGE TWO:
Executing the Drawing

In his poster study, Tenold Sundberg focused on large value shapes and simple temperature decisions—in this case, warm shadows, and cool lights. Speed is important when he executes his study because effects of warm and cool are fleeting—the longer he looked at the subject, the more confusing it got. Sundberg made quick judgments without second-guessing himself. He essentially divided the piece into big rhythms of warm, neutral, and cool passages. He spent three hours on the piece, two hours to mass in the paint, getting the surface covered, and a final hour to refine his first impressions.

Plan your composition by drawing your subject on paper in graphite. Compositionally, Sundberg wanted the cans to create one big shape, subdivided with diamonds and triangles, that read well from far away. He wanted the drawing to be as accurate as possible so he wouldn't have to do any correcting in the paint. Sundberg has found that he works best when dividing the tasks: first, creating a solid drawing and, second, focusing on paint handling, color, and turning form in the final piece. After your drawing is complete, transfer it using charcoal on the back of the paper and then outline the drawing on the panel using Pitt permanent ink pens.

STAGE THREE:
Applying the Wash-In Layer

Apply your underpainting layer. For this piece Sundberg chose to use a thin color wash as an underpainting. Using a color, versus a tonal wash, is a great choice if you have subtle color that could be deadened by the tonal ground. He kept this paint layer thin to allow the white of the ground to show through. To thin the paint he barely touched the mineral spirits with the tip of his brush and put the puddle on the palette to mix with the paint.

Sundberg started by covering the background with a dark tone, creating a strong figure-to-ground relationship for the cans. Then he worked one area at a time, washing in the entire underpainting in one sitting. Notice the rhythm he established—warm in the shadows and cool throughout the mid-tones. After he covered the surface of the panel he went back to make any adjustments.

STAGE FOUR:
Rendering Form

At this point you will have already made many decisions—such as composition, proportion, value, and color—yet there is more to be done. During the overpainting stage, you should concentrate on developing the form, building up a solid paint layer, and refining the edges. This thick paint layer creates physicality and a sense of bulk and mass; it also catches the light. Sundberg focused on one can at a time, turning form in a methodical way. He wanted to carefully observe and develop each can with all its idiosyncrasies.

STAGE FIVE:
Refining the Shadows and Highlights

Now it's time to focus on finishing the painting. A lot happens during this final stage. Step back and assess the painting to see if it captures your vision. Check to see if you have overlooked anything, if something appears odd or obscure, if any edges need to be softened or accentuated, and if the viewer's eye can easily move throughout the image.

Now is the time to catch any distortion in the drawing, or any transitions that need to be modulated between the background and the foreground. You may find that the background needs to be cleaned up. At this stage, Sundberg repainted his background a little darker and more solidly than before, finishing it in one sitting. (The background often needs to be done in one sitting or it can appear patchy.)

ABOVE Tenold Sundberg, *Family Portrait*, 2015, oil on panel, 12 x 16 inches (30.48 x 40.64 cm). Private Collection.

OPPOSITE Bobby De Trani, *Swan Song*, 2014, oil on canvas, 27 x 16 inches (68.58 x 40.64 cm). Private collection.

This painting by Sargent shows his colleague William Merritt Chase holding his palette. It is interesting to compare it with Chase's actual palette, shown opposite.

John Singer Sargent, *William M. Chase, N. A.*, 1902, oil on canvas, 52½ x 41⅜ inches (158.8 × 105.1 cm). The Metropolitan Museum of Art (New York, NY). Image courtesy of the Art Renewal Center® (artrenewal.org).

Painting from Life

Figure and portrait painting are well suited to the study of warm and cool, and for most of history, artists used a palette of earth colors (naturally occurring minerals like iron oxides) such as yellow ocher, red oxide, brown umber, and black pigment. This abridged range was not a real limitation—artists created timeless works of great emotion, recording their history and worldview. Although now we have a greatly extended range of color, the figure can still just as easily be approached with a few hues.

Under a natural light source, the human figure is not defined by striking hues, but by a sense of luminosity: the effect of bouncing light hitting translucent skin, creating an array of subtly shifting colors. The key to believable figure painting lies in the juxtaposition of well-placed colors, not in having a wide range of color options. This is demonstrated by the history of art, which is also a history

It is wonderful to compare this palette used by William Merritt Chase from the Pennsylvania Academy of Fine Arts collection to his portrait painted by Sargent, palette in hand, on the previous page. The placement of the white between the yellow ocher and the red paint is similar to the Beaux palette shown on page 133. Looking at the actual palette reveals that the magic of great artists' paintings cannot be explained by any uniqueness or specialness in their choice of colors. And that, in the right hands, very little color is needed to make a beautiful, successful figure painting.

Image courtesy of PAFA.

of the limited palette. When any palette is used well, the color disappears and the viewer is confronted with the image itself. The key to beautiful figure painting is not in using an exact palette but in understanding how the color on your palette works.

Learning to mix flesh tones is unavoidably a process of trial and error. In my first figure paintings, I had a palette filled with bright colors, and yet my figures emerged the color of a Band-Aid. Others had the opposite tendency, using just a few colors and creating rainbow-colored people. The goal is to avoid both extremes. I had my biggest insights into color by adding just a few colors at a time to a palette of black and white. A limited palette is not "better" or more pure than one with a wide range of color; however, this organization builds well on our earlier studies of value, form, and temperature, creating an easy entranceway to studying figure painting.

A masterful figure painting is a singular artistic achievement, providing us with a sense of companionship, solidarity, and human possibility. Robert Henri wrote, "There is nothing in all the world more beautiful or significant of the laws of the universe than the nude human body." However, for a figure painting to be exceptional, it is not enough to simply capture a physical likeness, as you would a still life of books. We expect more; there must be a feeling of inner life. We expect great figure paintings to be mirrors that help us interpret human experience and explore meaning in life. Painting a human being is the culmination of an artist's skill, bringing together every other aspect of art—drawing, composition, color, and narrative.

Figure painting is a great, but difficult calling. Differences in an artist's ability to draw are highlighted when it comes to a portrait or a nude. It doesn't take much for a figure to look wrong. The margin for error is slight because everyone is acquainted with the human form, down to the minutest details. I can notice that a friend is upset by the slight stiffening of her features or a sense of hardness around her eyes. Because human sight is finely calibrated to anatomical accuracy, distortions in a figure piece are hard to ignore. Proportional errors in figure painting can ruin the piece's illusionistic quality. (The study of drawing is best studied independently; please see *Lessons in Classical Drawing* for instruction on how to improve your drawing.) Yet taking time to practice your drawing skills and improve your eye is essential to strengthening your paintings. Oddly enough, the more complete the painting, the more critical the viewer is of proportional accuracy. The viewer makes greater allowances when judging an impressionistically rendered work than a tightly realistic one. In sketches and impressionistic work, the inaccuracies can be hidden by the energy of the color and brushwork.

Despite the importance of accurate drawing, obsessing over your drawing when you are just starting to paint can be chilling—a stumbling block to risk taking, and ultimately to learning. The only way to improve your figure painting is to actually do it, and the more frequent and fearless the practice, the better. Be patient with yourself while you work. Despite the difficulties, painting the figure is as much a joy as a challenge. It's exciting and collaborative to paint another person, and the movement in the pose brings energy and life to art.

Practice your figure palette by doing quick master copy sketches before working from life.

Even if your drawing skills need work, you can still move ahead with your figure painting. I recommend quick sketches, such as poster studies in value and color (see page 171) to build your confidence and accuracy. Looking through half-closed eyelids can help you see the figure as large shapes rather than anatomy. Just as we saw in Chapter One, simplifying tone down to essentials is important; you can distill hands, features, or limbs into larger masses. In this way you can practice shape and color, bypassing some drawing issues that occur when you bring a piece to a finish.

Artists and Their Palettes through the Ages

An artist's most important instrument is the palette, where paints are placed and mixed. After deciding between a handheld wood palette or a glass tabletop the artist decides what colors to place on it. The artist John Collier described three considerations when choosing paints: The colors must be permanent, capable of rendering nearly all the tints in nature and as few in number as possible. In this section we are going to work with a limited, historical palette, which is naturally harmonious because the colors are selective and generally muted. In Chapter four we will introduce the full palette, which covers a much greater range of the color wheel.

A traditional figure painting palette was limited in color and was well suited to capture the subtlety of human skin seen indoors under steady, muted natural light. The range of color required by today's alla prima artists working in plein air was unnecessary for historical painters. They were experts of a narrow range of colors in a way

Cesare Ciani, *Figure in Costume*, date unknown, oil on palette, 13 3/16 x 9 3/16 inches (35 x 25 cm). Private collection. Photo: © DeA Picture Library/Art Resource, NY.

The brighter impressionistic palette of paint replaced a traditional limited scheme of colors painted on a dark ground color and careful drawing to the lively, high-key painting of girls in sunlight perhaps painted in plein air.

Cecilia Beaux, *Study of Two Breton Women, Concarneau, France*, 1888, oil on canvas, 13¹¹⁄₁₆ x 10⅝ inches (34.7 x 26.9 cm). Acc. No.: 1950.17.7. Image courtesy of the Pennsylvania Academy of Fine Art (Philadelphia, PA). Gift of Henry Sandwith Drinker.

that is hard to achieve when our materials are seemingly limitless. Although there is no reason to artificially reduce the range of your palette we can learn from those who came before us by starting with a few colors and building from there.

Historical records (in the form of books, palettes, and paintings) offer us insight into what colors were commonly found on past palettes. Many out-of-print books written by artists can now be easily found and downloaded from online sources. These books are worth exploring to see how artists solved problems. Lord Leighton among many others encouraged students to look toward the past as a precious heritage speeding our journey.

We should learn from the past but with caution. Artist and writer Thomas Bardwell noted in his 1756 text that we can speculate on how the great painters worked but, "how it really was time has put it out of our power to determine." Few masters left us detailed writings of their process. Verbal description of a nuanced process, without pictures is complicated (as anyone who has assembled furniture without diagrams can attest) with painting there are too many variables to recreate an exact palette from text alone. A humorous and insightful caveat by artist John Collier not to take, 'too literally the accounts that artist give of their own methods. They always imaging they set to work much more systematically than is really the case.'

So, in short, study as much as you can from people you admire, either past or present, yet realize much is open to interpretation and you will have to use your intelligence to piece things together and apply the information. There is no art without experimentation.

Let's consider some simple palettes to see what colors artists considered essential. Often you will see the same central colors on most palettes both historical and contemporary: white, yellow ocher, a vermillion red (it looks similar to our cadmium red), an earth red, brown and a blue (sometimes only a cool black) with artists adding color from there. Renoir noted "If the Greeks had left a treatise on painting, you may well believe that it would be identical to Cennini's. All painting, from that of Pompeii … to that of Corot, passing through Poussin, seems to have come from the same Palette." By focusing on a common combination of colors it becomes much easier to see how the palettes shift and expand from artist to artist. Many paints are still in use and by seeing what stays the same you can understand what is gained by adding more color and can better able to contextualize color choices.

The central colors for figure painting on the artist's palette have remained surprisingly constant. Compare the palettes shown in this section to see the remarkable uniformity that spans hundreds of years. You often find a white (lead), a black (such as ivory black—named because it was made by burning bones or ivory), a yellow ocher, a red ocher (brown-red), a red lake (like our alizarin), a brighter red like a vermilion, umbers, a bright blue like ultramarine, and a green earth. More colors are added or subtracted as needed. These palettes are limited and naturally harmonious.

It was common in the seventeenth and eighteenth centuries for painters to premix palettes, adjusting the color (hue) or the value and creating tints and shades. This "closed palette" approach offered artists a ready-to-use mixture of flesh tones that could be used for the shadows, mid-tones, and lights. This approach not only extended the range of a limited palette, but also quickened the execution of paintings. Formulaic combinations such as using ivory black and Indian red for the shadows, could be used by an artist at each sitting.

Gilbert Stuart, one of the greatest American portraitists (he did the famous painting of George Washington that appears on the one-dollar bill) used such a palette, creating clean admixtures with his palette knife. His premixed fleshtones could be laid on cleanly without overworking them. Thomas Sully, who briefly studied with Stuart, recorded his systematic mixtures on a sheet of paper (see page 136).

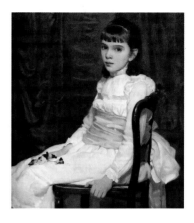

The Philadelphia artist Cecilia Beaux was influenced by the impressionist work of the time, which gradually became fused with her academic training.

Cecilia Beaux, *Seated Girl in a Long Black Dress*; verso: *Figure in Biblical Dress*, 1887, oil on canvas, 35 15/16 x 29 3/16 inches (91.4 x 74.1 cm). Acc. No.: 1950.17.5. Image courtesy of the Pennsylvania Academy of Fine Art (Philadelphia, PA). Gift of Henry Sandwith Drinker.

Cecilia Beaux's palette.

Image courtesy of PAFA.

This amusing painting by Emanuel G. Leutze is noteworthy for the tromp l'oeil palette smashed onto the front of the picture plane. The palette is traditional in its shape and shows us the range of colors used for his portrait. It looks similar to palettes used by many artists before him.

Emanuel G. Leutze, *Self-Portrait*, circa 1865, oil on canvas, 23⅞ x 23⅝ inches (73.3 x 60 cm). Acc. No.: 1928.8.1. Image courtesy of the Pennsylvania Academy of the Fine Arts (Philadelphia, PA). Gift of John Frederick Lewis.

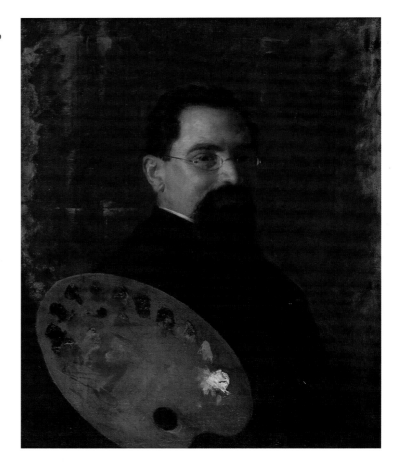

The figure painters of the early twentieth-century had more colors available to them than artists at any time previous. Yet the wonderful British figure painter Solomon J. Solomon recommended a palette that sounded familiar to those I described previously. He recommended flake white, Naples yellow, yellow ocher, light red, vermilion, rose madder, Indian red, raw umber, burnt umber, emerald oxide of chromium (like viridian), cobalt blue and ivory black as necessary for painting the figure and creating most color effects. Many artists who followed used essentially this same list with minor adjustments. Lawrence Alma-Tadema used this palette minus the umbers and adding burnt sienna, orange vermilion, and brown ocher. To study the ebb and flow of palettes through the ages, it helps to identify what has stayed the same, in order to appreciate the additions.

By the nineteenth century, artists often premixed colors specifically for each painting, based on a careful observation of nature or of ideas on color harmonies. Painters such as Delacroix, Whistler,

Seurat, and many others spent large blocks of time considering and preparing their palettes. By the twentieth-century, artists had a vastly expanded palette and elaborate new color theories to go with them. The challenge of negotiating more color choices than the artist could possibly use necessitated the development of a strategy to create harmony rather than chaos. That wasn't necessary when painters used a palette of half-a-dozen earth tones which worked together naturally (see chapter 4).

I have worked with both a premixed palette and an open palette, where I mix with a brush as I work. Regardless of what colors you use, it is helpful to use the same colors placed in the same location on the palette each time. That way your palette becomes like the keys of a piano that you learn to play instinctively over time and with practice. As a teacher, I continually see students engage in practices that hinder rather than help them. Using tiny amounts of paint on the palette, letting colors get dry and still trying to use them, scattering colors over the palette in no particular order, keeping the palette far away from the painting surface, these are all practices that will trip you up.

From the vantage point of today, it is good to appreciate the wide range of possibilities in oil paint. At the same time, you should avoid the temptation to explore every available path. Your progress will quicken with consistency: using one palette, and approach until you master it. Edward Poynter, an artist and influential teacher wrote in his *Lectures on Art*, "The method I prescribe . . . is no method of painting at all, but a method of study or education; it teaches no process; and I hope no one will imagine for a moment that there is any short road to painting." He advocated rigorously working from life. After learning to draw, painting from casts, and working from the life model, the student's eye would become trained in drawing, tone, and color. No shortcuts, no tricks. So with that in mind, when a student transitions from working in grisaille to using a full palette, I recommend creating the color layer in opaque paint.

Some artists work methodically, premixing their paints in advance and others mix with a brush from piles of paint straight from the tube. No matter the method, familiarity with your palette is only reached through practice. In *Conversations on Art Methods*, the nineteenth-century artist Thomas Couture left his students with advice that has a decidedly modern ring to it: "I leave you to your own inspiration when mixing your colors, experiment and make mistakes, but above all all, acquire habits of accuracy. I cannot say any more to you."

Here is a detail of a seventeenth century palette. To experiment with palettes of the past, visit naturalpigments.com to see recommendations for paints available now that come close to the original paints used in past palettes.

Stuarts Palette

yellow oker + white
Vermilion + white
yellow Oker Varmill + white
Vermilion + white
Cobalt blue + white
yellow oker + Vermilion
yellow oker + black
Vermilion
Vermilion + black
Burnt Umber
Lake
Black
These two last in painting are only used in finishing

Tho Sullys Palette. 1853

R Umber. + White
Cobalt + White
Burnt oker + white

These, with White & Black
are all the colours I use,
My Vehicle, is Magylup, made
of Mastic varnish 2 parts & Drying
oil, one part.

To Penna Academy of Fine Arts
from Charles Henry Hart
May 1856

THE LIMITED PALETTE

A limited figure-painting palette organized around the colors yellow, red, black, and white dates back to antiquity. In the first century AD Pliny the Elder noted in his book *Natural History* that the Greek painter Apelles, and others, used only four colors (including black and white) to create their immortal works: white, yellow, red-brown ocher, and black. Pliny wrote, "Now when purple finds its way on to the walls of rooms … There is no first-rate painting. Everything was better when resources were more limited. The reason for this change is because people nowadays value materials above genius." Regardless of the accuracy of Pliny's account (for none of Apelles' works survived), Pliny's comments were enough to ensure the four-color palette was used at various times throughout art history and on to today.

A limited palette requires exaggerated moments of color to create an effective illusion.

The attraction of an austere palette, at least for the painting of flesh and certainly underpaintings, remained ever since. William Hogarth in his eighteenth century book *The Analysis of Beauty* wrote, "There are but three original colors in painting besides black, white; red, yellow, and blue. Green, and purple, are compounded; the first of blue and yellow, the latter of red and blue." A visitor watched Sir Joshua Reynolds work on a portrait in 1754 and described his process of "Dead coloring," or the "Venetian method"—an underpainting specifically for flesh done with white, black, and red (in Reynolds' case, flake white, ivory black, and lake). The American painter Charles Willson Peale did a self-portrait in 1822 holding a palette of red, black, and yellow, and string of gradations between the three creating greens and oranges. Harold Speed recommended adding yellow ocher to your two-color palette of black and red thus: "With a red, a yellow, and a black a full realization of the color of most flesh can be obtained." The color range provided (and restricted) by this limited palette will be more clearly understood, after you complete the first color mixing project on page 190. Yet muted versions of the rainbow can be made from many triads and are still used for figure painting.

Artists of genius are not limited by the restriction of their materials, Pliny could have been referencing the brilliant Swedish artist

Anders Zorn, who combined solid draftsmanship with naturalism and fearless paint handling. Zorn's love of life is expressed through movement (his figures are seemingly caught mid-pose) and the fleeting effects of light. His work has a painterly quality that can only come from quick and direct paint handling.

Although there is no inherent virtue in using a limited palette many great figure painters did so, only adding colors to the palette as needed. In his self-portrait (above), Zorn holds a palette of yellow ocher, vermilion, black (functioning as a blue), and white, which he can mix freely with his brush. In this grouping of muted principle colors only red has a characteristic brightness. Zorn's portrait paintings reflect his palette, with just one strong color note. Zorn did not create his entire body of work using this palette; it's impossible to get strong greens, blues, and violets with such a restrictions, however, since some works are noted for their strong lighting effects, creating

iridescent greens and flickering violets that would require a stronger blue and yellow. Zorn shows what can be done when an artist has mastered a limited palette.

Many contemporary figurative painters use variations of the palette recommended by Pliny two thousand years ago, and which predates him by tens of thousands of years as evidenced by cave painting. Each time a bright color is added to the palette, the range is enlarged. If the only purple on the palette were an admixture between red and blue, the addition of a cobalt purple would greatly extend the palette. Likewise, replacing black with ultramarine or phthalo blue would enlarge the mixing range of the colors. However, an increased range doesn't always help. Sir Joshua Reynolds remained undecided well into his career whether he should use black or blue for his palette. He thought that perhaps any color cooler than a black for portrait painting was not necessarily an improvement.

The artist captures figures swinging in motion. The strong red notes are balanced by the green in the lower corner and the small spot of blue in the young woman's skirt and point to a slightly expanded palette.

Anders Zorn, *Midsummer Dance*, 1897, oil on canvas, 55⅛ x 38⁹⁄₁₆ inches (140 × 98 cm). Nationalmuseum (Stockholm, Sweden). Image courtesy of the Art Renewal Center® (artrenewal.org).

The palette to the left of black, cadmium red, yellow ocher, and white was used to make the color chart below. This color chart created by Michael Lynn Adams shows the three colors of red, yellow, and black mixed into numerous admixtures. It is remarkable how extensive a palette you can mix with so few colors. For more on how to create this color chart, visit his website at michaellynnadams.com/zorn-palette.

Adopting a Limited Palette

Jordan Sokol, *Tenold*, 2014, oil on panel, 14 x 14 inches (35.56 x 35.56 cm). Private collection.

Historically it was not uncommon for artists to premix their palettes into three categories: light, mid-tone, and dark. These three groupings correspond to the way light hits and reveals form (see the division of values along the step scale on page XXX). When using a small selection of color, it is a challenge to keep the color clean, as each drag of the brush can create muddy, unintentional admixtures. By premixing paint with a palette knife you keep the color consistent—ready to be painted directly on the piece.

When premixing colors, artists generally create a wider range of additional hues, such as a green, for their palette out of ivory black and yellow or a blue and yellow—or an orange out of yellow ocher and vermilion; or mixed shades and tints of colors. Few pure colors are light enough to use for the pale areas of a sitters complexion. Creating warm and cool admixtures such as a yellow ocher, burnt sienna, or vermilion plus white was convenient. Likewise, common admixtures or gradations for mid-tones and shades described by numerous artists including Ceninno Cennini who, in his *A Treatise on Painting* advises the use of three gradations of flesh color, each one lighter than the preceding, placed on the proper parts of the face.

In this demonstration, the artist Jordan Sokol, who trained at the Florence Academy of Art, and is now the director of its Jersey City, NJ branch, used a premixed palette that he created with three colors. The value string shows a simplified skin color that can be easily modified with the other paints on his palette.

SKETCHING THE DRAWING

Sokol used a brush to sketch in a uniform but thin wash of brown, an imprimatura (a thin wash of paint placed over the gesso). He then lightly toned down the shadow shapes. In this way Sokol locked in the proportion of his figure and the major divisions of his shadow shapes. By making the essential drawing decisions at this stage, he was able to shift all his attention to value shapes in the next stage.

Sketching the Drawing

Establishing Dark, Medium,
and Light Planes

Softening Forms and
Sharpening Edges

ESTABLISHING DARK, MEDIUM, AND LIGHT PLANES

Sokol massed in the background closest to the figure, establishing
its value context and linking the shadow shapes to the background.
This immediately embedded the figure into the atmosphere. He also
established the light, medium, and dark planes of the figure. This
allowed him to then focus primarily on temperature shifts—in this
case, a general ruddiness coming into the lower legs of the figure

Jordan Sokol, *Nude Study*, 2012,
oil on linen, 10 x 19½ inches (25.4 x
49.53 cm). Collection of the artist.

SOFTENING FORMS AND SHARPENING EDGES

Sokol transitioned the simplified planes of the body necessary
of the previous stage, transitioning them into softer forms with
carefully observed gradations. Next, he focused on more specifically
observing the values, which he initially had placed fairly broadly,
and more carefully modeling the form. Finally, he evaluated and
softened or accentuated the edges, bringing the figure painting into
a greater likeness and accuracy.

Extending the Palette

Thomas Eakins, active during the late nineteenth and early twentieth centuries, was a noteworthy American painter who studied in Paris with Jean-Léon Gérôme, among others, and brought his own version of academic teaching to the Pennsylvania Academy of the Fine Arts. He was a controversial figure in his lifetime, selling few of his works and losing his post at PAFA. Yet, ultimately, he was one of the most influential American painters and instructors of his day.

In *The Swimming Hole* (opposite), Eakins is seen swimming into the composition from the right toward students and friends, the family dog already having joined the activity. I like to imagine that the palette (opposite, bottom) was used for this painting because of all the high-spectrum yellows, which would be mixed with blue to make the green of the landscape. Many artists don't add a green to the palette because greens are easy to mix and most tubes

Susan Macdowell Eakins, *Portrait of Thomas Eakins*, circa 1920–1925 (circa), oil on canvas, 50 x 40 inches (127 × 101.6 cm). Philadelphia Museum of Art (Philadelphia, PA). Image courtesy of the Art Renewal Center® (artrenewal.org).

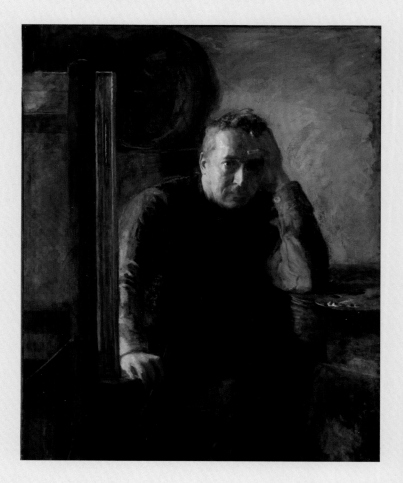

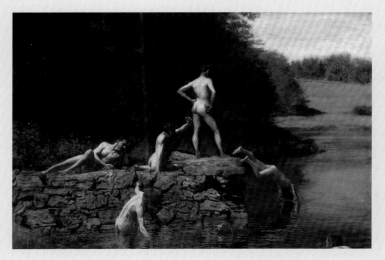

Eakins's brilliant greens are dragged on top of a brown "sauce" commonly used in the French academic tradition. This iconic Pennsylvania image shows Eakins and his companions swimming nude in Mill Creek Lake. Showing the male nude was rare in Eakins's day and continues to be controversial even today. Eakins completed several sketches on location and finished the final painting in his studio.

Thomas Eakins, *The Swimming Hole*, 1885, oil on canvas, 27⅜ x 36⅜ inches (70 × 92 cm). Amon Carter Museum of American Art (Fort Worth, TX). Image courtesy of the Art Renewal Center® (artrenewal.org).

are of admixtures, not single pigments. Some artists keep their white in the center of the palette instead of the more traditional placement near the thumbhole of the palette.

Compare the palette in the portrait of Eakins by his wife Susan Macdowell Eakins, a former student and painter, to the photograph of his palette shown below. Its limited range of white, yellow ocher, and cadmium red more closely matches a portrait palette. The brown of the wooden palette formed a nice match for the ground color of the paintings, enabling the artists to be able to better judge their colors. Conservators analyzing Eakins's paints identified such colors as lead white, vermilion, red, yellow, and earth browns, chrome yellow, ultramarine blue, and viridian—keeping his color choices very close to others we have looked at. It was common for artists to have several palettes, such as one for figure and one for landscape.

This palette looks more geared to landscape painting, as in *The Swimming Hole* (above) because of all of the highly chromatic yellows. It is not uncommon for painters to change their palettes, depending on what they're painting.

Photograph courtesy of the Pennsylvania Academy of Fine Art.

Adopting an Extended Palette

Many figurative artists use an expanded palette, building around the same triad of colors that Pliny mentioned so long ago. Some artists choose to mix color strings with a palette knife to save time and gain unity with their admixtures. Others use an open palette directly, bringing tiny touches of various colors into every brushstroke. The palette you choose will become like a friend over time.

Generally, artists aim for believable color and rhythms over a perfect color match. Each area of color can appear different in various contexts.

In my studio program we begin by painting from a white object, where the options are more contained between two colors, and move to using full color. The challenges become exponentially more complex because of the variations in transparency, the vividness of color, and the necessity of mixing between the paints.

In this piece by Tenaya Sims, you can see how he goes from a drawing to a finished painting in three stages. Sims, the director of the Georgetown Atelier, studied at the Aristides Atelier.

Drawing the Figure

DRAWING THE FIGURE

Sims thoughtfully composed and drew his figure. Executing the drawing on a separate sheet of paper allowed him to develop proportional accuracy without damaging the painting ground. Sims devoted all of his energy to proportion without multitasking color and paint handling at the same time. He then transferred the final drawing onto his canvas, tracing it with ink to secure it to the surface.

Establishing a Tonal Range

ESTABLISHING THE TONAL RANGE

Sims established the tonal range, placing a mid-tone umber wash over the drawing, which created a unified surface upon which he could work. Notice how much lighter this tone is than the values found in the final piece. This is important to keep the luminosity of the work.

Sims also heightened the lights by adding white into the lightest areas. In addition to helping to extend the wipeout time and achieve a light-enough range, this also gave him a jumpstart on building the thickness of paint in the lights. This stage can be thought of as a tonal pattern because the subject is subordinated into larger, simplified shapes. Turn to page 43 to see how to create a wipeout.

EMPLOYING A FULL-COLOR OVERPAINTING

During the final paint layers, Sims worked directly on individual areas, bringing each to a finish with full-color overpainting. During this stage he worked with an open palette, directly mixing with a brush (compared to the premixed color string palette). He positioned the shadows of the figure, taking care to connect them into the background, and then applied them thinly, thus allowing subtle warmth from the underpainting tone to show through. Notice how the drapery, so accurately placed in the drawing, now gets subordinated to the larger piece. Sims worked a number of color notes (such cadmium red, which appears in the bridge of the nose, ear, and fingers of the figure) into his painting.

BELOW Tenaya Sims, *Alchemist*, 2012, oil on panel, 24 x 24 inches (60.96 x 60.96 cm). Collection of the artist.

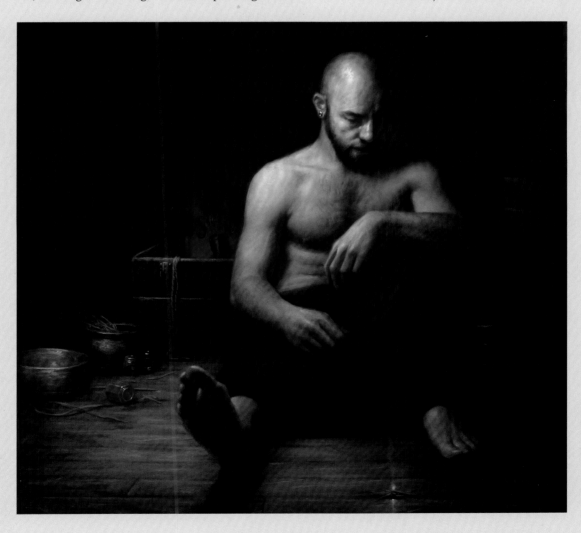

Employing a Full-Color Overpainting

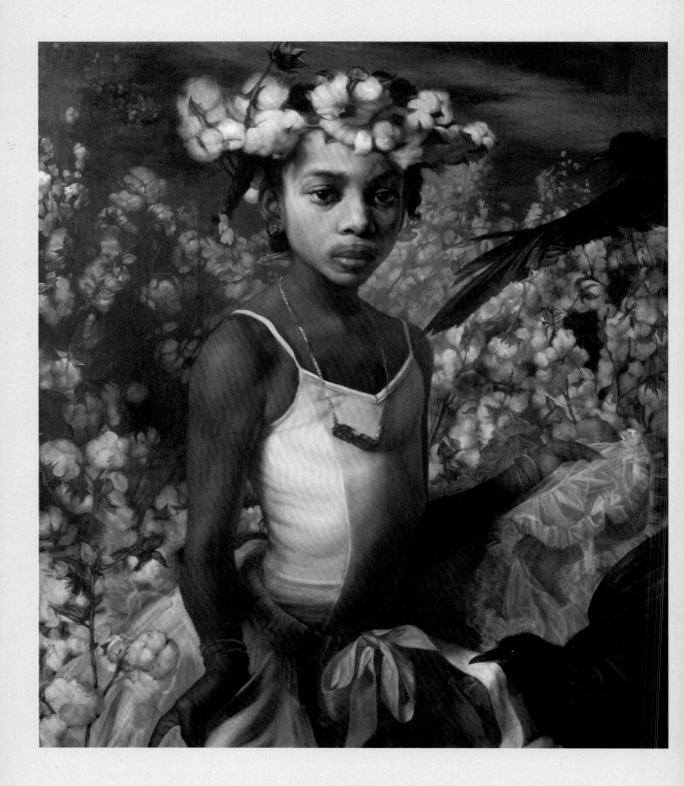

LIMITED PALETTE PORTRAIT PAINTING

The human form is one of the most challenging and rewarding subjects to paint. The preparatory work described in the previous Lessons should provide you with the foundational skills needed for working with a life model. Although the essential principles of painting are the same, whether your subject is a pear or a person, there is an added complexity at play when working from life. This is due mostly to the subtlety of drawing, the viewers' familiarity with the subject, and the time constraints imposed when the artist works from life. Regardless of these challenges, artists often find working from life to be the most rewarding and enjoyable experience. If you are not in a position to hire a model, try bribing a family member or working on a self-portrait.

OPPOSITE Margaret Bowland, *And the Cotton is High*, year unknown, oil on linen, 82 x 70 inches (208 x 178 cm).

EXECUTING YOUR PORTRAIT PAINTING

The human form is a continuously curved surface with shifts of color that vary from area to area (such as the movement from the ruddiness of a hand to a pale wrist). The earth-color palette is sufficient for capturing the effect of human skin as it's hit by natural light. At first, the subtlety of coloring in the figure may be hard to identify; however, if you work in stages, focusing on drawing, value, and temperature, you will find yourself on solid ground.

MATERIALS

Canvas A pre-primed painting panel

Brushes A range of varieties (including filberts) and sizes including a 2, 6, and 8

Palette glass or wooden

Paints titanium or flake white, raw umber (for underpainting), Naples yellow, yellow ocher, cadmium red medium, burnt umber, burnt sienna, permanent alizarin crimson, ultramarine blue, ivory black

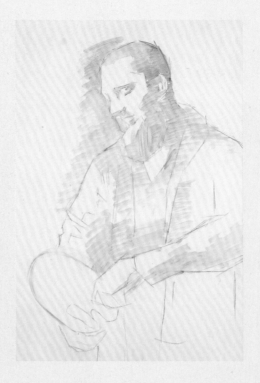

STAGE ONE:
Setting Up

For this painting, a window provided illumination on my model from the left and the white panel on the easel from the right. You can use natural light or an artificial light source. I prefer simple, direct light. In this photograph, you can see how the shadows group together to form big shapes. To start this painting, I stood far enough away so I could see my canvas and the model at the same time. I prefer to stand because doing so allows me to check the larger accuracy of my painting. It is a good idea to do a quick color poster study to practice using your palette (see Stage 1 on page 171).

STAGE TWO:
Creating the Drawing

I drew directly on the panel, using a filbert brush and raw umber diluted with odorless mineral spirits. You could create a more systematic underpainting method by following the example on page 41. Above, you can see an early stage of the underpainting, where both the lines and the beginning of the tonal masses are visible.

Using straight lines, sketch the broadest lines of your subject. Having detailed information before capturing the general likeness will work against you. Treat your core shadows as if they are as significant as anatomy. These shadows will help you achieve a likeness. After all the major shapes are placed, group your lines into shapes by massing in your shadows with a wash of paint. Flick your eyes quickly between your drawing and the model to fine-tune.

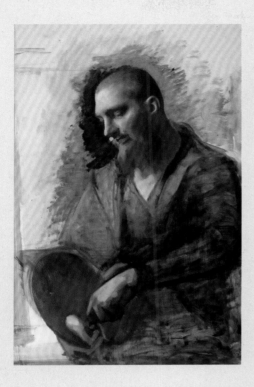

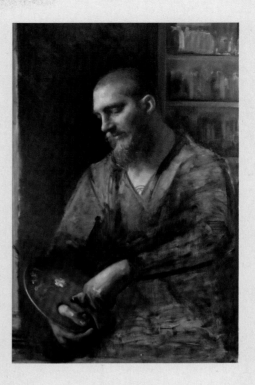

STAGE THREE:
Massing in the Color

Start painting in the shadows, essentially embedding the color layer into the underpainting by matching its values. By focusing on value accuracy and noting the temperature shifts, you will find it becomes easy to connect the color layer to the underpainting. Generally, when starting a painting like this one, I don't start at a critical area—like the eyes. Instead, I start at the back of the head or at the neck to give myself time to warm up. I prefer to work on multiple areas at once, so that each area is considered in relation to the others. Here, I painted the head into the neck and the light side of the face into the background. Doing so allowed for subtle edge work while the paint was still wet. Using a full palette, work on one area at a time, moving from darks to mid-tones to lights as you complete your first color pass.

STAGE FOUR:
Setting the Scene

Adding backgrounds can be difficult for new painters. I encourage you to either paint what you see or reference masterworks to find examples of the successful treatment of atmosphere. The spotting of tone in the background moves the viewer's eye through the picture.

Once your background is placed, move to the foreground of the picture. For this stage, it is necessary to slow down and bring one part of the picture to completion at a time. By appreciating the small shapes of the model and the specific characteristics of his or her form, you can discover a world of information and beauty hidden when you only consider big shapes.

Juliette Aristides, *The Painter*, 2016, oil on panel, 36 x 24 inches (91.44 x 60.96 cm).

STAGE FIVE:
Finishing the Painting

Finishing is an art in itself. You'll find that your painting often changes and becomes tighter through lots of relatively minor adjustments. Add whatever final touches are required, like the background details, the drapery, or hair. You may decide to bring some parts of the painting to a highly finished state, applying several passes of paint, while leaving others less resolved. Some parts of your painting will most likely need another coat of paint to ensure forms transition more smoothly, or to darken or lighten a portion of the work. Now is a good time to consider if your edges accurately reflect what you see. Scan your eye across the work. If something jumps out at you, take time to resolve. Achieving balance here will help to guide the viewer's eye through the picture.

Juliette Aristides, *Wildfire*, 2012, oil on panel, 24 x 18 inches (60.96 x 45.72 cm). Private collection.

LESSON 7

A New Variety
Try One

S. S. David

158 Lessons in Classical Painting

MASTERING TROMPE L'OEIL

One fascinating category of still life painting is trompe l'oeil, which is French for "trick the eye." The artist creates a painting that appears lifelike—fooling the viewer into thinking that it is the object itself. Within trompe l'oeil, there is a wide range of subjects to tackle. Painters have created room-sized pieces, such as painted ceilings that allow the viewer to see the sky opening to heaven, sculptural elements on open doors, or architecture elements. In the ancient cultures of Greece and Rome, artists delighted in tricking their viewers with illusory flies, curtains, gardens, and even food tossed onto the floor.

The key to a successful trompe l'oeil painting lies in sheer technical skill. Careful attention to detail, believable placement of shadows, and, often, a working knowledge of perspective, all allow you to convincingly portray your subject. To set up your trompe l'oeil still life, aim for a shallow depth of space. In other words, part of the image should be touching the picture plane. Carefully arrange the lighting so you have a range of shadows, some of which are sharply in focus and others which are softly defused. Because there is such a small depth of field, there is no background, behind the object is a wall—or some other backdrop.

Jennifer Baker, *Bindezauber (für meine Großmutter und Urgroßmutter)*, 2013, oil on panel, 13 x 11 inches (33.02 x 27.94 cm). Collection of the artist.

OPPOSITE De Scott Evans, *A New Variety, Try One*, circa 1887–90, oil on canvas, 12 x 10 inches (30.48 x 25.4 cm). Pennsylvania Academy of the Fine Arts (Philadelphia, PA).

MATERIALS

Charcoal paper

Drawing materials vine charcoal, kneaded eraser

Canvas oil-primed linen, stretched

Copy of the original drawing

Paints flake white, titanium white, cadmium orange medium, cadmium red medium, cadmium green, Naples yellow, yellow ocher, English red, raw umber, burnt umber, ultramarine blue, Prussian blue, alizarin crimson, ivory black

Palette

Brushes such as filberts in a range of sizes including ⅛ and ½ and hog's hair bristle for the wipeout

Odorless mineral spirits

Linseed oil

Rag

STAGE ONE:
Finalizing the Composition

John Zadrozny created his drawing with charcoal on paper. He focused on the groupings of his objects, getting them to relate to one another between the shelves. He concentrated solely on placement, proportion, and orientation, not small details like the individual rose hips or the wrinkles in the paper bag. He then transferred his drawing to the canvas, using graphite paper and tracing the drawing on the panel in brown ink with a pen. Creating a drawing ahead of time is often a good idea because it means that you do not have to struggle to find your placement and composition while finishing the painting.

STAGE TWO:
Applying the Wipeout

Zadrozny created his underpainting over the course of several sittings because the arrangement was too detailed to cover in a single pass. Placing a unified layer of raw umber, he then organized the lights and shadows by pulling out the lights. Zadrozny used a mid-tone umber, wiped down to a light brown (using no paint medium or turpentine), and employed cotton rags to pull out the lights. John wanted to place all the individual objects into a larger context, the shelves, creating an effective pattern with his values. This also gave him a chance to work with lost and found edges. Pushing some of the spices into shadows while heightening the contrast in others.

STAGE THREE:
Completing the Underpainting

STAGE FOUR:
Introducing Color

Zadrozny finished each shelf, pulling out the light side of the objects and brightening the effect by adding white. This paint layer gave opacity and bulk to the objects and the surface of the panel. He placed spectral lights and reflections that give the feeling of metallic surfaces. Next, he added more umber, painting the shadows opaquely and giving a stronger local tone to the dark objects.

Zadrozny painted each shelf in color. His approach was methodical, and slowing down allowed him to fully appreciate each object. He could relax, focusing on turning form in paint and exploring the shifting color, because he had already locked in the drawing and the value. He had also taken care of the global considerations, so at this stage he could make the small decisions without losing focus.

STAGE 5:
Bringing Color to Life

Zadrozny went back after seeing the whole image at a glance and adjusted as needed. He brightened the whites and darkened the shadows. He unified areas that appeared fragmented, softening edges, such as in the white card toward the left, and sharpening the high contrast area on the right. He also bumped up the chroma of certain objects such as the peppers and adjusted the temperature of the wood, making it cooler.

ABOVE John Zadrozny, *The Spice Must Flow*, 2014, oil on linen, 21 x 15 inches (53.34 x 38.1 cm). Private collecgtion.

OPPOSITE Zoey Frank, *White Dress*, 2013, oil on panel, 39 x 22 inches (99.06 x 55.88 cm). Private collection.

To paint the existent is an act of resistance inspiring hope.

—*John Berger* (*from* The Shape of a Pocket)

The Importance of Making Master Copies

Sundberg found the experience of working from the original painting invaluable. He noticed things that could only be fully appreciated in person such as the scale and the differences in surface (some areas unfinished compared with others fully realized). Above, you can see him working in the Prado in Madrid. His study is shown at bottom right.

Tenold Sundberg, *Apollo in the Forge of Vulcan (after Velázquez)*, 2014, linen on panel, 16 x 20 inches (40.64 x 50.8 cm). Collection of the artist.

We have few family pictures of my parents and grandparents, so it was exciting to discover a rare video of my relatives. The crackly black-and-white film turned out, however, out to be only a twenty-second panorama of my relations at a barbeque. It was the only film I ever saw of my mother when she was young. Nonetheless, I got a jolt when I saw her for a second in the video; it was uncanny how her tiny unconscious mannerisms were just like mine. How she managed to copy me before I was born is mysterious.

Emulating others is a form of learning that happens both innocently and deliberately throughout our lives. We watch, learn, and imitate. Great athletes pore over the position and movements of their rivals, orators study great speeches, chess enthusiasts memorize groundbreaking games, and musicians study brilliant performances. We all have our heroes. Looking at the work of others, whether in adulation or competition, pushes us to become more than we are. We embody, through osmosis and proximity, some of their attributes.

The goal of intensely studying the work of others is not to become them; rather, it's to become an improved version of ourselves. While the term *master copy* can feel musty, like a return to a bygone era of guilds and apprenticeships, it simply means emulating an expert. That is something we all do, no matter what field we are in. It's simply a matter of keeping good company.

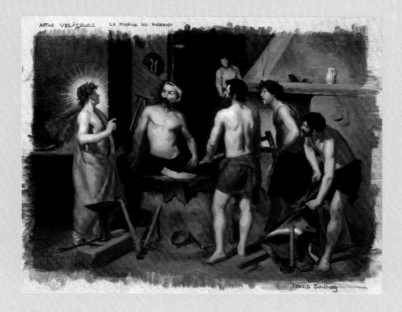

This painting, done by Walker Hall as a student in the atelier program, gave the artist an opportunity to practice studying how a master handled painting flesh tones.

Walker Hall, *Patroclus (after J.L. David)*, 2009, oil on linen, 18 x 24 inches (45.72 x 60.96 cm). Private collection.

BELOW Here students from my atelier are shown painting from the permanent collection at the Frye Art Museum in Seattle, Washington.

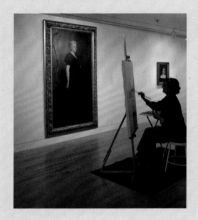

When copying, whether you spend one day or many weeks immersing yourself in a single painting, you will develop a unique relationship with the art. R.A.M. Stevenson, cousin of Robert Louis Stevenson, wrote that when you spend a stretch of time in the presence of a painting, it speaks to you. "A picture," he wrote, "is . . . one of those quiet figures . . . who sit and smoke opposite you, till you seem to exchange thoughts with them by something like mental transference." We absorb a world of ideas and they add to our experience. We study the piece until we own it.

Historically, artistic training was centered around learning by emulation—apprenticing in the master's studio, working on the master's painting, or copying great art. Edgar Degas, along with countless others, suggested this practice as a sound source of training. "The masters," he recommended, "must be copied over and over again and it is only after proving yourself a good copyist that you should reasonably be permitted to draw a radish from nature." The atelier curriculum incorporates the practice of copying masterworks as a way to continue this teaching method. My atelier continues this tradition by copying various pieces in the collection at the Frye Art Museum in Seattle. An important note: Artists never sign copies as original; it is customary to put the original artist's name after the person copying (e.g. Halsell after Corrodi).

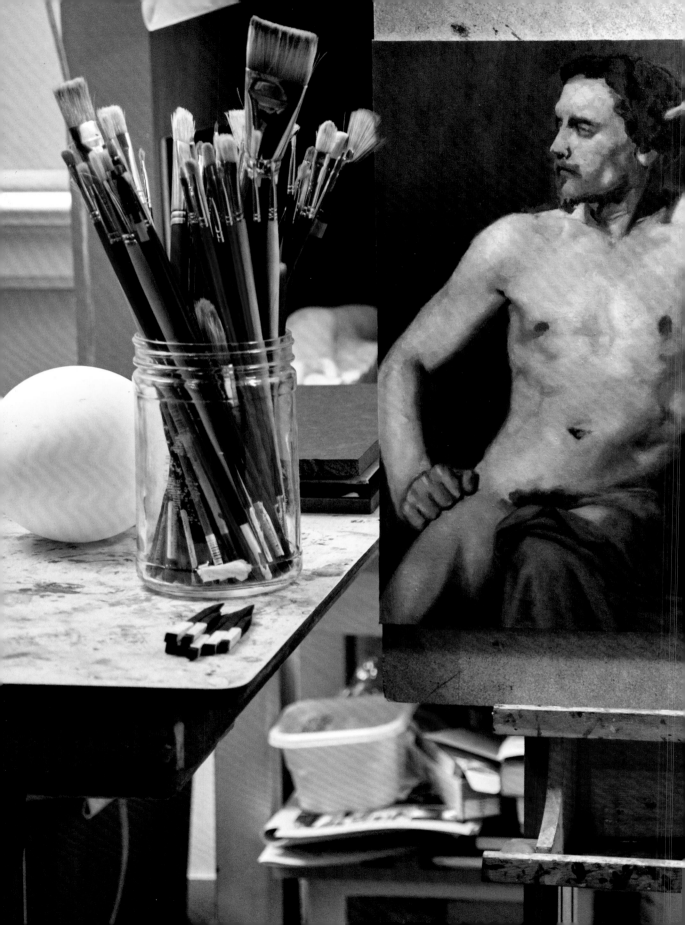

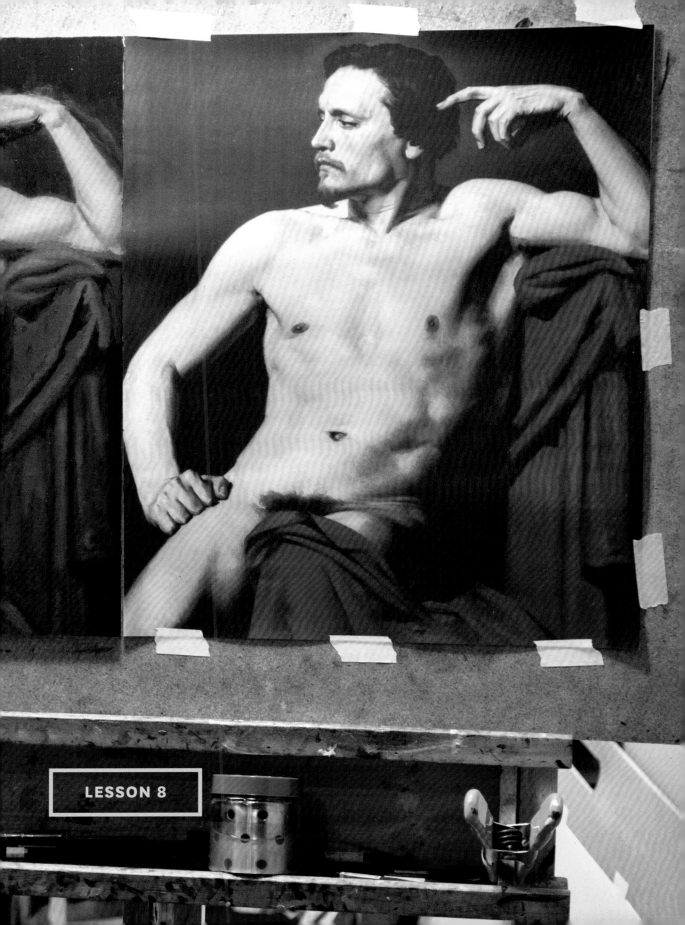

LESSON 8

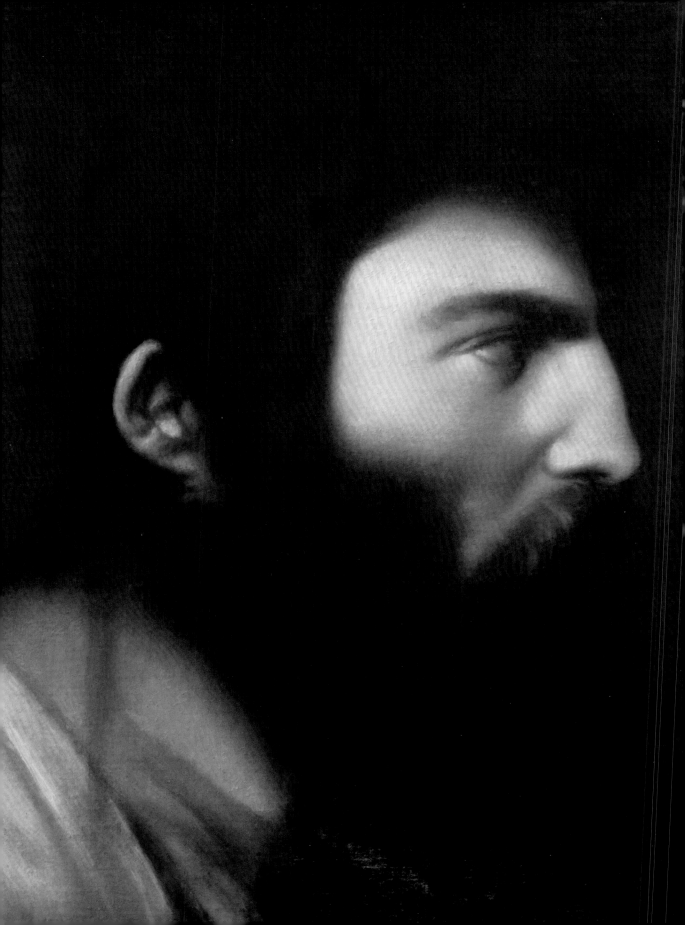

MASTER COPY

Studying a finished painting will allow you to learn from your favorite artists. Find a painting that you love, or one that you feel has strengths that you would like to internalize. Your goal should be to expand what you think is possible in your own work by a process of emulation.

SELECTING YOUR IMAGE

Most of us create master copies from reproductions because they are accessible, but working from an original is better if you get the chance. No photograph or reproduction can capture the presence of a physical painting. Standing in front of an original painting you get the scale of the piece along with the surface texture and the true color of the paints. In person, you also discover that what appear to be minute details in a scaled-down reproduction are, in fact, broad strokes, carefully placed, that evoke value, form, and color. When a work is viewed in person, it becomes obvious that the texture of canvas peeks through thinly painted areas, creating a glowing layered effect. Often that can be misinterpreted in reproductions as solid paint. There is simply no reproduction that can capture the subtlety and beauty of a physical work of art. Those who wish to master their craft must experience artworks firsthand to understand the vast amounts of knowledge required to breathe life into a painting. That being said, working from a reproduction is infinitely better than not studying masterworks at all, and there is much to learn from paintings at any size and in any form. Most of us only have the opportunity to work from reproductions, yet it is important to know why the originals still matter.

OPPOSITE Brett Downey, *Portrait of a Bearded Man (after Ingres)*, 2010, oil on linen, 13½ x 10¼ (34.29 x 26 cm). Collection of the artist.

MATERIALS

Panel or canvas

Brushes In a variety of sizes, such as 2, 6, and 8

Palette Handheld or tabletop

Paints Many artists have a favorite palette already. You can use this basic list or add your own colors according to your preference.

Lead white or titanium, Naples yellow, yellow ocher, Venetian red or English red, alizarin crimson, burnt umber, raw umber, ultramarine blue, ivory black

Cloth or paper towels

Odorless mineral spirits

Linseed oil

Palette knife

Underpainting

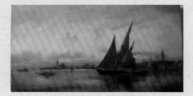

First Color Pass

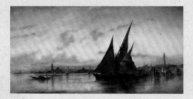

Patricia Halsell, *Venice, After Corrodi,* 2014, oil on linen on panel, 16 x 36 inches (40.64 x 91.44 cm). Frye Art Museum (Seattle, WA). Private collection.

Painting is a subject that is best learned through experience. In the midst of painting, you will find yourself making different choices to match a masterwork than you would if painting on your own. You encounter the unexpected as you learn through a silent guide—the artist who created the work. Exposure to masterworks also cultivates your taste. With this in mind, it is important to choose carefully whose work you emulate. You have the whole world of art at your disposal, so choose high-quality paintings that have withstood the test of time.

DEFINING YOUR GOALS

If you are studying value distribution, you might choose to do a small poster study, such as I did on page 34. Or if you are exploring color, edges, and finished areas of form, perhaps you will do a finished version, such as Patricia Halsell's painting of Venice at left. You choose the degree of finish you want in your master copy; it can be a quick gestural study or a meticulous replica. The purpose of the project is to have a learning experience, not to create a finished piece. No matter how refined your skills are, your master copy will never be an exact copy of the original because it is impossible to completely reverse-engineer a finished painting. Keep in mind that your work will be inspired by the original, not a slave to it.

GETTING STARTED

You may be fortunate to live in an area with a museum that allows you to work from an original painting; if not, work from a good reproduction. Start by collecting a dozen of your favorite images, looking at paintings online (at institutions such as artrenewal.org or at museums' websites), and in books. Keep in mind copyright issues; if you choose any contemporary work (or if the artist has been dead fewer than seventy-five years), you may need to get permission to reproduce the images. From this portfolio, pull out a few that most speak to you and print them the same size (if possible) as your painting. For this example, David Dwyer was really attracted by the strong chiaroscuro (light-dark) in the portrait *The Young Musician*, as well as its charm and simplicity.

SETTING UP

Transfer the drawing from the reproduction to your panel or, for a looser interpretation, you can sketch freely from the original. Place your reproduction and your painting panel next to one another, lighting both from the same light source.

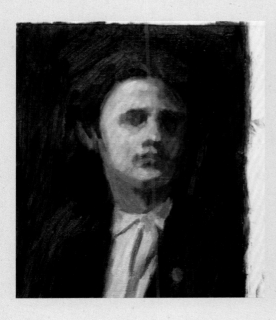

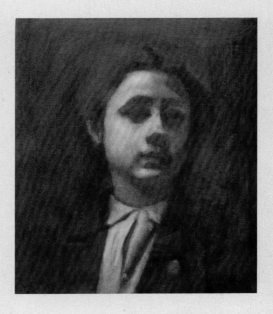

STAGE ONE:
Creating a Poster Study

STAGE TWO:
Applying the Wipeout

Create a poster study to determine your palette and plan your painting. (For more on poster studies, see page 34.) Dwyer did a small color poster study of the painting as a first step in approaching color mixing for the flesh palette, and to explore which blue pigment might work best for the coat. Dwyer used a palette with premixed color lines (see page 169) to do this work. He augmented the palette with alizarin crimson and ultramarine blue.

Keep in mind that poster studies like this one are generally only a few inches tall, but should not be treated like miniature paintings. They are simplified planes of color that provide a rough trial-run for a final work. If possible, you should finish a poster study in one sitting.

Dwyer chose to copy *The Young Musician* (1889) by William Sartain from the collection of the Pennsylvania Academy of the Fine Arts.

Transfer your drawing onto your canvas and create a wipe out underpainting (see page 35). Sartain's painting is low in chroma making it a good choice for a tonal underpainting. Dwyer used raw umber for his ground, making sure to leave the tone of the canvas very light on the lit areas of the face. Doing so locks-in the overall structure of the painting. After the underpainting dries, you will be ready to work on individual areas and bring them to a finish without worrying about any loss of context.

If the painting you have selected is brightly-colored, it is a good idea to use a color underpainting rather than a tonal one. See the opposite page for an example of a brighter (burnt sienna) underpainting or look at the floral Lesson on page 214 for examples of alternate approaches to the underpainting.

STAGE THREE:
Articulating Dark, Medium, and
Light Passages

STAGE FOUR:
Establishing Lost and Found Edges

After your underpainting is dry, apply color to your piece, devoting all your attention to bringing one area to a finish at a time. The limited earth-color palette Dwyer used centered on a yellow, a red, and black (which functions as a low-chroma blue). (You can see a picture of this palette on page 169.) He prepared the colors into shades and tints, creating a closed palette (one where premixing is done in advance). He used white, Naples yellow, yellow ocher, and raw umber to form the main components of his yellow line. He also used English red, burnt umber and alizarin to form the bulk of his red line. He mixed black with a little raw umber for his neutral line. When mixing with his brush, Dwyer simply mixed between like values. You can use whatever palette you are comfortable with and whatever colors are appropriate for your master copy.

Dwyer started his color layer by massing the shadows of the face into the background. It's a good idea to start painting in the shadow areas first, as the dark tone is easier to match without new color jumping out of harmony with the rest of the piece. Next, he blocked-in the mid-tone and the light planes of the face. Once he defined the major passages of the face, Dwyer massed in the bright white of the shirt and placed the jacket. Notice how carefully he considered lost and found edges from the crisp delineation of the shirt to the entirely lost edge of the jacket into the background. (For more on edges, see pages 80–81.)

At this stage, you want to avoid building up ridges of paint along the edges like between the head and the background in this example. Doing so can be distracting and make it hard to correct later. For this reason, artists like to paint large areas such as the background in one sitting, to avoid a piecemeal look when their paintings dry.

STAGE FIVE:

Finalizing the Image

Apply the finishing touches. Dwyer completed the background and did nuanced touches to finish the work. Dwyer was curious when he started about how well a limited palette would work. He found the mixture of raw umber and ivory black used for the "neutral" string satisfactorily cool when included in this flesh palette, and appear "blue" when placed next to the comparatively warmer reds and yellows.

David Dwyer, *After William Sartain*, 2014, oil on linen, 16 x 45 inches (40.64 x 114.3 cm). Private collection.

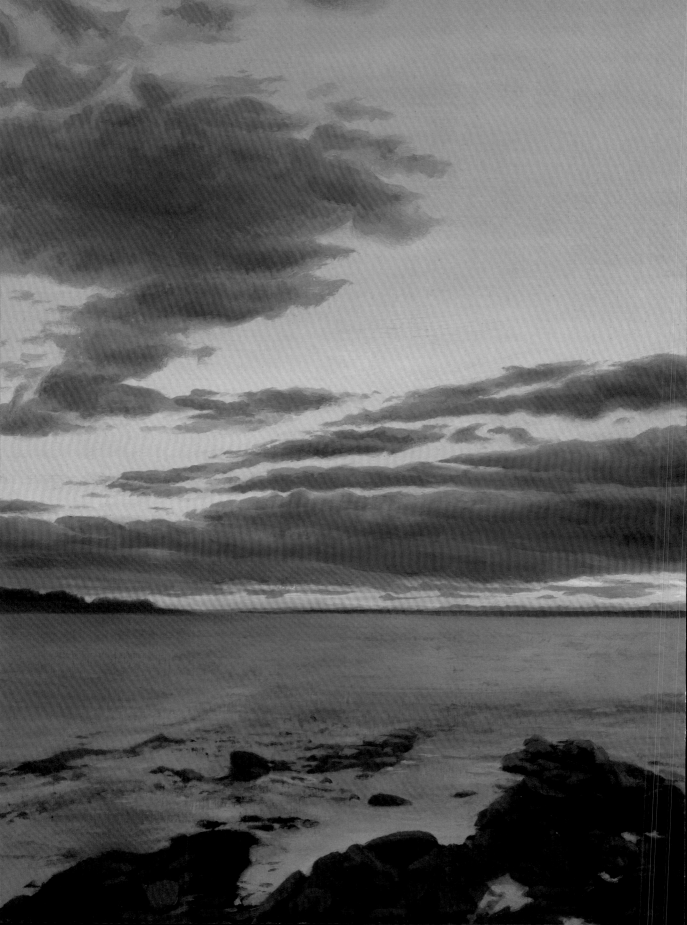

CHAPTER 4
COLOR
the palette of nature

When I get to heaven I mean to spend a considerable portion of my first million years in painting, and so get to the bottom of the subject. But then I shall require a still gayer palette than I get here below. I expect orange and vermilion will be the darkest, dullest colors upon it, and beyond them there will be a whole range of wonderful new colors which will delight the celestial eye.

—*Winston Churchill (from* Painting as a Pastime*)*

Light provides us with fleeting color effects that alter with each passing hour and each shifting cloud. Part of the joy of being alive is experiencing the variety and extravagance of a world in color—a good unto itself. In *The Enjoyment and Use of Color* by Walter Sargent, Helen Keller describes how, even without sight, color enlarged her life: "I understand how scarlet can differ from crimson because I know that the smell of an orange is not the smell of a grapefruit. . . . Without the color or its equivalent, life to me would be dark, barren, a vast blackness." Effects of light are inherently beautiful and we process them as naturally as breathing; yet we can experience color more deeply, enlarging our perception, through study.

Any beginning painter wielding a brush has encountered the gap between a stirring subject and the muddy picture that can ultimately follow. Once painting starts, the thoughts of the artist quickly shift from inspired to practical. How to accurately identify color and mix among the infinite number of color permutations becomes a real concern. Studying basic color-mixing concepts and discussing how to choose a color palette can shine a light into a shadowy understanding. I have found that it is possible to know lots of theory and still be unable to paint well, so my focus in this chapter will be to guide you through a number of short color mixing exercises.

Most of us learn to cook by watching people cook, not by going to culinary school. We eat meals, become familiar with ingredients, and try recipes of the dishes we enjoy. Eventually, with practice, the recipes disappear and we are able to improvise. This is the best way to approach color—exposure, copying masterworks, and practice, in time, leads to improvisation. In this chapter, you will explore color

OPPOSITE Joshua Langstaff, *Dusk at Kettle Cove (detail)*, 2011, oil on panel, 12 x 16 inches (30.48 x 40.64 cm). Private collection.

ABOVE The colors of the rainbow are laid out in a circle of even gradations.

That light is color, and not an inherent attribute of an object, is something we know intellectually, but not emotionally. We know the earth revolves around the sun, but from our personal experience it feels like the opposite. Likewise, we see an apple as red, when, in reality, it's the light reflected by an object that determines its color.

RIGHT Dan Thompson captures shimmering effects of bouncing light by using broken color, a technique in which many hues are used in quick succession, a contribution of the Impressionists.

Dan Thompson, *Persian Archer*, 2004, oil on canvas, 28 x 18 inches (71.12 x 45.72 cm). Private collection.

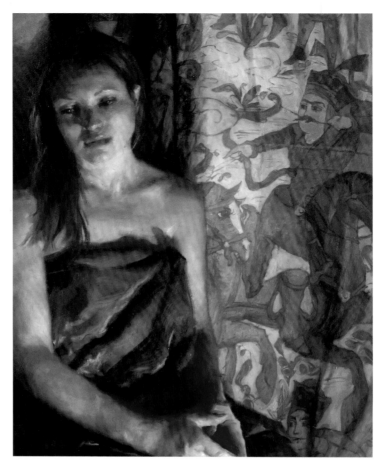

through exercises that gradually increase in complexity, enabling you to gain confidence with your palette. You can then practice some specific painting assignments—always linking theory with practice, your head with your hands.

In art, color sense is a matter of taste, not truth. We study naturalistic effects and strive for optical truth. However, a painting is a composition, not a series of scientifically observed color notations. The goal of art is to communicate thought and emotion, not to re-create a photograph.

Painting is an opinion of the artist about the world in which he or she lives. Churchill loved the raw emotion of color and had an almost physical aversion to the intellectualism of value: "I cannot pretend to feel impartial about colors. I rejoice with the brilliant ones, and am genuinely sorry for the poor browns." By contrast, Tonalists, such as Eugène Carrière (see pages 26 and 40), savored the limited range; his entire body of work appears to be created using an earth brown.

Before the wide range of highly saturated colors was invented in the nineteenth century, painters had limited access to the full palette. Fewer colors were available, and many beautiful pigments were too expensive for regular use. Most of the colors we use today had not even been discovered or created. Not surprisingly, most paintings emphasized line and value, using earth pigments. The art of the past was an expression of freedom within limits; the mastery achieved in both color and expression within such narrow constraints was, in many ways, unsurpassed.

Contemporary painters, however, face unique challenges. With access to an exponentially increased range of colors and a limited availability of technical training, we may have more hues, but we often don't know what to do with them. Oil paints available at art stores are displayed in such overwhelming variety that buying something as apparently straightforward as white or black can be baffling because of the differences in brands, opacity, pigments, and binders.

Even more challenging than choosing between colors such as cobalt or cerulean, which are very different, is choosing among more subtly varied colors, like Naples yellow, Naples deep, Naples hue, and Naples light. How do we know which paints are best and essential and which are redundant on our palettes? Even artists don't agree, as each person has his or her own favorite palette colors. My philosophy about the best way to get a handle on materials is to get back to the basics, paring things down to essentials, and expanding out as needed. With that in mind, I'll begin with the components of color.

ABOVE Notice the contrasts in this painting: the golden warmth of the setting sun opposing the cold palette of blues and violets. There is a tiny moment of red/orange by the subject's elbow—a complement to the blue. There are multiple light sources in this picture. The figure is backlit, yet is also hit by the light coming from above and from the finger. The repetition of the circle motif keeps the viewer focused on the head.

Stephen Bauman, *When I Was Young*, 2014, oil on canvas, dimensions unknown. Private collection.

LEFT The simplified shapes of the black hat and shirt create a graphic contrast with the background. The light from the side creates a core shadow down the center of the nose. The only strong color note is the red of the lips. This painting gives the illusion of color, even though the artist actually uses very little.

Antonio Mancini, *Prevetariello*, 1870, oil on canvas, 26 x 20⅞ inches (66 x 53 cm). Musei di Stato di San Marco (Naples, Italy). Image courtesy of the Art Renewal Center® (artrenewal.org).

Making Sense of Paint Names

Paint producers and designers make succinct names to label colors based on their pigments, origin, processing method (raw or burnt), or whim. To know for sure what pigment you are buying, look past the manufacturer's name and examine the color index name and pigment code shown on the tube, which divides all pigments into ten simple categories: PG (pigment green), PBk (pigment black), PB (pigment blue), and so on. Each pigment is additionally given a number. Take for example PR102: PR means the pigment is red and 102 is the number for natural red iron oxide. There are complete listings online to reference.

There are dozens of different names of paints. If one instructor asks for English red, sinopia, and another red umber, you can compare the color index numbers on the paint tubes to see if the same pigments are used. In this case, all of these colors would have the same pigment index number. Remember, it is best to choose paints that are comprised a single pigment, rather than multiple pigments, as you will do in the color mixing examples ahead. Likewise, for this book you won't use hue versions, which are combinations of pigments created to replace more expensive or paints (or ones that are no longer available).

OPPOSITE Look closely at each area of the figure and notice how much color Dan Thompson has placed throughout this image. Each brushstroke of color alternates between pinks, violets, blues, and greens. He manages the broken color while creating volume in the figure with believable lights and shadows.

Dan Thompson, *Freddy*, 2007, oil on canvas, 24 x 20 inches (60.96 x 50.8 cm). Private collection.

BELOW The choices of color on Thompson's palette help influence the nature of his painting. This artist is a strong colorist who loves the variety and play of strong chroma.

The Four Questions about Color

Often when we start painting we have a tendency to look for colors right out of the tube that replicate things such as skin or sky, or we agonize over finding the actual individual color note. Yet, the first step to understanding color is to think about painting not as a formula, but as a series of questions requiring answers. It may feel cumbersome initially, but you should identify color by asking the following four questions: what is the hue, the chroma, the value, and the temperature—until those questions become an unconscious part of your routine over time. It is useful to work from general to specific, breaking down color into its attributes. The aspects of color are hue, chroma, and value.

> *Seeing color can be an act of faith. Sometimes you have to place the color note before you see it in your subject.*

These three aspects correspond to the three dimensions in space, which we will explore in depth throughout the chapter. *Hue* denotes placement around the color wheel (width), *chroma* indicates where the color falls within the color wheel (depth), and *value* represents a range of tone from white to black (height). Temperature is not a true component of color. However, it is a significant "felt" presence and is especially useful when the color is too muted to accurately identify by hue.

WHAT IS THE HUE?

The word *hue* refers to the name of the color along the visible spectrum—red, orange, yellow, green, blue, and violet (in other words, the colors of the rainbow). These prismatic hues, such as sky blue, or lemon yellow, are found in every box of crayons. The color wheel (which you can see on page 194) is a pictorial aid to help you visualize this concept; the outside of the wheel designates the hue in its purest form.

> *Try changing your hue instead of your value when modulating changes in your lights.*

Even people who are not observant of color can identify high-spectrum colors with accuracy because we learn them as soon as we can talk. However, most of the colors we encounter daily exist within a more muted range with only a few accents of pure hues. Unless you spend your days in a fast-food restaurant, an arcade, or a daycare, it is unlikely that you live among predominantly strong color notes.

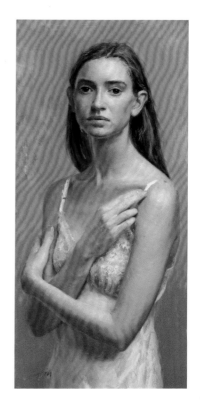

ABOVE Often artists choose to subdue the background of a painting, giving the illusion of atmosphere. Jeff Hein does the opposite; he places a vibrant hue in the background and connects it to the figure with brightly colored reflected light.

Jeff Hein, *Karlie in Pink*, 2012, oil on board, 34 x 14 inches (86.36 x 35.56 cm). Private collection.

OPPOSITE This engaging self-portrait shows the artist in his studio. Jim McVicker is shown with a full palette of colors and tubes of paint that are tied into everything from the sunflowers to the roll of paper towels.

Jim McVicker, *Self Portrait at 62*, 2014, oil on linen, 72 x 48 inches (182.88 x 121.92 cm). Private collection.

ABOVE The spheres on the outside of the wheel are adapted from an exercise I did as a student. They show a gradation from light to dark of the highest chroma version of a color. The color chips going into the center show, not a change in value, but a change in intensity. As the color moves to the center, it gets closer to grey.

RIGHT The sky, gradating from pale blue to cerulean at its apex, is reflected in the cool shadows and by the light of Erica's face. The strong red color notes form the strongest color accent. The red color is a small part of the picture, yet it activates the entire work.

Qing He, *Erica's Sky*, 2015, oil on wood, 36 x 24 inches (91.44 x 60.96 cm). Private collection.

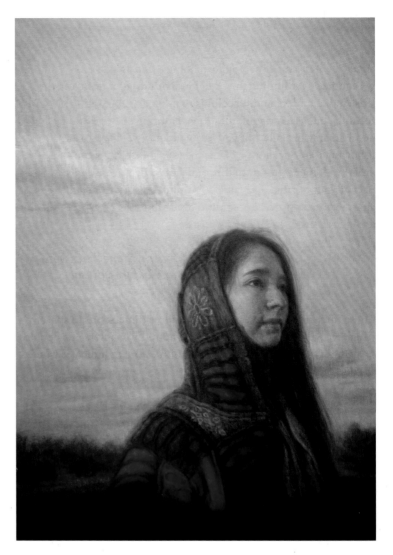

So how do you describe the colors of things that you routinely encounter—a glass of milk, running water, or dirt? Those can also be classified as being part of a hue family, a subset of their prismatic parents.

Being able to identify which part of the color wheel a note originates from is a big part of successful color mixing. When you put your brush to the palette your first question becomes: *Is my subject mostly red, orange, yellow, green, blue, or violet? Or, is it within the spectrum of that hue family?* For example, a rose may appear almost white with a blush of pink around the petals; in which case, it could be lumped under the red spectrum.

WHAT IS THE CHROMA?

Chroma, which is the Greek word for color, refers to the measure of a color's intensity. Imagine a color intensity scale with its purest, most vibrant note at the top and pure gray at the bottom. Chroma refers to a note's position along this intensity scale (see page 187).

In the color wheel, the center of the wheel represents an achromatic neutral, showing no leanings toward any particular hue family. The wheel represents how a hue can change in intensity, becoming less saturated as it slides toward the middle of the diagram. At the center, all the colors become increasingly similar until they meet in gray. An important thing to keep in mind: *chroma* does not refer to the value (the lightness and darkness) of a color; it simply denotes the intensity of a color.

Just because colors appear muted does not mean they are achromatic. Much of the beauty of color is found within a subtle range, and successful pictures in color rely on a careful management of grays for their success. The artist Albert Henry Munsell, who developed the influential color identification system that shares his name, wrote, "The use of the strongest colors only fatigues the eyes, which is also true of the weakest colors. In a broad way, we may say that color balances on middle gray." Yet identifying exactly which hue family a gray is derived from can be almost impossible without a point of comparison. In the right context, even black can appear as a blue in a painting. Correctly identifying which hue family a color belongs to is essential for accurate painting.

> *Great paintings require both boldness and subtlety with color; a harmonious picture is the balance of extremes.*

Sensitivity to chroma will help you identify all those mysterious, nuanced colors you see in life. First, you identify the hue, asking, "What hue family does my color belong to?" Next, you consider chroma and ask, "How intense or neutral is the hue I am painting?" For example, if you are looking at a tomato, ask yourself: "is it fire-engine red, brick red, or muted red-violet?" A balloon can appear lemon yellow; however, a pilsner beer and brown paper bag are also yellow hues, albeit lower in chroma. A freshly peeled carrot will be an orange hue; however, so will a chestnut, but much lower in chromaticity.

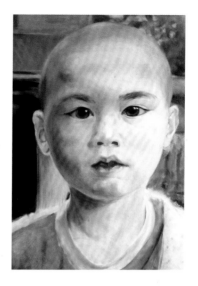

What tube of paint do you use for a figure? The answer is, of course, that the color of life can't come from a tube. Not when you take into account the ruddiness of the cheeks, the cool ribbons of veins seen under the skin, or the sunken notes under the eyes. Here Mark Kang-O'Higgins paints the translucent skin of his youngest son.

Mark Kang-O'Higgins, *Moment*, 2014, oil on canvas, 72 x 48 inches (182.88 x 121.92 cm). Collection of the artist.

WHAT IS THE VALUE?

Value is a measure of a color's lightness on a scale between black and white. When looking at a color, ask: "How light or dark is it?" Value is an essential part of color and knowledge of it remains indispensable for the representational painter. Value gives us shades and tints, which provide the impression of light hitting an object and casting shadows. Value is what gives color an anchor in space, providing a feeling of depth and believability. Without value to secure our hues, paintings would feel like the ether, without form or substance. If the value is correct, it will lend an immediate believability to the work that is hard to get any other way.

In Chapters One and Two, we explored how much of an object's character resides in its values alone and you saw how our eyes are particularly adapted for quick identification of those tones. Working through the lessons in this book will strengthen your ability to translate color into black and white.

High-spectrum colors can be particularly confusing to translate into value because the vivid nature of the color obscures the tone. I find bright red to be one of the hardest colors to read accurately, as it can appear both bright and dark. There are a number of ways to become

BELOW The image of figures walking toward a fiery sky contains much emotional content that lies beneath the surface. Steven J. Levin's use of color in the environment brings the three men into a larger context.

Steven J. Levin, *After the Party*, 2014, oil on linen, 26 x 40 inches (66.04 x 101.6 cm). Private collection.

more skilled at determining a color's value. Some artists use aids, such as looking at the subject through a piece of colored Plexiglas or reflected in a black tile. Others use a black mirror, which reduces the brightness of a color and highlights the tonal qualities. When painting, many artists work out value arrangements by creating tonal underpaintings (see page 41). This establishes the value range, allowing the artist to match color paint to the tone in the underpainting.

WHAT IS THE TEMPERATURE?

Temperature refers to the relative amount of yellow/orange (warm) or blue/violet (cool) in a color compared to the colors around it. The previous three questions covered the fundamental elements (hue, chroma, and value), which are inherent qualities of color. Temperature is not considered a foundational component; however, it is important for color accuracy. A study of temperature helps us understand, perhaps more than any other aspect of color theory, how to think about color in general.

> *A symphony of grays—subtle neutrals,*
> *like those seen during twilight or dawn,*
> *are the life of a picture.*

When you paint brightly colored objects, like oranges, limes, or daffodils, thinking of temperature seems unnecessary because the color is unambiguous. However, I paint many figures, portraits, and low-chroma still life pieces (such as silver bowls on white drapery). When painting subtle compositions often there are no obvious colors. What color is an egg, a piece of paper, or a plaster cast? In those instances, the hope for believable color comes from a study of warm or cool. This reduced palette can yield some remarkable results.

This broken color exercise involves correctly matching a color to the value square. If the value of the color is perfectly matched, it will feel like part of the square; if it doesn't, the color separates. We have three values: a light, a mid-tone, and a dark value square. In each square we have multiple color notes; as long as the color is the exact same value as the ground it's floating on, the color will look believable. Look at all the color changes within the lights of Dan Thompson's *Freddy* (page 179) to see an application of this principle.

Louise Fenne, *Blue Macaw*, 2013, oil on canvas, 35⅖ x 21⅗ inches (90 x 55 cm). Private collection.

Start by identifying the most extreme temperature notes: *Where is the clearest warm note and the most chromatic cool note?* Keep in mind that the coolest note in a painting may be gray. Then, key the rest of the piece to those clear examples. For example, *How warm is the reflected light in the cast shadow in comparison to the local light?* Having identified the opposite temperature notes, you will have two extremes with which to compare the other, more neutral colors. So, the question would be, *Is this color note warmer or cooler than ___?* Repeatedly asking that question will help you identify where each color falls in the overall spectrum.

The Color Wheel

The simplest and most commonly used system for organizing and understanding color is the color wheel, which was created as an aid for envisioning the color spectrum. Sir Isaac Newton discovered that light passing through a prism exits refracted into the color spectrum (red, orange, yellow, green, blue, indigo, and violet), thus revealing that light is responsible for the colors we see. The early color wheel that Newton drew was subdivided into irregular parts. Now we simplify it by eliminating indigo and dividing the wheel into six regular intervals. The hues straight from the light spectrum are placed on the outside of the circle. So, when looking at a color wheel, we know that those are the brightest, purest versions of the color available.

The painted color wheel opposite shows twenty-four different hues on the outside and numerous gradations of chroma in the interior. Each concentric circle represents a decrease in chroma. Therefore, as the dots get closer to the center, they become increasingly neutral. Each of the dots is a unique color mixture. It is interesting to note, as a principle, how much harder it is to read color when it is shown in a smaller area. The first inner ring of the circle features almost the same chroma as the perimeter hues, yet they are much harder to see because of their size.

The color wheel itself is a simplified fiction, as real light is neither flat nor circular. Nonetheless, it's an effective symbol, much like a map of California. The physical state has mountains, rivers, streets, and buildings, yet a diagram on a piece of paper can show us exactly where we need to go without getting lost. A map helps us contextualize our location and visualize an area, and informs us how to get from point A to B. Likewise, the color wheel is a map, and, as such, it works brilliantly. It is a visual metaphor that captures an

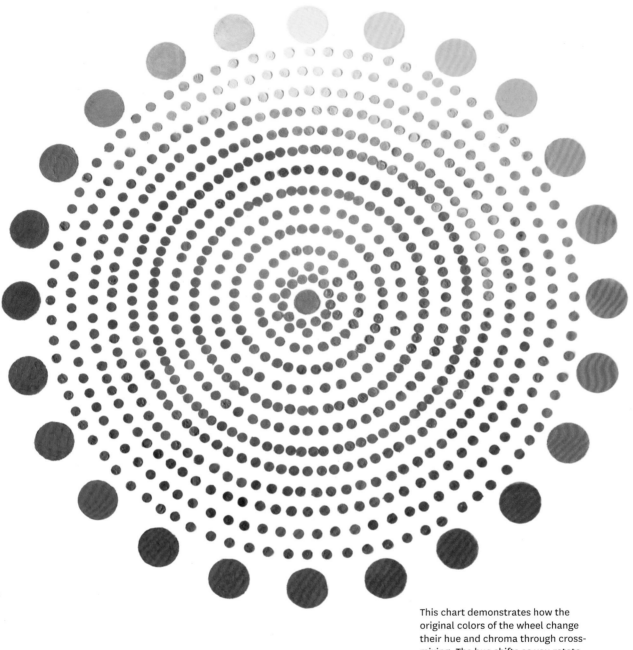

This chart demonstrates how the original colors of the wheel change their hue and chroma through cross-mixing. The hue shifts as you rotate left or right around the color wheel. The intensity changes, becoming more neutral, as you follow the lines into the center of the wheel. The only attribute of color not accounted for is value. To take into account all three aspects of color, you would need a three-dimensional diagram.

essential aspect of the truth. The most accurate color charts are three-dimensional constructions that position the three elements of color (hue, value, and chroma) in space. Yet we mix color on a flat palette, so a two-dimensional chart works just fine.

Color reacts consistently within its own laws. Therefore, when we understand color basics and combine them with hands-on experience, we can begin to anticipate how colors will respond when mixed together. It is challenging to identify and mix color; however, the relationships generated within the circle have their own consistent logic. If you mix two particular colors together, you will get the same result each time. Becoming familiar with color mixing within the wheel and on the palette can help you internalize color combinations, making the mixing process more intuitive. Over time, you can learn much about the way color works simply by doing it yourself and experimenting with paint mixtures on a piece of glass.

The best way to understand an artist's palette is through hands-on practice with it. Be bold in your experiments.

Color can be mysterious until you have enough opportunities to practice with it and see how it works in various situations. Two essential aspects of color mixing are: One, learning how to mix inside the wheel to neutralize the color; and two, keeping the color intense

This landscape sketch is simplified nearly to abstraction. The strong orange accent point is the color key—the smallest note of color—yet the contrast stimulates the surface color and activates the entire painting.

Jacob Collins, *Catskill Sunset* (detail), 2009, oil on canvas, dimensions unknown. Private collection.

while darkening, lightening, or gradating it. If you learn how to regulate chroma (by intentionally changing the saturation), and then later focus on how to darken a color (while keeping the brightness intense—essentially introducing value to the outside of the color wheel), you will know much that you need to about paint.

Keep in mind that when your palette is limited, as a two-color palette with earth-colors in the figure painting section, very little needs to be done to neutralize color. Small steps have a big impact; the colors almost temper themselves with very little help from us, aside from the addition of white or analogous colors. We know that most figure painting can be done with an extremely limited palette. However, that will not work for everyone or in every circumstance, so it's important to go on to explore the full palette.

When looking for a usable palette, it is advisable to start with the fewest colors and add more as you need them. When choosing colors, look for those that afford flexibility, range, and ease in color mixing. The quest for a perfect palette is enticing. However, unchanging perfection doesn't really exist; even the most restrictive painters will vary the colors on their palette occasionally to account for different subject matter. For example, painting a figure will require a different range of colors than a forest; you rarely need all of them at once.

Artists are always looking for logical systems to control their palette and create harmonies by limiting the color wheel. In the early twentieth century complex palette-control systems flourished; artists such as Robert Henri worked closely with color theorist and paint manufacturer Hardesty Gillmore Marata, who organized a palette of colors linked to the musical scale. Other palette systems, such as the one developed by painter Frank Morley Fletcher, also centered around dominant color notes and worked in "keys" providing different primary triads for each painting. Each system required premixing and wrestled with a way to limit and organize palettes that could otherwise be chaotic. Other artists who followed created their own systems to provide a logical method for understanding color, the most famous of which was the system created by Albert Henry Munsell. I recommend starting with a few simple explorations of the color wheel before following your interests into in-depth studies.

Later in the chapter I will show you how to analyze a few palettes, comparing them with the full wheel, so you can see exactly how much of the surface area of the circle that palette will allow you to control. So let's start at the beginning—mixing the color wheel.

Here is a triad made of green, orange, and violet. When mixed together, these produce a neutral yellow, red, and blue.

Color Mixing

I find that an understanding of color theory is most useful when gained through hands-on experimentation. Practice mixing color on a glass palette to see the remarkable number of gradations that can be created. Use this simple color exercise to explore two points: (a) that paints change hues as you move across the wheel and (b) that colors neutralize as you move closer to the center of the wheel.

As early as the nineteenth century, artists recognized that there are no true primary colors (i.e. Three colors that mix with all others at full intensity) in oil paint. However, you can mix versions of all the hues from any three colors, as long as they are far enough away from each other on the color wheel. For the example here, I chose the classics—red, yellow, and blue—because of their usefulness and ubiquity in even the most limited palettes (see page 189).

TUNING YOUR COLOR

Tuning your paint colors is like tuning a musical instrument. You make a few adjustments so all the strings play harmoniously together. High-spectrum colors like yellow and orange come out of the tube at a lighter value than cooler colors like violet and blue, which can appear almost black out of the tube. You have to add white to lighten those darkest colors and see your mixtures better.

After you create the palette here, try experimenting. Instead of equally-spaced increments between your starting colors, make a triangle with gaps for colors like red-orange, yellow-green, and so on. Rotate your triangle and try different combinations for a more dynamic color mixing experience.

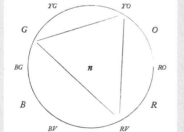

Rotate the central triangle so that it points at a color (like red-violet). Try mixing using the three principle colors to see how they change the balance of the palette and to see what new colors you can create.

MIXING A TRIADIC PALETTE

On a piece of paper, draw a large circle with color notations placed equidistantly around the circumference (see examples below), and place that under a sheet of glass. Prepare a panel in the same shape with a triangle whose lines connect the three colors you have chosen (here red, yellow, and blue).

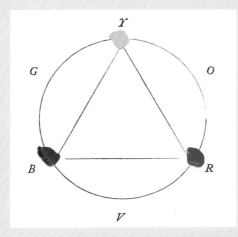

1. Squeeze cadmium yellow light, cadmium red medium, and cobalt blue (or its equivalent) on the appropriate spots around your color wheel.

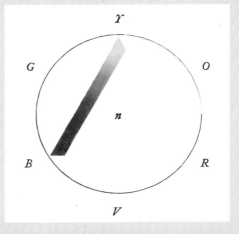

2. Moving along the line from yellow to blue, mix individual piles of paint into gradations of color with your palette knife. (Make sure to clean the knife with a paper towel after each use.)

3. Mix the line from blue to red and the one from yellow to red. Then transfer these paint piles to your triangle-shaped panel.

Balancing the Palette

In the previous feature, you mixed an entire palette from three colors. However, you probably noticed the greens and violets you created were dull or desaturated. That happens because as you move closer to the center of the wheel, the more neutral your colors become. The traditional three-color palette is fine for figure painting, but leaves you with a reduced range for the rich greens of landscapes or the blue-violets of night skies.

To create a more balanced high-chroma palette, you need more color. Instead of mixing an orange, green, or purple, use bright versions of these colors direct from the tube. Six high-intensity colors will provide expanded coverage for your wheel. This new palette will encompass almost the entirety of the wheel, leaving only small, unreachable gaps.

MIXING A SIX-COLOR PALETTE

Place your color wheel with notations under the glass palette. Prepare a small panel with a color wheel and hexagon pattern as shown at the end of the example below. You will transfer the mixed color to this surface when the palette is prepared.

1. Place cadmium yellow light, cadmium red medium, cobalt violet, cobalt blue, and phthalo green.

2. Using your palette knife, mix a color transition between yellow and green. Mix each gradation separately, adding a tiny bit more of the second color each time.

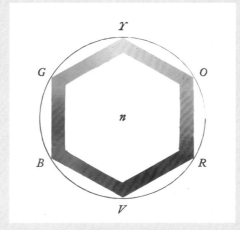

3. Repeat the process in step 2 for each leg between the six colors. Finally, transfer these mixed color notes to your prepared panel.

Creating The Color Wheel

The color wheel is a simplification of a complex reality. It functions as a handy map for visualizing how colors relate to one another. The wheel takes into account shifts in hue only; not value or intensity changes.

For this exercise, I chose the mid-intensity colors I use on my own palette. These twelve colors provide me with a wide enough range for most things that I paint. However, remember that these colors lose intensity with the addition of white (see page 200). There will be times when you will need to switch to a color with a higher tinting strength to capture the intensity seen in your subject. You can substitute stronger colors as needed, for example the alizarin crimson could be substituted for a quinacridone magenta. I encourage you to let these simple color exercises be a beginning exploration. Now it's time to incorporate the following tertiary colors to your palette: yellow-orange, red-orange, red-violet, blue-violet, blue-green and yellow-green.

MAKING THE COLOR WHEEL

Use the same color chart under a piece of glass as before. Again, you will have a corresponding panel with a circular diagram to which you will transfer your mixed colors. Place your colors (either direct from the tube or from your tuned paints) around the outside of your wheel in their appropriate color notations.

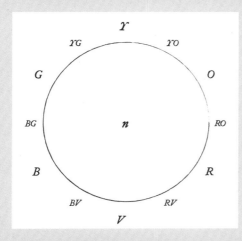

1. Start at 12 o' clock on your wheel and move clockwise to place the following colors: cadmium yellow light, cadmium yellow deep, cadmium orange, cadmium red medium, alizarin crimson, cobalt violet, cobalt blue, viridian, and viridian + cadmium yellow light (for green and yellow-green spots).

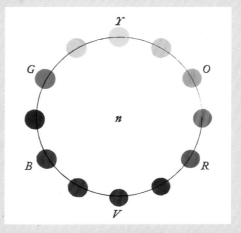

2. Mix gradations between colors by incrementally mixing one color into its neighbor. Start with orange to yellow-orange and move around the wheel.

3. Place the mixed colors from around the wheel on your prepared panel, using a brush or palette knife.

Neutralizing Color

The aim of this feature is to compare a number of common ways of neutralizing color to see the differences and similarities between the neutrals you create. Learning how to neutralize or desaturate a color is an important part of painting. Many beginners just add black to drop the chroma of a color; many potentially good paintings have died this way. Too much black makes a painting look leaden. There are many different ways to lessen the chroma of a color without resorting to black, methods that will leave your color more vibrant.

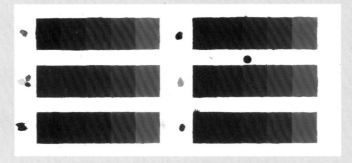

Using Complementary Colors

SETTING UP

Set up your glass palette with the color wheel underneath just like you did on page 190, with R, O, Y, G, B, and V in the 4, 2, 12, 10, 8, and 6 o'clock positions respectively.

On your panel, draw six long rectangles, each at least 1 inch by 5 inches and divided into five 1-inch squares. Paint the left-most square in each of the six long rectangles cadmium red medium.

USING COMPLEMENTARY COLORS

Place green directly opposite the red, gradually add more green to the red, which will dull the color. Place four steps of your mixtures on the squares in your panel, ending with a neutral on the left. Wipe the glass palette clean.

USING SPLIT COMPLEMENTS

Mix your phthalo green and cadmium yellow to create the green-yellow note and place it at the correct location for GY: place cadmium red medium at its correct location for R on the color wheel. Mix the color with one of its split complements (a color adjacent to the complementary color).

Using Split Compliments

USING BLACK OR GRAY

Place black or gray in the middle of your color wheel in the spot reserved for "neutral" and mix across with the red.

Place four steps of your mixtures on the squares on your panel, ending with a neutral on the left. Wipe the glass palette clean.

MAKING A TRIADIC NEUTRAL

Place any three colors far enough apart on the color wheel such red, blue, and yellow. Mix a triadic neutral (a neutral created by mixing three colors that are far apart on the color wheel) and place it in the center of your color wheel. Gradually mix it into your red until you have four clear steps of decreasing chroma. Place these steps on the squares in your panel, ending with a neutral on the left. Wipe the glass palette clean.

Neutralizing Yellow

You may have noticed that neutralizing yellow is a difficult and unsatisfying experience. It is worth taking a moment to discuss why this is the case. Unlike the other colors, yellow does not go gray as you mix toward neutral—rather, it turns brown or green. This can be maddening until you realize that it is not due to poor color mixing, but due to the fact that the eye often sees dark yellow as a brown. Artists (including me) often have numerous variations of yellow (including brown) on their palette to offset the difficulty of keeping the purity of its color.

Using Black or Gray

Making a Triadic Neutral

There are so many different brands and versions of yellow that it can be hard to know their differences and similarities. We tested every yellow we had to see how they compare.

Moving Inside the Color Wheel

As a realist painter, you will likely spend most of your time working from the interior of the color wheel. Nature reveals itself in an infinite amount of subtle color shifts. Often the very brightest hues are accents, while more subtle variations are the main course. This feature may help sensitize you to a wide range of neutral colors and grays and to give you the skills to identify and duplicate these subtle colors. I will show you how to mix neutrals from more prismatic colors, as well as how to identify where commonly used colors like yellow ocher or burnt sienna fall on the color wheel.

For this example, I created pattern of rectangles leading to neutral, keeping each line within the same hue family (i.e. not cutting across the wheel and changing hues). As a result, you can clearly see the distinct decrease in value as I move into the center of the circle.

ABOVE The pure color, out of the tube touches the outside of the color wheel, and then each spoke is mixed by connecting the complementary opposites.

DECREASING SATURATION

For this exercise, you need to use white to lighten the darker colors on the outside of the wheel, so that you can clearly see the colors when mixed. Create a large pile of triadic neutral or mid-value grey and place that in the center of your glass. Make sure your neutral pile leans more toward brown than cold gray or the resulting yellow line will turn green. Follow the steps below for creating the patterns. When this exercise is finished, you will be able to find the placement of many of your favorite earth tones from this diagram

1. Draw the color wheel on your panel and place your paint swatches.

2. Mix a string from one of the high-chroma colors (yellow-green in this example) found on the perimeter of the wheel. Work toward the center, gradually decreasing the color intensity.

3. Move around the color wheel one color at a time, mixing from the outside of the wheel to the neutral center. Transfer to your panel.

In this diagram the color to be darkened is yellow ocher (shown at the bottom of the "V" in its purest form). By adding black to the color, as seen in the branch to the right, you turn it green. To keep the appearance of a warm yellow, you would add burnt and raw umber.

In this diagram the color to be lightened is raw umber—shown at the bottom of the column. Simply adding white quickly turns the color to gray, as shown in the curve veering off to the left. To both lighten and keep the integrity of the color intact, you must lighten it with yellow rather than white.

The Challenge of Tints and Shades

Painters are often tempted to create the illusion of brilliance by simply lightening a color with white, only to find their paintings look washed out instead. Likewise, painters often have the temptation to create a shade by adding black, only to find that their paintings look dull and heavy.

Lightening a color with white creates the unintended effect of also cooling the color. To counter that effect and preserve luminosity, add small amounts of yellow as well. Similarly, darkening a color with black can cool and deaden it (see diagrams at left).

At times you will want a color to become more neutral and cool, so just adding white or black would work perfectly. Just being aware of these shifts in color can help avoid unintentional actions in your painting. The diagrams to the left highlight a tricky aspect of mixing shades and tints.

Color Strings

When painting a highly saturated object, it is important to keep the colors bright as they move into the lights and shadows. To do this, first identify the local color of your object (in other words, which hue family the object belongs to). For example, if you are painting a lime, the hue family is green. Make sure to choose the most chromatic version of the color available.

Next, create a color string—a premixed line of paint in different values. Imagine painting the lime and having several shades and tints of green prepared in a green color string to match the fruit you are painting. This requires some color logic and planning because you need to account for any shifts, such as the movement toward yellow-green in the lightest area and perhaps toward blue-green in the darkest shadow.

To find the local tone of your object in paint refer to your color wheel. Because most of the cold colors (blues, red-violets, greens) will appear black out of the tube, you will have to tune it with white until you hit the middle of the value range. At that point the color will feel most vibrant and match the hue shown on the outside of the color wheel. If the darkest note you need is the color straight out of the tube, then that can be used for the bulk of your shadow. If you need it darker still, look for a more opaque and darker color to graft into the mixture to give it better opacity in the darkest notes.

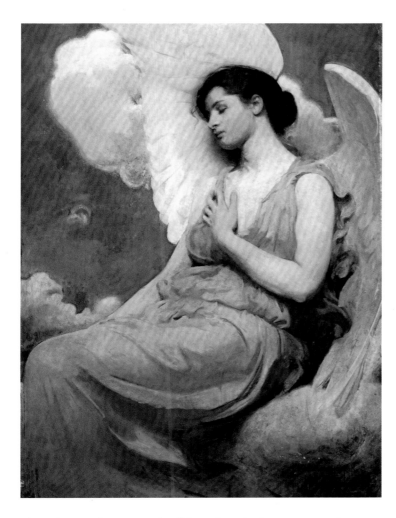

This sensitive Thayer painting shows a wonderful manipulation of a warm limited palette. Although it looks as if it was predominantly created with a palette of yellows, it never looks gray or washed out.

Abbott Handerson Thayer, *Winged Figure*, 1889, oil on canvas, 51½ x 37¾ inches (130.8 x 95.9 cm). School of the Art Institute of Chicago (Chicago, IL).

The colors on the warm side of the palette (reds, oranges, and yellows) come out of the tube at their most intense, so there's no need to lighten them. However, the challenge comes when trying to darken them while still keeping the same brightness of color. In this case, you should look for darker versions of the color right out of the tube to decrease the value. For yellow, look to colors like yellow ocher to bring it a notch darker, and raw umber to make it deeper still. Orange can be brought down with burnt sienna and burnt umber, red with burnt umber and alizarin.

When lightening all colors—from the local tone to the lightest parts of the value step scale—there is a change of strategy. The colors require *tuning*, or *bracketing*, which means mixing a color with its analogous neighbors. You should shift a step or two over in the color wheel for the lightest notes: blue moves toward violet in the lights, violet toward red, red toward orange, and orange toward yellow.

Application of the Color Wheel

It is useful to be able to see where the paints on your palette fit into a broader context. One way to do this is to look at the color wheel as a map and plot the location of your paint choices. This can quickly give you a bird's-eye view of your color range and help you decide which colors to add or which ones are redundant on your palette. Your range of hue and chroma is affected by your color choices; this can work either for or against your subject.

I recommend that you plot your favorite palette on the color wheel to better understand the colors, giving them a bigger framework. Don't worry about being exact. This is not a science. Rather, it's an artistic diagram meant to capture the general idea.

In this section, you will find a selection of palettes, which we can overlay on the color wheel diagram. Note that I placed the colors that come right out of the tube on the perimeter of the color wheel, whether they were bright or dull. Yellow ocher may be the brightest yellow on your palette; however, when placed on the color wheel, it is shown to be closer to neutral.

The two colors used for this painting cut across the color wheel; notice how the palette only provides a thin slice of the overall possible. You can see how the color line recreates a low-intensity yellow, but provides no reds, blues, or violets.

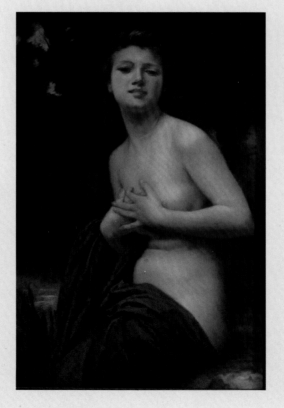

TWO COLORS MAPPED

John Zadrozny used a two-color palette, featuring viridian and burnt sienna, to create his master copy of the Bouguereau. This meant that his hue and chroma were limited to one narrow band of warm/cool,

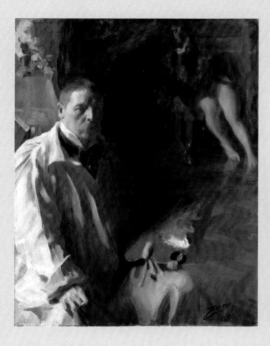

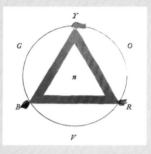

Great painters can make any palette, regardless of how limited, convincing through their skillful play of contrast with value and temperature.

a sliver of the color wheel. Notice that he was still able to achieve a muted yellow as the band cuts under the yellow notation. The two colors bypass the center of the color wheel. The effectiveness of the color in the painting is due to his careful undulations of temperature.

THREE COLORS MAPPED

Yellow ocher, cadmium red (or vermilion), and black form a muted triad for many historical palettes. Anders Zorn bypassed the entire cold side of the color wheel in the self-portrait above, considering that the primary "blue" he is using is actually a black. When this triad is overlaid onto a full-color wheel, you see how much he is able to do with so little. The range of his palette is extremely limited with only the red really hitting the maximum chroma at the outside of the wheel.

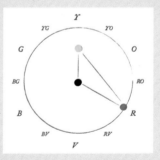

In the diagram, above, you can see where the three-color (black, yellow ocher, and red) palette would sit when overlaid on a color wheel. Taking time to map your colors in this manner will show you how much or how little real estate on the wheel is accessible with your palette.

LESSON 9

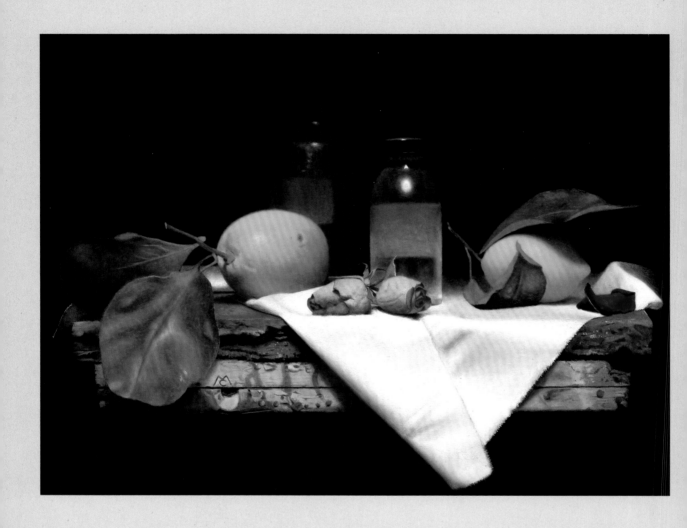

PAINTING A FULL-CHROMA OBJECT

The goal of this lesson is to practice using the full-color palette, including a few high-intensity colors. A full-chroma palette is easier, in some ways, to handle than a limited palette because you can get more lively, eye-catching color right out of the tube. The challenge with a bright object is how to paint tints and shades of its color without lessening the feeling of brightness in the light areas and the shadows. In the section on shades and tints (page 207) I discussed the dilemma of how lightening an object with white can make the color chalky, and how darkening it with black can make it appear dirty. Now is your chance to experiment with turning form on the full-chroma object.

SELECTING YOUR SUBJECT

Still life subjects for a high-chroma study are easy to come by. A trip to the grocery store will afford you many such objects. You could work your way around the color wheel: tomatoes, oranges, lemons, limes, grapes, figs, eggplants, and strawberries. You could also paint bright jars, teapots, boxes, children's toys, or drapery. Anything brightly colored, and not quickly perishable, will make for a good subject for this lesson.

OPPOSITE Carlos Madrid, *Composition with White Cloth and Lemons*, 2014, oil on linen, 13 x 17 inches (33.02 x 43.18 cm). Private collection.

MATERIALS

Panels or canvas Approximately 9 inches by 12 inches, either white or toned light gray

Charcoal (optional)

Brushes In a variety of sizes, such as 2, 6, and 8

Palette I use a handheld wooden palette but feel free to use a tabletop one

Paints Colors are determined by the objects you choose and your experience using the color wheel. I recommend using white and ivory black on the palette along with yellow ocher and burnt umber no matter what color your objects are, as these provide some convenient neutrals. In addition, I suggest cadmium yellow light, cadmium orange, burnt sienna (or transparent earth orange), an iron oxide red (such as Venetian red), cadmium red medium, burnt umber, alizarin crimson, viridian (or phthalo) green, and ultramarine blue. Check your color wheel to see what you are missing or unable to get with your current palette and add as needed.

Cloth or paper towels

Odorless mineral spirits

Linseed oil

Palette knife

STAGE ONE:
Articulating the Shape

Draw your subject carefully with a piece of charcoal or a brush loaded with thin paint mixed with odorless mineral spirits. (In the nineteenth century this was called "the sauce.") Keep these preliminary lines slim and light, so they are easy to move around or erase. Spend a little time getting the drawing accurate and placing the shadow shapes on the object and the ground plane. Consider including the horizon line at this point to delineate the ground plane from the background.

STAGE TWO:
Defining the Ground

I recommend working from background to foreground, to create a context for your still life object. By placing the background color first, you will eliminate some of the glare from the pale ground, thereby making the other colors easier to gauge. Keep in mind that it is difficult to get the color exact until the surface of the ground has been covered.

STAGE THREE:
Laying In the Local Color

STAGE FOUR:
Finishing

Identify some of the high-intensity mid-tones and local colors of your subject, trying out colors in a few areas to make sure that they feel correct. Some artists even touch paint to the surface of their still life subject to see if the hue of the mixture feels like a close match. A best guess is often close enough for this first paint layer—you can always adjust the color in the the next pass. Remember that for intense hues, like the red in this pomegranate, white will cool and gray the color, so to lighten you will need to add other colors.

You may find that your single-hued object can shift in appearance the longer you study it. The pomegranate that I used as my demonstration object first appeared as a clean, chromatic red; however, as I studied it it suddenly seemed flecked with red-violet and orange, or even yellow. Refine your color by trying to capture in paint some of the mottling of the surface, and the differences in the color of the reflections. Once you have placed the whole first pass of the painting, you can assess its success at your leisure. At this stage I modified my edges, sharpening some and softening others. Use this time to deepen shadows, brighten colors, and turn areas of form adjacent to the core shadow to bring the object to a finish.

Juliette Aristides, *Pomegranate*, 2015, oil on panel, 5 x 7 inches (12.7 x 17.78 cm).

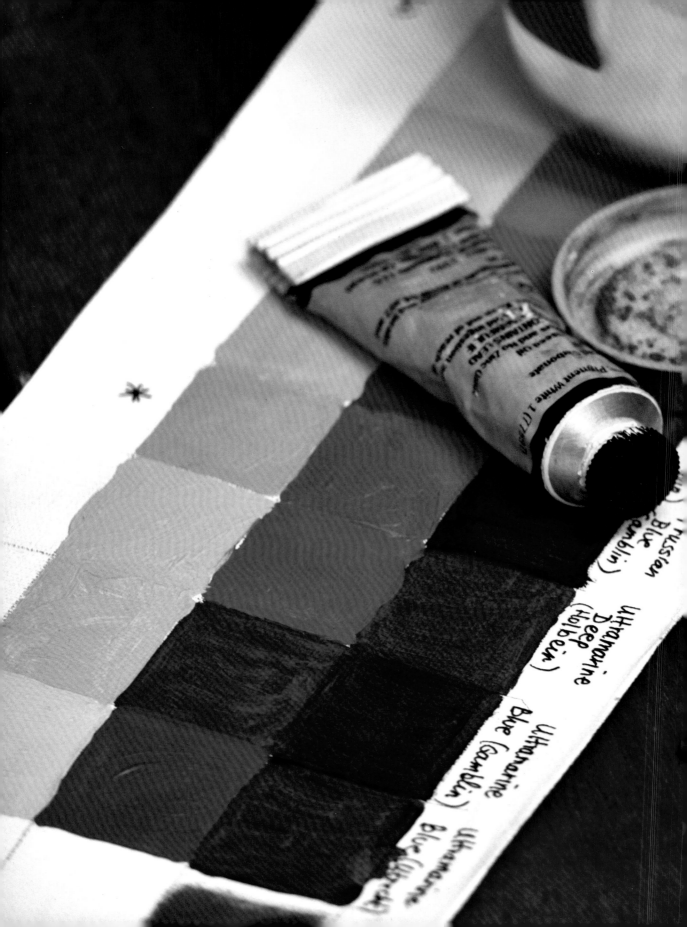

LESSON 10

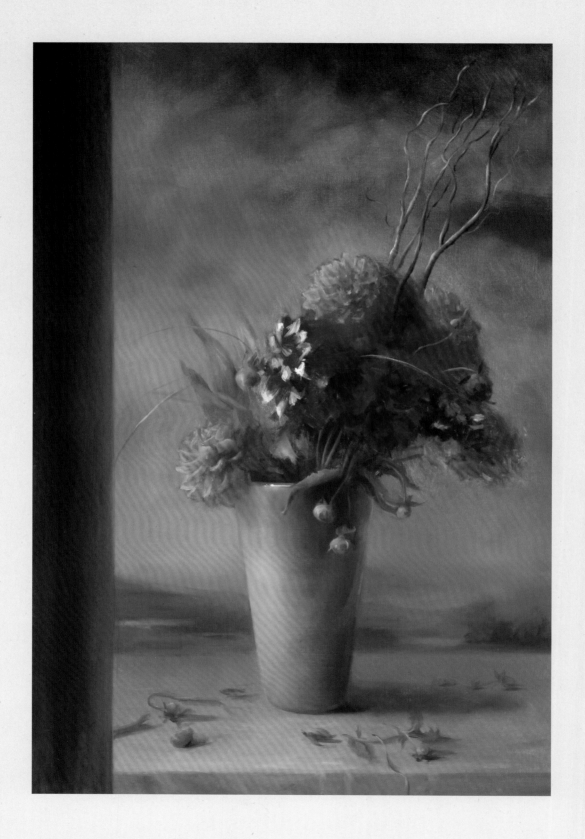

FLORAL PAINTING WITH A COLOR-WASH UNDERPAINTING

Flowers are an excellent subject to practice using a full-color palette because often their colors are pure and bright. Light can shine through and into the petals, making them appear to glow. Also, flowers are living so they have movement, which is constantly shifting. Because of the delicate nature of the subject, there is great urgency to get something on the canvas; most flowers only last a few days and then they no longer conform to the original design.

SETTING UP THE STILL LIFE

To set up the still life, I arranged a bouquet of flowers in a big vase and put it next to a window in my studio. It took me multiple attempts to get the flowers to look the way I wanted, a few roses grouped into several larger shapes. I tried half a dozen vases, endeavoring to find one that felt like a match, one where the base was substantial enough to visually balance the roses. I had no other light sources, so the effect was a simple stream of light coming from the left. I used the same window to light my canvas, so both my subject and canvas had uniform lighting. For this painting I used an open palette and mixed directly on it with my brush.

OPPOSITE Juliette Aristides, *Nature Tamed*, 2012, oil on linen, 36 x 24 inches (91.44 x 60.96 cm).

MATERIALS

Still life objects flowers and vase

Palette A handheld wooden palette or tabletop

Panel or canvas the size you wish to paint.

Paint rags or paper towels Baby wipes are also great for clean up

Brushes Such as filberts in a variety of sizes, including a few larger square or round ones to mass in your initial paint layer

Paints This list is a suggestion. Tailor it to your actual still life: if you have strong violets in your still life, you will need to add it to your palette; if there is no green, adjust accordingly.

Titanium white

Naples yellow

Yellow ocher

Cadmium yellow light

Cadmium orange

Raw umber

Burnt umber

English red or burnt sienna

Cadmium red medium

Permanent alizarin crimson

Cadmium green (you may need a stronger green or blue such as phthalo or Prussian)

Olive Green

Ultramarine blue

Ivory black

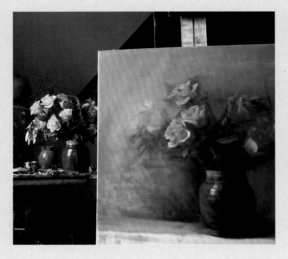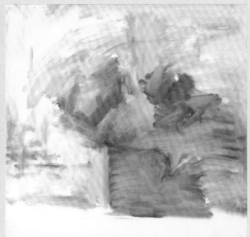

STAGE ONE:
Massing In the Large Shapes

STAGE TWO:
Refining the Color Wash

I always start painting flowers by grouping them into shapes. I choose a color wash, rather than a value wash, because I want the white of the ground to lend a brightness to the color.

It is helpful, but not necessary, to paint the flowers before they fade. I grouped the individual flowers into shapes early in my painting process. Doing so allowed me to lock-in the composition, even though the individual flowers may have subsequently moved or faded.

I established my drawing with shapes rather than lines, which is more of an *alla prima* (all at once) approach. This technique is commonly used when an artist is planning to go for a finish in one sitting (rather than doing an underpainting and overpainting).

I drew the big masses in with a large brush and established a muted version of my subject by thinning down to a color wash, almost like a watercolor. I started with the base, which anchored the flowers. Compare this method of doing an underpainting with the wipeout method (shown on page 43). A color wash ensured that my color was going on top of a luminous white ground and the first pass was the color itself, not a tonal approximation. This enabled me to get a brighter, cleaner color in the finish. A color wash is a great choice for a painting where color is the major player.

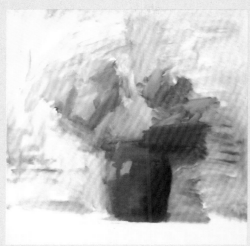

STAGE THREE:
Defining Broad Color Placement

STAGE FOUR:
Articulating the Flowers

I started to find my roses by working from general to specific. (At this stage of the painting I find the overall shapes, the broad color placement.) I also considered the individual roses in terms of light and dark volumes. They looked more like splotches than roses. However, this broad treatment allowed me to focus on the whole effect rather than individual flowers or petals.

I started to find the bigger shadow shapes of the roses. This gave them form and definition, allowing me to creep up slowly on accuracy. I also decided to take one area of the painting and bring it to more of a finish. In this case, I chose the vase, which is actually a jar. I treated it like one of the geometric solids discussed in Chapter Two, with a focus on turning form.

I brought the roses (my focal point) to a greater degree of completion. Doing so required me to slow down and focus all of my attention on one rose at a time. More precisely, I focused on a single petal at a time, looking for such things as: where the light was concentrated on an edge or where there were turns into darkness. The contrast between found edges and other less developed areas of paint is often a characteristic of *alla prima* work.

Color 215

STAGE FIVE:
Finishing the Foreground and Background

I finished the background, the foreground, and ground plane at this stage. In the background I adjusted the value so that it was not monotonous, but alternated between dark and light. I anchored the space with some objects in the foreground and took care to manipulate some edges, making sure there were no gaps between my subject and the background.

ABOVE Juliette Aristides, *Roses*, 2015, oil on canvas, 30 x 36 inches (76.2 x 91.44 cm).

OPPOSITE Juliette Aristides, *New Years Day*, 2014, oil on linen, 36 x 24 inches (91.44 x 60.96 cm).

Gray is the balancing of all color so that any true harmony of color, however rich it may be, is always quiet in effect as a whole.

—D.B. Parkhurst (from The Painter in Oil*)*

LESSON 11

FIGURE PAINTING FROM LIFE

The figure is one of the most challenging subjects to paint because the color is subtle and the drawing has a low margin for error. Yet figure painting also offers some of the greatest opportunities for self-expression, once you reach proficiency. The goal of this demonstration is to show the preparatory stages that lead into a finished figure work. By creating the painting in stages, you can bring your best efforts to each aspect—such as drawing, value, and color.

Working with a model is a professional collaboration. The best models bring their own vision and personality to the studio, which in turn influences the creation of the art. To set a pose, I always take time with my model prior to our session, so we can experiment with different posing and lighting options.

The ideal light source is a north-facing window or skylight that hits both the canvas and the model. I did not have access to ideal natural light in the studio so I lit the model with a balanced light bulb. I worked from an easel with a clamp light about 5 feet away from the model. She posed for twenty minutes at a stretch for a total of six three-hour sessions.

OPPOSITE John Singer Sargent, *Nude Study of Thomas E. McKeller*, circa 1917–20, oil on canvas, 49½ x 33¼ inches (125.73 x 84.45 cm). Museum of Fine Arts, Boston (Boston, MA).

MATERIALS

Drawing materials (if you are doing a preparatory sketch)

Paints

Flake white (preferred, but this is lead so be careful not to ingest it) or titanium white

Naples yellow light or medium

Yellow ocher

Raw sienna

Burnt sienna (or transparent earth orange)

Venetian red

Raw umber

Burnt umber

Permanent alizarin crimson

Ultramarine blue

Ivory black

Palette Handheld or tabletop

Paint medium

Brushes A selection of midsize and small brushes: I use filberts a lot—in sizes 2, 4, and 6 (synthetic or natural, whichever you prefer). A flat brush is useful for toning the canvas beforehand, and a smaller round brush works well to draw on the canvas.

Cotton rag Such as an old t-shirt

Paper towels

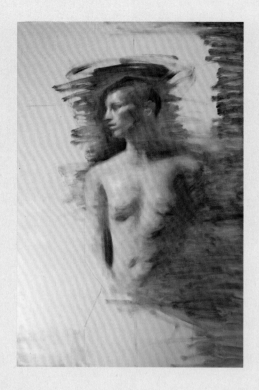

STAGE ONE:
Creating the Preparatory Drawing

Working with charcoal on paper gave me an opportunity to explore the likeness and gesture of the model before starting the painting. Some artists just develop the preparatory drawing to the block-in stage—in other words, they show the main structural lines and indicate the proportion and movement of the pose. Anything beyond that does not necessarily help with the painting, although many people like to finish a drawing as a work of art for its own sake.

STAGE TWO:
Mapping the Shadows

I enlarged the drawing and transferred it to a panel. You can draw directly on the panel with a brush and paint, skipping the drawing and transfer stage if you wish. I chose to do this wash-in of tone on a light gray panel from the drawing rather than from the model, saving me time for the color layer. For this tonal wash-in, I concentrated on massing in the shadow shapes on the figure and linking them to the environment (for example, blending the side of the body and neck into the background).

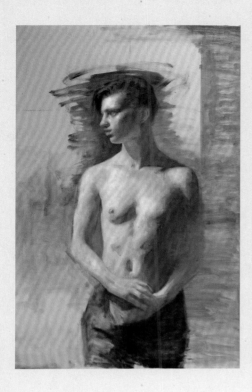

STAGE THREE:
Blocking In the Lights

I did a simple "massing in" of the local color, articulating the planes in lights, mid-tones, and shadows. You can see this stage most clearly in the hands and abdomen of the figure. I placed the big lights, keeping in mind the general local color and not concerning myself with tiny variations of color. Notice how the shadow shapes stayed very similar to the last tonal pass. In this stage I also corrected shapes and made the drawing more accurate.

STAGE FOUR:
Refining the Form

At this point I placed the dark shape of the tank top and found the shadows from the straps on the shoulders. I increased the color in the reflected lights and the features. Once I had articulated the color rhythm, establishing believable large shapes, it became a solid foundation onto which I was able to push the color. I also zoomed in, focusing on individual areas of form and volume, and transitioning from the core shadow into local lights.

Juliette Aristides. *The Spark*, 2015, oil on canvas, 36 x 24 inches (91.44 x 60.96 cm).

STAGE FIVE:
Painting the Background

Turning a nude into a thematic painting requires playing with space, choosing at what point the background comes forward or dissolves in to the figure. I also push certain areas of color to be more intense.

There are times when I start painting from the background and finish the figure afterward. In this instance, I did the reverse, placing the background at the end. The way the figure interacts with the environment is an important part of creating a unified image.

The figure is a combination of large areas of broadly placed masses contrasting with tightly observed form. During the finishing stage of the painting I was concerned with manipulating the edges, softening some and sharpening others. I made small touches after the model left, looking at the whole image for emphasis and balance. This is an essential part of finishing the painting.

Happy are the painters, for they shall not be lonely. Light and color, peace and hope, will keep them company to the end… of the day.

—*Winston Churchill (from* Painting as a Pastime*)*

Juliette Aristides, *Tree and Leaf*, 2013, oil on linen, 36 x 48 inches (91.44 x 121.92 cm).

AFTERWORD
a note of encouragement

A thing of beauty is a joy for ever:
Its loveliness increases; it will never
Pass into nothingness; but still will keep
A bower quiet for us, and a sleep
Full of sweet dreams, and health, and quiet breathing.

—*John Keats* (*from* Endymion)

Every painting begins as a vision in the mind of the artist; yet the moment the brush touches the canvas, the painting no longer exists only as an idea, but as painted marks on a surface. Even if the resulting work is close to the original vision, it is always different. The chasm between what you hope to achieve and what you actually create can be painful. Drawn to this gap are the critics. Those inner and outer voices remind us of our shortcomings. Permanent inner satisfaction is difficult to maintain, and neither fame nor success seems to form a bulwark against self-doubt.

Every artist presumably must face failure at some point in his or her career. I have never met an artist who didn't suffer from a season of failure, either real or imagined. Discussing the subject may not help you avoid it, but it may help you take it more lightly in your stride as an occupational hazard.

I was almost wiped out by one such cascading moment. It started with a beginner's mistake—the absorbent chalk surface of my panel was too porous and rendered the surface of my painting unworkable. A solo show loomed imminently and my still life painting, which should have taken days, was instead taking weeks. A family member's surgery left me with little time for painting, the light from the window faded, and I had wasted another day. My thoughts, which had been dark for days, took a turn toward black: "I have spent my life fighting to make art. If I were meant to do this, it wouldn't be so difficult. It's time for me to do something else with my life."

This decision gave me momentary relief, but then I realized the opposite could be equally true: "What if this is meant to be an arduous journey and those of us who don't realize it are weeded out?" Which interpretation was correct?

OPPOSITE John La Farge, *Agathon to Erosanthe (Votive Wreath)*, 1861, oil on canvas, 23 x 13 inches (58.42 x 33.02 cm). The Lunder Collection, Colby College Museum of Art (Waterville, ME).

227

At that exact moment the phone rang. Unbelievable, but true. A man introduced himself; he had seen my painting in a show and told me to carry on doing good work. The one random voice, the one word of encouragement at that exact time saved me that day and gave me the courage to keep going.

While encouragement came at the right time in my own story, it is possible for just the opposite to happen. Look at one historical example: In 1818, poet John Keats was twenty-three years old and had just published his sprawling four-book poem *Endymion*. In response, he received some spectacularly negative reviews. One critic wrote: "This author is a copyist of Mr. Hunt; but he is more unintelligible, almost as rugged, twice as diffuse, and ten times more tiresome and absurd than his prototype." Two years later Keats was dead from tuberculosis; his friends believed he was killed by psychological trauma induced by his critics. Percy Bysshe Shelley wrote, "The savage criticism of his *Endymion* which appeared in the *Quarterly Review* produced the most violent effect on his susceptible mind."

The poet Lord Byron wrote:

Who kill'd John Keats?

"I," said the Quarterly,

So savage and Tartarly:

"Twas one of my feats."

Keats requested to be buried in a tomb with no name and date. His friends added the words, "This Grave contains all that was Mortal, of a young English Poet, who, on his Death Bed, in the Bitterness of his Heart, at the Malicious Power of his Enemies, Desired these Words to be engraven on his Tomb Stone: Here lies One Whose Name was writ in Water."

Keats's life is an example of how damaging criticism can be. In his case, bad reviews by his contemporaries and the fears in his own heart did not accurately reflect the quality of his work. He remains one of the most beloved of the English poets, and the continued popularity of his work shows that his vision and its expression have enduring value. Keats's legacy is a testimony to the power of art amidst suffering and a belief in the restorative power of beauty.

Despite the pain it can cause, criticism is not always bad. This inner and outer antagonist can function like a rival, spurring you on to greater achievement, keeping you from becoming complacent, and encouraging you to look further and deeper. The American

philosopher John Dewey suggested that to be fully alive we need the stress of conflict and the harmony of resolution—allowing us to have a creative aesthetic experience. He said that if we lived in a perfectly stable world there would be no art, because, "Where everything is already complete, there is no fulfillment."

Theodore Roosevelt famously noted: "It is not the critic who counts; not the man who points out how the strong man stumbles, or where the doer of deeds could have done them better. The credit belongs to the man who is actually in the arena, whose face is marred by dust and sweat and blood; who strives valiantly; who errs, who comes short again and again, because there is no effort without error and shortcoming."

The inner critic is a strong driver toward fulfillment. It is, however, important to remember that none of us can know the value of our own work. So we must hold lightly the estimations of our art—not only from our peers, but also from our own inner critics, who are never satisfied. We must do the work for the joy of the vision and the experience of creation itself, enduring the gap—the chasm—that exists between what is and what we wish could be, knowing the longing itself may actually be a predictor of its own fulfillment.

Juliette Aristides, *Sartorio and the Fox*, 2015, oil on panel, 36 x 42 inches (91.44 x 106.68 cm).

BIBLIOGRAPHY

Bardwell, Thomas. *The Practice of Painting and Perspective Made Easy*. London: S. Richardson, 1756.

Callen, Anthea. *The Art of Impressionism: Painting Technique and the Making of Modernity*. New Haven and London: Yale University Press, 2000.

Collier, John. *A Manual of Oil Painting*. London, Paris, New York, and Melbourne: Cassell & Company, Limited, 1886.

Couture, Thomas. *Conversations on Art Methods*. Translated by S. E. Stewart. New York: G.P. Putnam's Sons, 1879. Originally published as *Méthode et entretiens d'atelier* (Paris: privately printed, 1867).

Eakins palette: http://cool.conservation-us.org/jaic/articles/jaic31-01-007_2.html.

Gage, John. *Color and Culture*. Berkeley and Los Angeles: University of California Press, 1993.

Parkhurst, Daniel Burleigh. *The Painter in Oil: A Complete Treatise on the Principles and Technique Necessary to the Painting of Pictures in Oil Colors*. Boston: Lee and Shepard Publishers, 1903.

Solomon, Solomon Joseph. *The Practice of Oil Painting and of Drawing Associated with It*. Philadelphia: J.B. Lippincott Company, 1910.

Speed, Harold. *Oil Painting Techniques and Materials*. New York: Dover Publications, Incorporated, 1987. Originally published as *The Science and Practice of Oil Painting* (Chapman and Hall Ltd., 1924).

SPECIAL NOTE

Many of the artists featured in this book studied with me at the Aristides Atelier. They include:

Jennifer Baker (page 159)

Andrew DeGoede (page 118)

Bobby DiTrani (page 127)

Brett Downey (page 168)

David Dwyer (pages 44, 173)

Zoey Frank (page 165)

Walker Hall (page 165)

Patricia Halsell (page 170)

James Hansen (page 88)

Rebecca King (page 32)

Joshua Langstaff (page 174)

Kevin Scott Miller (page 106–110)

Tenaya Sims (page 147)

Tenold Sundberg (pages 55, 126, 164)

Carrie Williams (pages 20, 24)

John Zadrozny (pages 111, 162)

Elizabeth Zanzinger (page 91)

ACKNOWLEDGMENTS

This book would never have been created without the help of the following people my thanks (truly) to:

Jennifer Baker, a friend and fearless tamer of the Excel spreadsheet.

John Zadrozny, partner in long hours of color chart mixing and all-around encourager of the fainthearted.

Melissa Messer and Margaux Keres, gifted designers who, with grace and focus, shaped images and text into a beautiful presentation.

The Art Renewal Center (artrenewal.org) for making great art accessible to so many people. A big thank you to Yvette Lytle, Graphics Associate and Museum Archivist, at the ARC for all your help with securing images for this book.

Jenny Wapner, Executive Editor at Ten Speed Press for your faith in this project.

Patrick Barb for editing this book (along with early edits by Allison Hagge, Steve Whitney, and Paul Gelbach).

Barbara Kadus, Manager of Imaging Services, and Jennifer Jones, Associate Registrar, at PAFA, for your kindness in sharing the treasures at PAFA with so many.

Alan Carroll for his essay. More of his work can be found at surfacefragments.blogspot.com.

Andrei Kozlov, who turned a grimy studio setting into compelling images of life in an artists studio through his beautiful photography.

Robert Armetta who, so many years ago, introduced me to the world of the atelier.

All artists and students who contributed art (especially my advanced students who helped with color charts: Mandy Hellanius, Patricia Halsell, Karin Roth, and Martijn Swardt).

Thank you to all the models who posed for images in this book, there would be no great art without you.

I first met Jacob Collins as a student in his life drawing class at the National Academy of Design in New York in 1994. Jacob took a small group to study in his studio in Brooklyn, NY. From there he opened Water Street Atelier before moving the studio to NY as Grand Central Academy. Jacob was the first person to fully embody, to me, what it meant to be artist. Jacob Collins's painting is as inspiring today as the first time I saw it. Students and the art world alike owe him a debt for touching so many of us with his fearless belief in the transformative power of beauty in art .

Jacob Collins, born 1964 in New York, New York, a respected artist, teacher, and role model in the field of contemporary realism. Combining a technique reminiscent of the nineteenth-century American realists with a freshness of vision scarcely encountered among today's traditional painters, Collins's works form that rarest of unions where classic beauty and striking originality meet as harmonious equals. He received a Bachelor of Arts from Minneapolis School of Art and studied drawing, painting, and sculpture in New York and Europe. Collins's work has been widely exhibited in North America and Europe, and is included in several American museums.

ABOVE Jacob Collins, *Fire Island Sunset*, 2004, oil on canvas, 24 x 38 inches (60.96 x 96.52 cm).

PAGES 234–35 William Trost Richards, *Old Ocean's Gray and Melancholy Waste*, 1885, oil on canvas, 40¾ x 72¼ inches (103.5 x 183.5 cm). Gift of Mrs. Edward H. Coates (The Edward H. Coates Memorial Collection).

PAGE 236 John La Farge, *Sleep (Study of Female Figure Asleep)*, circa 1884–5, watercolor on paper, 8 x 6½ inches (20.3 x 16.5 cm). The Lunder Collection, Colby College Museum of Art (Waterville, ME).

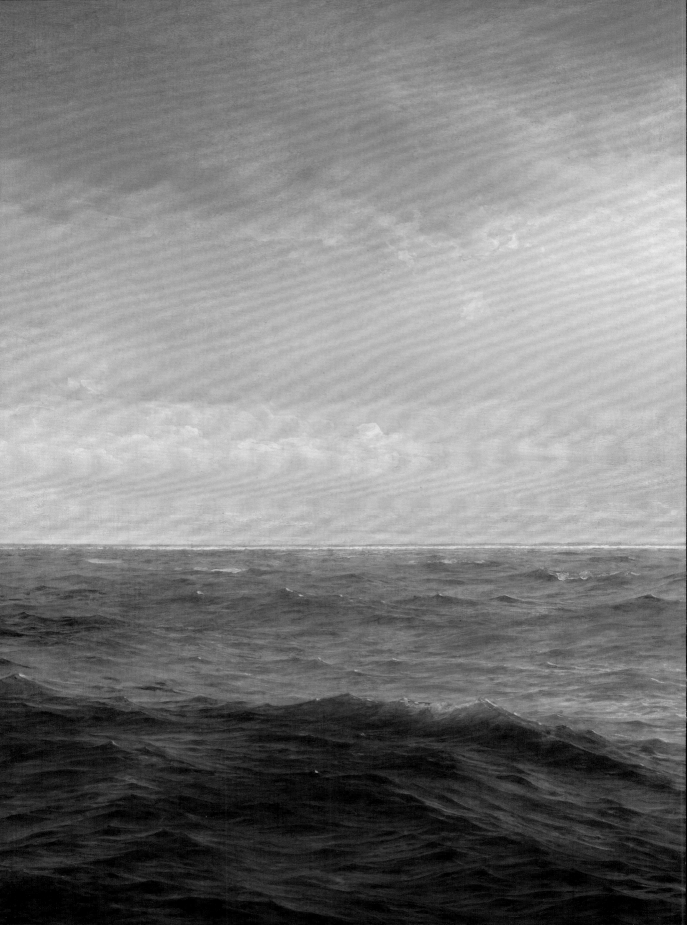

INDEX